How to Get a Job You'll Love

How to Get a Job You'll Love

☞ A practical guide to unlocking your talents
and finding your ideal career

JOHN LEES

THE McGRAW-HILL COMPANIES

LONDON·BURR RIDGE IL·NEW YORK·ST LOUIS·SAN FRANCISCO·AUCKLAND·BOGOTÁ
CARACAS·LISBON·MADRID·MEXICO·MILAN·MONTREAL·NEW DELHI·PANAMA
PARIS·SAN JUAN·SÃO PAULO·SINGAPORE·SYDNEY·TOKYO·TORONTO

Published by
McGraw-Hill Publishing Company
Shoppenhangers Road, Maidenhead, Berkshire, SL6 2QL, England
Telephone: +44 (0)1628 502500
Fax: +44 (0)1628 770224
Web site: http://www.mcgraw-hill.co.uk

Author's website: www.johnleescareers.com

Sponsoring Editor:	Elizabeth Robinson
Production Editorial Manager:	Penny Grose
Desk Editor:	Alastair Lindsay
Cover design:	Senate Design
Produced by:	Steven Gardiner Ltd
Text design:	Claire Brodmann Book Designs, Lichfield, Staffs.

British Library Cataloguing in Publication Data
A catalogue record for this book is available from the British Library

McGraw-Hill

A Division of The McGraw·Hill Companies

Designed by Claire Brodmann Book Designs, Lichfield, Staffs.

1 2 3 4 5 IP 5 4 3 2 1

Printed and bound by Bell & Bain Ltd., Glasgow.

ISBN 0 07 709800 5

CONTENTS

PREFACE

WORK – YOUR FUTURE

Most people spend more time planning a car purchase, one annual holiday, or their new kitchen than they do thinking about their career. Generally speaking, we're not good at career planning at all. It's staggering how many people drift from one job to another with no clear idea of the way their career is heading.

It's easy to think of career management as a crisis activity. *I must get out of here. I must find work. I've got to get a better job.* You do need to plan your career at times of transition: when you leave full-time education, when you are out of work or under-employed, or when you have a strong impulse to move on and make progress. Sometimes a sense of career crisis is expressed as an overwhelming need to do something more meaningful or relevant.

Who is this book for?

This book is written for anyone who is trying to make conscious, informed decision about career choice. All kinds of people have difficult career decisions to make. This book can help you if you are:

- Leaving full-time education or returning to work after bringing up a family;
- Facing redundancy and asking 'what do I do next?';
- Unemployed and looking for better ways of identifying opportunities;
- Seeking work and short of ideas about job possibilities;
- Feeling 'stuck' and looking for new challenges, and wondering 'what on earth can I do'?;
- Ready to plan your next stage of your career;
- Trying to anticipate the rapid changes in the twenty-first-century world of work;
- Discouraged because you believe you have little to offer the labour market.

How to use this book

There are many 'how to' books about career change and job search. They are good at getting you organized and giving you ideas. Some of the best ones are listed in an Appendix to this book.

This book aims to do something different. Its approach is to look at the way that people generate brilliant ideas and new ways of solving problems or designing products, and it then applies that breakthrough thinking to you

and your career, the way you work, and the way you find work. It challenges your perceived limitations, and helps you discover your strengths. Finally, it provides practical advice about making your chosen future happen.

Quite simply, the aim is to help you make connections between your natural creativity (yes, we all have it – but more on that shortly) and the way you plan your life's work.

The first step is to *take a sideways look* at the way you think about yourself and the work you do (Chapter 2), and then take a fresh look in Chapter 3 at your *career problems* – what's preventing you from getting a job you'll love?

The central section (Chapters 4–8) is a step-by-step guide towards a deeper understanding of your chosen areas of *knowledge*, your preferred and hidden *skills*, and the key aspects of *personality* that will shape your career.

Your field of work is a vital choice, so you get a chance to *leap into a new field* (Chapter 9) and then try out a unique tool to help – the *Field Generator* (Chapter 10).

Next, some highly practical aids to achieving your goals. Chapter 11 offers a comprehensive range of *creative job search strategies*, Chapter 12 offers a guide to *interviews*.

Planning your career requires a clear focus on the needs of the twenty-first-century workplace, which are addressed in Chapter 13: *'What the Future's Looking For'*.

Chapter 14, *'Beginning it Here'* is a five-point plan to put things into action, supported by a series of highly practical *checklists* in Chapter 15 covering everything from CV preparation to your first week in a new job.

Finally, you will want to know where else to look for ideas. The book closes with recommendations of some great books to help with career decisions, job search, the future of work, and creative thinking, and there's also *a list of useful web sites* providing career assessments, on-line testing and thousands of vacancies.

HOW THIS BOOK WILL HELP

In these pages you will look at the way businesses and individuals generate ideas about products, services and organizations, and apply that creative energy to career planning.

This book aims to unlock your hidden potential and apply it to your career, your life planning, to make the way you spend your waking hours more creative, more meaningful, more enjoyable. Its focus is not on job change for its own sake. As a result of reading it, you may discover tools to improve your present job and create career opportunities where you are now.

The chapters ahead approach one major issue: your career. You may find the one tool that unlocks your potential, or you may gain multiple insights from using several ideas or exercises. One word of advice: if the exercise doesn't work for you, don't feel you have 'failed'. All it means is this: *the exercise doesn't work for you*. Put it aside and move on. Remember, if there is not enough space in the book to write down your responses to the exercises, you can make an enlarged photocopy of the exercises to give you more room.

- Making sure that work provides the things that motivate you most – status, recognition, independence, learning;
- Planning for retirement or changes of lifestyle.

IS WORK THAT IMPORTANT?

Judging by the amount of time people spend complaining about it, it must be. A huge amount of negative energy goes into, and comes out of, work. If it wasn't for work, we would have far less to complain about.

Far too many adults of working age in Europe are either unemployed or under-employed, even in boom times. Being underemployed is as worrying as unemployment: people who are underemployed or in the wrong kind of work become demotivated, depressed and ill. Work matters.

If we begin with life and work, we should ask ourselves one question: do you *work to live* or *live to work*?

One reason you might *work to live* is that your life's centre is outside your work. You are more motivated by the things you do outside work than the things which earn you a living. You are living out your dream in a different reality, and your salary is there simply to fund your dream. A lot of people live that way, and can be happy. Others feel that something vital is missing, but they struggle to define it.

If you work full-time hours you spend more of your life in work than in any other waking activity (if you live for 70 years, you'll spend about 23 of those years in total asleep, and 16 years working). Perhaps one reason you're reading this book is because you want more out of that huge slice of life we call *work*.

If you really believe that you *work to live*, then maybe you just want to earn and spend money. Whether this is on antique books or fast cars, you're more interested in *when* the money comes in than *how* it comes in. If this is you, put this book back on the shelf until you need it. You will, some time.

If you feel that you *live to work*, it may be that you've found the best job in the world. There are dangers here, too: your work/life balance may need adjustment. Perhaps work plays too important a part in your life? Those who suffer the greatest impact of redundancy are those who have made their work the most important thing in their life, perhaps at the expense of family or personal development.

WHAT IS CREATIVE CAREER MANAGEMENT?

Valuing creativity

To achieve a breakthrough in any kind of planning or exploration, you need to be aware that there is more than one approach. There is a straight-line, logical approach, but there is also the kind of thinking that comes from applied creativity.

The first thing to recognize is that we are all creative. We're all capable of inventing extraordinary solutions to cope with life's problems. For most of us these problems are everyday: taking children in opposite directions in one car; paying this week's bills with next week's money, mending things using old bits and pieces rather than buying an expensive component. We are all creative. We have to be: that's how humans have survived.

Being creative isn't, essentially, about being able to do artistic things. Some of us can dance, paint, draw, compose music. That's just one kind of creativity.

CREATIVITY:
· ·
- Is not just for geniuses;
- Isn't just about advertising;
- Is accessible to everyone;
- Can change your life ...

You will probably have come across many different ways of describing the way people think. This book will look at some of them. However for many of us lists, plans, diagrams and flow-charts don't work. We don't read life that way. We're inspired by conversations, by people, by movies, by music; our natural creativity needs a different kind of kick-start.

The important thing to remember at this stage is this: *we are all given a particular kind of creativity*.

Those who look at the left and right brain sometimes make the mistake of assuming that creativity is associated just with right brain activity, in other words associated with artistic, expressive or entrepreneurial activity. Not so. All parts of the brain are the creative brain, whether we are making a sculpture or planning a family party, mixing a cake or designing an opera house. The creative brain is about new possibilities, new ways of doing things, new ways of being. We rethink who we are and how we do things all the time, at an ever-accelerating pace. To stop being creative is to become a function, a role, and to stop being human.

☞ There is no point in work unless it absorbs you like an absorbing game.

D. H. LAWRENCE

Creativity can be expressed in (conventionally) unusual areas. We might:

- Make a page of numbers dance, and read a balance sheet like a musical score;
- Take an engine apart and put it back together, perfectly, without a diagram;
- Find a new way of explaining a complex theory in everyday terms;
- Care for three or four difficult children at their most unpleasant;
- Make dinner out of six things found in the cupboard;
- Make rotas run as smoothly as clockwork;
- Persuade sworn enemies to talk to each other for the first time in 10 years.

What has creativity got to do with career exploration?

Let's think, briefly, about the way we use creativity in life. We use it to solve problems where ordinary solutions don't work. Isn't your career this kind of problem? You've tried to deal with it logically, by progressing in a sequence from A to Z. You've done the right courses, taken the right initial steps, gained

the experience. ... Does work provide the right answers? You've tried to look at career change as a *business discipline*, because you've been told that getting a job is itself a job. Maybe that worked, but did it get you the right job?

So, we turn to another method. We've already looked at some of the ways we use creativity as a tool in our ordinary life. Let's look for a moment at the way creativity is tapped as a resource in business life.

Every day business executives wake up and have to think of new ideas: new names for brands, new ways of selling old products, new ways of communicating with people. They have to *generate ideas*. Ideas come from hard work, from experience, but principally from the creative imagination. We all have it. It's the ability to think yourself into someone else's shoes, to think of possibilities, alternative futures, what if ...

Necessity, it's said, is the mother of invention. If so, creativity is what drives invention, the source of ideas. Human beings have a great many unique capacities, but the one we should celebrate is our *conceptual thinking* – our ability to generate ideas, concepts and visions, to turn them around in our heads until they seem to work, to express them to others, and to make them real.

Where do ideas come from? – The age-old question of the tired mind. Writers, designers, inventors and advertising executives all have the same dread: the blank piece of paper. Yet there are ways of learning how to generate ideas.

Jack Foster, in his excellent book *How to Get Ideas*, tells of the time when he gave his advertising students the exercise of designing an outdoor display advertisement:

☞ One of the assignments I gave each student was to create, overnight, an outdoor board for a Swiss Army knife. Most of the students would come in the next morning with the required billboard, but several of them would say that they worked for hours and couldn't come up with anything. This happened three years in a row. The fourth year I tried something different.

Instead of asking for just one billboard, I asked each student to create at least ten billboards for a Swiss Army knife. And instead of giving them all night, I told them they had to do it during their lunch hour.

After lunch everybody had at least ten ideas.

Many had more. One student had 25.

How To Get Ideas, JACK FOSTER

Jack Foster talks about the fact that we normally look for the 'right' solution, but creativity works better where we seek multiple solutions – first one idea, then another, then another. Creativity thrives on abundance.

Being faced with hundreds of choices – doesn't that just lead to indecision? Don't confuse idea generating with decision making. How many meetings have you been to when the first good idea is shot down in flames? Ideas are tentative, fragile things that in their early stages can't stand up to the strong light of decision making. It's no use thinking 'I wonder about medicine ...' if you immediately say 'Do I want to be a doctor, or don't I?' Forcing a decision too early

simply crushes creative thinking. Maybe not a doctor – maybe a medical journalist, or a pharmacist, or a physiotherapist ...

When we think about ideas about our future, we must allow ourselves space to *play* with ideas, with possibilities, to allow life to be open ended.

That's where this book is designed to help. In a nutshell it will:

● Help you look with new eyes at your own skills, talents and knowledge;
● Explore who you are, and look for clues about your life's work;
● Check out the barriers to effective career planning;
● Help you discover the fields and jobs which will fill you with energy;
● Show you how to discover hidden career opportunities;
● Seek breakthroughs in the way you think about work;
● Prepare you for an innovative job search strategy;
● Develop lateral thinking to anticipate what twenty-first-century employers are looking for;
● Offer you strategies for career change and personal growth.

Why do people avoid creative career planning?

It's true, in general people tend not to apply creativity to career planning. Why?

Well, first, people do what feels safe. You will be aware of some creativity in your life, but you will probably have two key strategies for suppressing it:

1 *I'm not a creative person*
 This generally means: 'I'm not good at arranging flowers/painting/writing poems'. These are only aspects of creativity.
2 *Creativity is all right in its place*
 This is an equally powerful restrainer: 'Creativity is about fun. That's OK for leisure time. Reality is about hard work.' Creativity is seen as an optional add-on rather than a tool for living.

The problem with 'I'm not a creative person' is that it can become a self-fulfilling prophecy. Roger van Oech's ground-breaking book *A Whack on the Side of the Head* reports on research undertaken by a US oil company into why some of its staff lacked creativity. A team of psychologists looked into the problem and discovered that 'The creative people thought they were creative, and the less creative people didn't think they were. As a consequence, the people who didn't think they were creative never put themselves in a position where they could use their creativity.' If you believe 'I'm not creative', your energy goes into making sure this is true. You're probably very good at creating self-fulfilling prophecies. If a golfer says, 'I bet I slice this ball', he probably will. If your daughter walks into a room carrying a full glass of milk and you say 'Mind you don't spill that', you almost certainly increase the chance of milk on the carpet.

Do you compartmentalize your creativity? Do you save your playful self for the times when you can really let your hair down, or for your line dancing class, or for weekend gardening? What is your most creative part? Do you keep that part of your self quiet and protected?

Even in work, too many people see creativity as a 'soft skill' reserved for those

people who work in obviously 'artistic' or 'creative' roles such as advertising or design. Too many firms have drawn a line between 'creative' and 'functional' staff. Creative solutions are fine for marketing, but not for accounting.

Habit and fear also play a large part – 'This is the way I've always done things.' We accept that as a given, but say in the same breath, 'I need a new way of doing this stuff'.

If you put creative thinking in a box marked 'for leisure use only' or 'for the use of the creativity department, not me', then you're deliberately switching off part of your brain. To deny your creative brain is to switch off possibilities, to close the door on innovation, to fail to make connections between what you learn and what you can do tomorrow. The greatest sin, according to the poets, is a *failure of the imagination* – switching off the creative mind just when you need it most. In work terms, that means ignoring your natural talents and living half a life.

Years ago in the US I heard a motivational speaker say 'If you only live half your life, the other half will haunt you forever.' It took me 10 years to understand those words that have stayed a part of me ever since.

But in reality . . .

We'll get on to this kind of thinking in Chapter 3. Applied early in the lateral thinking process, this kind of thinking can be deadly. It is true that organizations and people all have *constraints* – bills to pay, mouths to feed. It's important not to underemphasize that fact. However, what matters is that these basic requirements are seen for what they area, not the centre of life. Doing something different requires you to give careful attention to the *first thing you do when the constraints are dealt with*. A business needs to manage its cash flow and its finances, but doing this won't set the world on fire.

'I just need a job'

By now you've maybe come to the conclusion that creative career management *might be a good thing for somebody else*. Why not you? Because you feel that reality is harder and tougher than that. You need something real, right now, that pays the bills. You *just need a job*. This might be because you're unemployed, or because you're just not paid enough to make ends meet. This places you in a vulnerable position in the labour market. It forces you to become a *job beggar* – going round with your hat in your hand with one message for employers: I need a job. Desperately.

If that's what you communicate to employers, colleagues and family, that's what you will become. Desperate. It's all too easy to create a negative image of your future which is self-fulfilling.

The good news. This book doesn't just offer creative techniques and words which will perhaps motivate or even inspire you to get a job you'll love. It also provides a great deal of practical support, a lot of it focused on the difference between your own internal conversations and what's going on in the real world of work.

I spent some time in early 2000 working with a group of job seekers from one of the townships in Johannesburg. One of them, Gugu, was aged 17 and had given

up looking for work. Why? *'There are no jobs in South Africa'*, she said. But new jobs are being created in that country every day ... 'Yes, but so many people are chasing them', she said sadly.

Talking to her I realized that too many job seekers are giving a totally undifferentiated message. Fortunately, she and her fellow job seekers all found jobs as a result of a programme which allowed her to focus on her true strengths, and gave her the tools to demonstrate those to potential employers.

South African job seekers, like job hunters all over the world, suffer from three damaging assumptions:

1 There are no jobs (or no suitable jobs) available;
2 The only jobs available are for skilled and qualified workers with extensive experience;
3 Employers are looking for people who are prepared to do any job and work hard.

Think of the message job hunters give out, and what employers actually hear:

What job hunters say	What employers hear	What to say so that employers feel their risk is reduced
I just need a job	I'm desperate	These are the skills I have to offer ...
I'll do anything	I don't do anything particularly well; OR: I'm unskilled/untrained	I'm enthusiastic I like what I'm doing I get results I'm flexible
I'm a hard worker	I make up for lack of skill by effort, but I will need a lot of training	I respond well to training I'm a self starter I'm reliable

No, it's true: I just need a job

Do you really? How long will it be before you're back asking the same questions: What am I doing this for? Where's my life going?

Don't allow 'I just need a job' to be a justification for suppressing what you have to offer, otherwise you end up saying that there's no point thinking about my career, my skills, my future, because there are no choices. There are very few occasions where that's true. And if you need money, just earn it. Don't pretend that's all there is. We all have choices.

US careers guru Dick Bolles tells of a seminar participant some years back who was asked the question 'What do you love doing?' ... This man was a business executive, but his love was playing Bridge, teaching Bridge, talking about Bridge, reading about

Bridge. 'So there's your career opportunity', colleagues said. The man gave a wry smile and said 'Bridge is what I do for fun, not a way to make a living.' Nevertheless, he was persuaded to begin a Bridge school at weekends. The school took off, spread to other cities, and tutors had to be hired. Now this business executive makes his living by running one of the USA's most successful Bridge teaching networks. What you love doing isn't necessarily to be confined to leisure time.

There will always be those who say '*get real* – few of us have the luxury of career choice'. Yet we all know people who broke out of that box. Listen to successful people talking about the work they do. They don't often say 'Well, the money's good'. They talk about work being like a 'game', being 'fun' or 'the best job in the world'; they talk about the privilege of doing for a living what they would gladly do for nothing.

Effective career planning is about finding a job that works for you – matching who you are to the life you are going to lead. That's not a luxury: that's the clearest reality there is. Doing that provides you with a great career, and gives you a greater chance of contributing to life.

One spin-off from exploration is that you may recognize that your work can be adapted around you so that it is more closely related to your interests or the skills you really enjoy using. Career development doesn't always mean changing jobs.

Finally, there are those that argue that work cannot always provide a match with your interests. You might find, however, that if there is no overlap at all between the things you find most meaningful in life and the work that you do, then you will be dissatisfied in the long term. Others have used the kind of process outlined by this book to enrich their time outside work – to make sure that their lives are a balance of work, leisure and learning.

Working smarter rather than harder at career building

Actively planning your career is hugely rewarding, but it's also demanding. There are plenty of things we would rather do. What we would really like is for the phone to ring and a pleasant voice to say 'Hey John, we at XYZ have heard all about you, and we think you'd be just right for. . . .' A small proportion of people in business get those calls. Headhunters persuade them to take a job which pays more money and gives bigger ulcers. The majority of us have to rely on a mix of good judgement, inspired guesswork, and a pinch of luck. Luck has been described as two mathematical laws working together: chance and averaging. We can't control chance, but we can increase the odds by setting goals and aiming carefully.

A long time ago I learned that any form of public speaking relies on the *three P's*: preparation, preparation, preparation. Any good comic act or public presentation *looks* creative and inspired, but as the wisecrack goes, it's 5 per cent inspiration and 95 per cent perspiration. Career planning requires *applied creativity*, which means getting your preparation right, planning things right, giving enough time to thinking and reflecting.

But the key to planning time in any area of work or personal life is not to work harder, but to *work smarter* – to use your precious thinking time carefully, to learn

from the mistakes others have made before you, and to learn to think openly, because a moment's inspiration can sometimes take you far, far further than a year's dull planning.

Draw a flow chart of your life so far, indicating all the most important steps and decisions. It might look a little like Figure 1.1.

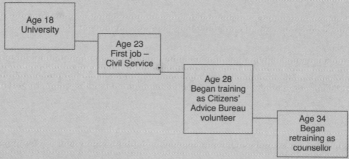

FIGURE 1.1 Life flow.

Now at each critical point draw add in as many choices, real, remembered or imagined, as in Figure 1.2.

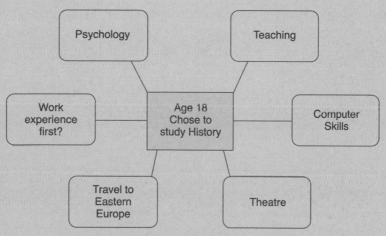

FIGURE 1.2 Possible choices at each turning point.

Mindmaps

You might find it helpful to use a *mindmap*. This is a technique pioneered by Tony Buzan which provides a tool for individual brainstorming. You place a topic at the centre of a large, blank piece of paper, and draw lines out of it to represent new ideas or connections. It's useful for exploring possibilities, as Figure 1.3 demonstrates.

FIGURE 1.3 Mind-mapping your career options.

'MUST DO' LIST

☞ What difference would active career planning make in your life? Complete the *Life Flow* exercise, and then ask yourself whether your career decisions were made consciously, or whether you largely responded to opportunity.

☞ Think about how you can use this book to help. Begin a hardback notebook to jot down your discoveries and the results of the exercises in this book.

☞ Begin by writing down the areas of your life where you have been most creative.

☞ *Write down your goals.* It makes a difference.

☞ Enlist help. Find a supportive listener/coach who can help you through some of the exercises in this book.

☞ Plan ahead. Look at the chapter headings and decide how and when you are going to set aside time to go through this process.

TABLE 2.1 Managing personal change

Six ways organizations deal with change	Personal change
1 Organizations think about the impact of change on workers as *individuals*, and changing the way they think. The focus is often on transforming stress into positive energy, and on personal coaching to help staff cope with *transition*.	How far is your normal work pattern blocked by *the way you think* and *the way you normally see things*? Try looking at a motivational book like Steven Covey's *The Seven Habits of Highly Effective People*.
2 Some models of change draw on the idea that we are more influenced by *social environment* than by personality.	How far has your career been shaped by the expectations or norms of family and friends? What would be the impact on your career of an entirely new network of friends and colleagues?
3 Directly influencing *culture* has a huge impact. Most of us are unaware of the prevailing culture of organizations and find it difficult to see the need for new behaviours. This is one of the reasons why companies bring in new leaders from outside the organization.	Our ideas about 'realistic' or 'practical' thinking and 'appropriate' career choices are strongly influenced by the cultures we live and work within. Think about the way a new leader can be a fresh of breath air in a deadlocked organization. What person or idea could have the same impact on you?
4 An *Innovation* approach promotes change by championing a new idea or practice, and makes sure it is communicated. Success is measured in degrees of resistance or adoption.	If you fall across a good idea, are you an early adopter, a reluctant adopter, or a resister? What if it's *your* idea?
5 Other approaches look at organizational change from a *global* perspective (e.g. life-threatening changes dictated by external factors, or the long-term position). Such a view often assumes that processes, structures, strategies, values, are all subject to change.	What's your *big picture*? What external factors (family, health, changes in the economy) are going to have a big impact on your career?
6 Most developed organizations in fact take a *multiple* approach, taking elements from 1 to 5 above.	What elements are in your personal change toolbox?

TABLE 2.2 Your journey

A Mapping the road ahead	B Journey planning
Where are you going? What tools, resources and techniques are you going to use to check out possible and preferred destinations? How are you going to make an inventory of what you take with you – your skills, knowledge, motivators, qualities . . . What maps are available to help you get there? – Resources, investigative tools, interesting conversations . . . Who has taken this road before? Don't plan alone. Who will be your travelling companions – your active support team?	How will you plan to succeed? How can you find out more about your destination and the best way to reach it? – Access to good quality information about entry routes, job creation, changes in the economy . . . What 'rules' do you have to change – maybe including your own 'rules' about change and risk? When have you done this before? Remember how you succeeded then, and what you got out of the journey. How are you going to behave? Will the travelling actively help you, or do you just want to get from A to B as quickly as you can without enjoying the view?
C First steps	D Reading the signs
What will you do first? Without the first mile, there is no journey. Where is your first stepping stone? – You may have to take an indirect route. How will you keep the chosen destination in your sights (your long-term goals)?	How will you interpret what you discover? How will you measure your success – in terms of what you learn, or in terms of job offers? How else? What style will you travel in? Will you be cautious, reluctant to make mistakes or step outside your comfort zone? Or will you be playful, experimental, open . . .?

on a hill one summer's day, and let the sunlight flicker through half-closed eyes. Seeing thousands of tiny beams of light, he wondered what it would be like to travel through the universe at the speed of light or faster. One imaginary trip formed the foundation of modern physics.

Career explorations are a kind of journey, but a journey that is open to possibilities. Your journey has four stages, as in Table 2.2.

Be experimental

My wife and sons recently enjoyed their first canal boat holiday. They got stuck, they rescued themselves and others, and they learned quickly. In the middle of one particularly sticky manoeuvre an old hand was in another boat watching.

They apologized for their errors. He beamed at them: 'Don't worry about it. It's all experimental.' It's a great approach to life – far better than a blame culture. Experiment and failure, 'making mistakes', is a necessary part of creative thinking. And if you are going to use the word failure, then 'fail forward' rather than 'fail backward' – in other words, make your mistakes positive steps forward in your learning. Every successful product brought to market required a thousand near-misses, almost-theres, nearly-got-its. Experiment away.

EXERCISE 2.1 COPING WITH CHANGE

A great deal of what you will read in this book is about *change*. How you respond to change is a reflection of your personality and your experience of change in the past. Look at the words in Table 2.3 below.

TABLE 2.3 Elements of change.

Make new friends	Learning curve	Flash in the pan	Travel	Change of scenery	Access to learning
Alter pension arrangements	Take risks	Promotion ladder	Change for change's sake	Competition	Quick fix
Learn new skills	In at the deep end	Benefits package	No clear picture	Young company	Tradition
New boss	Need to study	Job too small	Lack of vision	New technology	Throw out the rule book
Build new relationships	Be disappointed	Core values	Investing in my future	Performance	Look foolish
Prove myself	Job too big	Dead end	Calling	Targets	Unknown

Put a tick next to the words or phrases that fill you with optimism and energy. Highlight or underline the words that give you a sense of discomfort or panic. Then ask yourself the following questions:

- How can I increase the number of positive responses?
- How can I diminish the impact of the negative ones?
- How can I help others who perceive change differently to the way I do?
- How can I learn from the way others cope with change?

EXERCISE 2.2 USING FORCE-FIELD ANALYSIS TO MANAGE PERSONAL CHANGE

This technique was devised by Kurt Lewin, and presents a variation on traditional problem solving techniques. Lewin argues that change is brought about when the driving force for change exerts greater pressure than the restraining forces that resist it.

Draw up two columns. In column one list all the benefits that would be obtained if you manage to change your career, either by changing your job or re-negotiating it. In column two list the negative forces (i.e. the forces against change). Figure 2.1 shows some typical examples:

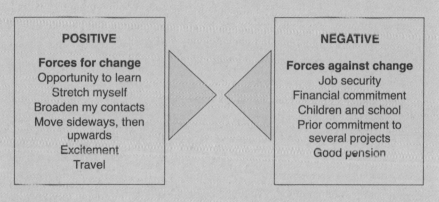

POSITIVE	NEGATIVE
Forces for change	**Forces against change**
Opportunity to learn	Job security
Stretch myself	Financial commitment
Broaden my contacts	Children and school
Move sideways, then upwards	Prior commitment to several projects
Excitement	Good pension
Travel	

FIGURE 2.1 Force-field analysis and career change.

Lewin's theory is that driving forces are generally positive, reasonable, logical, conscious, and economic. In contrast, restraining forces are often negative, emotional, illogical, unconscious, and social or psychological. Positive reasons for accepting a new job, for example, would be that it would add to your CV, give you an opportunity to train and gain professional qualifications, and give you the opportunity to attend international conferences. The elements on the negative side are much more about feelings – insecurity, uncertainty, fear of the unknown ... Both sets of forces are very real and must be taken seriously when dealing with any change.

Increasing the positive driving forces is not enough. Negative elements have a strong conservative influence. For example, it is often easier to stay where you are rather than face a set of difficult decisions. Do nothing is always an attractive option.

Increasing the driving forces may bring results in the short term. As long as the restraining forces are still there, change becomes increasingly difficult. Think of it like pushing against a spring: at first it's easy, but the harder you push, the greater the resistance.

Force-field analysis

1 Pick one important decision you are going to have to make which involves personal change.

2 Draw up your two-column force field. Be honest and comprehensive about both positive and negative factors.

3 Add as many new positive factors as you can.

4 Next look in detail at your negative forces. How real are they?

5 Give each factor a score from 1 (weak) to 5 (strong).

6 Add up the total score on each side: Which side is strongest at the moment?

7 Now we are going to make the force-field analysis really work. See if you can strengthen any of your positive forces. If 'opportunity to learn' is a positive factor encouraging change, then ask yourself what your job will be like if this is taken away from you. This might mean that you increase the score for factors which you discover are *really* important.

8 Can you add any new positive factors? They will only make a difference if they are both real and important.

9 Can you reduce the negative forces in any way? This means really looking at them and seeing if you can weaken their impact or turn them into positives. How transferable is your pension? Is your present job really as secure as it seems? If you are worried about the effect of change on your family, what would be the effect if you do nothing and remain unfulfilled? If you are worried about the risk of making mistakes in a new job, then look back at your work history and think of a time when you were worried about exactly the same thing – maybe as a result you achieved something which is now a central plank of your CV?

'MUST DO' LIST

☞ Look over your CV (or your life flow from Chapter 1). When did you successfully manage change? Have you recorded that?

☞ When did you actively promote change as a champion?

☞ Look again at Table 2.1 'Managing Personal Change' – what are your top six barriers to personal change?

☞ Identify someone you know who is a champion of change. Find out how and why they do it – what motivates them, and how do they generate the energy to convince others.

☞ Use the force-field analysis technique to help someone else with personal change, and then come back to try it again for yourself.

☞ Take the first steps of your journey, and think about the exploring style you adopt – it matters. Remember: *it's all experimental.*

WHAT'S THE PROBLEM?

☞ What's the problem? – why careers go off-line.

☞ Why people follow careers they hate, and fail to get careers they would love.

I DON'T HAVE TIME FOR A CAREER CRISIS ...

How many times have you heard someone talking about where they have 'ended up'? Freeze frame for a moment, and listen to the kind of comments that usually follow:

- A job's a job. It will pay the bills.
- Well it sounded good at interview.
- I was told it would lead to higher things.
- The job just, well, came along. It seemed as good as anything else.
- I was headhunted, in other words flattered and sold the job.
- It seemed glamorous on paper.
- I'd like to do something else, but ...
- I make the best of things.

How many of us are buffeted along by the winds of change? – Well, more and more of us, according to the statistical evidence. People are changing jobs ever more frequently, and because of the flexibility of the new labour market, they're changing occupational fields more often, too. Does this mean that people are happier in work? Does this mean that we're getting better at choosing career paths? No. Sadly, work for many can be:

☞ ... a Monday to Friday sort of dying.

STUDS TERKEL

Awareness of your work/life balance

British workers work longer hours than their counterparts in European countries, but with little measurable increase in productivity. It's a culture that can be immensely damaging. In 2000 a British government research project looked at the need for a balance between home and working life, particularly for men. The report found that:

- One in nine full-time employees work 60 hours a week or more, and many are men with children;
- Britain's employees are more likely to be offered stress counselling (49 per cent) to help with the effects of the long-hours culture rather than be offered assistance with their basic childcare needs (9 per cent);
- 80 per cent of workplaces have employees who work more than their standard hours; and 39 per cent without extra pay.

Danger signals – burn-out

An international study of 90,000 workers has identified the top seven occupations which are prone to 'burn-out':

1 Industry and manufacturing workers;
2 Council-office workers;
3 Managers, administrators and supervisors;
4 Parole, probation and prison officers;
5 Teachers;
6 Social workers;
7 Nurses.

The fact that manufacturing and council workers are higher up the list than social workers and nurses causes many some surprise. Co-author of the study Vivian Collins, Professor in Psychology from Southeastern Oklahoma State University, said that the likelihood of burn-out is increased by 'a lack of knowing exactly what is expected of you, having a range of conflicting roles and being made to think that your actions will not make a difference' (*The Independent*, 7 August 2000). Professor Collins suggested that people who had chosen jobs such as nursing or teaching had more commitment to their profession, so had developed ways of coping with the stresses and demands of the job. The report gave some of the symptoms of burn-out: 'an increase in absenteeism and staff turnover, reduced productivity, ineffectiveness, reduced creativity and alcohol and drug abuse'.

Why should people be happy at work?

Have you ever worked at the kind of place where they tell you 'you're not here to enjoy yourself'? What tends to happen if you believe this is that you create a world of compartments. *This is the compartment where I work. This is my family compartment. This small compartment in the corner is where I really enjoy myself.* It's all part of that *either/or* thinking we're so good at. I *either* have a job that pays the bills, *or* a job that's fun. I can't have both.

☞ I work to please myself. I'm still not sure if movies are an art form. And if
they're not, then let them inscribe on my tombstone what they could
about any craftsman who loves his job: 'Here lies Vincente Minnelli.
He died of hard work.'
VINCENTE MINNELLI, Film Director

Carole Pemberton of Career Matters, author of several careers books, talks about the Faustian pact we make in our careers – a deal you make that allows you to think in these either/or terms, like Faust's pact with the devil.[1] A pact typically says 'I can only be successful if ...' Here are some examples: 'I can only be a top sales person if I work long hours and eat badly', 'I can only be a great manager if I don't empathize with my staff.'

Why should people be happy at work? Work isn't fun, your friends will tell you. Work is real. If this all sounds reasonable, look at the people who have most fun in their jobs. They're often running their own businesses, making new things, meeting new people, sharing what they know and inspiring people. Are they poor as a result? Sometimes. However, some of them are richer and more success- ful than most. Being unhappy is not a key to being successful, holding down a job, making a living. Unfortunately it's often the unhappy, unenthusiastic, low-energy people that companies get rid of first.

Why should people be happy at work? Take a deep breath. Read that question again. Work is where you spend most of your waking life. It's where you put about 80 per cent of your personal energy. So that question really means *why should people be happy?* What do you think? Do happy people live longer, have great children, and make a difference. You know they do. So let's stop that all-time Faustian deal: 'I can only get a great job if I forget about being happy at work.' That's a self-fulfilling deal. Be careful what you ask for in life, you might just get it ...

☞ One of the symptoms of an approaching nervous breakdown is the belief

that one's work is terribly important.

BERTRAND RUSSELL

THE GOOD, THE BAD AND THE JUST PLAIN AWFUL

What are the things at work that give you the greatest buzz? The sort of things you go home and talk about? Write them down. It's worth recording the good things.

THE REALLY GOOD STUFF
. .

[1] Carole tells me the original concept comes from John Gray.

When do you find work boring or dull?

THINGS I COULD LIVE WITHOUT
· ·

What aspects of work fill you with dread or loathing?

THINGS I PUT UP WITH AT WORK THAT I NEED LIKE A HOLE IN THE HEAD
· ·

Table 3.1 sets out some common statements or perceptions from people who were asked how happy they are at work. Not all of the statements will match your personal situation, and you may have your own that you would like to add.

Which category describes you best?

TABLE 3.1 How happy are you in your career?

How you feel about work

A Dream job
I can't wait to get into work. Work is the place where I grow and learn most, where I am set healthy challenges, where I am valued and appreciated. A great deal of fun and self-esteem are centred in my work, which fits my values, talents and personality. I *know* that I make a difference. I express who I am in my job. The rewards are right, and I would be happy to be paid less if necessary. I love life, and love the part work plays in it.

B Thumbs up
I enjoy work most of the time, but sometimes there are headaches and problems. My work feels useful and contributes to my self-esteem. My contribution is clear, acknowledged and significant. My career is a good match to my talents, personality and values. I am appreciated by others. I feel that I make a difference, and that I add something positive to the organization. I find supervision helpful, but my boss is more a mentor than a supervisor. I lead a satisfying career which contributes to all parts of my life.

C Mustn't grumble
I accept the work I do. Sometimes I feel valued, other times exploited or ignored. Work is stable, largely unexciting, doesn't interfere with my inner life too much. New ways of doing things are sometimes discouraged. I may be in the right line of work, but in the wrong organization. I am valued for some of what I do, but not always the most important things.

D Someone's got to do it
I work because I need to. Otherwise I don't feel I owe a great deal to my employer. Several parts of the job are unpleasant/boring/demeaning/pointless. Real life begins at 5 o'clock. I'm not learning anything. I try to make a contribution but sometimes hit a brick wall. Some of my best skills are getting rusty. Sometimes I feel I would just like a quiet life.

E Wage slave
There are days I almost have to drag myself to work, and every moment is miserable. I feel a huge mismatch between the person I am and the person this job requires me to be. I feel trapped. Each day makes things seem worse. I take all my sick leave because the job makes me ill. At times it feels like I am just surviving.

Past experience, backed up by research in the USA suggests that answers from workers will typically give the following results:

A	Dream job	10%
B	Thumbs up	20%
C	Mustn't grumble	30%
D	Someone's got to do it	30%
E	Wage slave	10%

So, we can conclude that only 30 per cent of people working are happy at work, or we could say that most people are *reasonably* content – it depends where you put your benchmark.

If you're already in box A, you're up there with about 10 per cent of the workforce. Congratulations. Recognize what's good about your work, and ensure that it remains that way. Maybe it's time to use your career-planning skills to help others to achieve the same satisfaction. If you're in box E, again you're among about 10 per cent of workers. Make a review of how you can change things. Soon. The thing about an unfulfilled life is the damage done by what's missing.

☞ Nothing has a stronger influence psychologically on children than the

unlived lives of their parents.

CARL JUNG

Most of us are somewhere between B and D. Moving straight to box A, to the kind of job where you just love to get up in the morning, is tough going. The most important thing is to aim to keep moving up a level. If your job is miserable 100 per cent of the time, then maybe your short-term goal for the next 12 or 18 months is to find a role where 25 per cent of your time you will be undertaking work which draws on the skills you love using, work which matches your values, seems meaningful, and provides the right rewards. You can then build that up to 50 per cent. If you get past 70 per cent you'll probably discover you're already in the right job.

YOUR WORLD VIEW

Ask your friends what they think is the key to great job moves. They'll probably talk about skill shortages, connections, and being in the right place at the right time. There's another vital ingredient: motivation.

Careers specialists have long talked about *motivated skills* – in other words, the skills you *relish* using, the skills you would exercise for next to nothing, even for free. There's a huge difference between doing something because you know how, and doing something because you actively choose to do so. That difference is the power of motivation. Motivation turns a task into a joy, an errand into a quest, a job into a vocation.

The key ingredient in your career exploration is the degree of motivation you apply to the process. You get out what you put in. Read that last sentence again. Your success in gaining a stunning career depends as much on your own personal motivation as it does on any other combination of factors, internal or external.

Unless you are one of the small number of entirely self-motivated people in the world, you'll be asking: Where does that motivation come from?

Here's one approach to that, and there are many. Think about your *world view*. Think about what makes up that picture. It contains your memories, your history, elements of the world views held by your parents, friends and loved ones. In it you'll find your preconceptions, your fears, your values. A world view is made up of sentences as well as pictures. We have an all-too-familiar script running most of

the time: 'charity begins at home', 'if you want a job doing properly, do it yourself', 'keep your cards close to your chest'.

Look closely at the picture you hold of yourself, the script you run in your own personal soap opera. Do you think positively about the world, about life, your friends. And what do you think about yourself?

Do you see the bottle as half full or half empty?

Ah, that depends ... And it does. It depends on the way you look at it, not the bottle. Look at the signals you receive during the course of a day. How many times do you receive praise and ignore it? How many times do you hear neutral feedback and take it the wrong way? How often do you hear criticism and clutch it to yourself as the last, final and totally accurate picture of *you?* The reality is that most of us have an impressive talent: to ignore positive information, distort neutral information and attach ourselves to negative information.

Where you put the energy matters. If you put your energy into believing the bottle is half empty, what you see is emptiness, absence, insufficiency. If you choose to put your energy into seeing a bottle that is half full, you will see fullness and abundance everywhere.

Information is neutral. But where do you put your energy and attention? You fill your personal bubble with evidence of what you lack: 'I can't do that', 'I've never been good at ...', 'Nobody's interested in me when I ...' You have a natural, inexhaustible ability to hang on to these favourite ideas. Those who understand the secrets of motivation are generally masters of two areas of personal growth:

1 They know who they are, and what they are good at;
2 They know when to ignore negative data, when to accept a neutral picture as simply neutral, and when to remember and act upon all the good things they ever learned about themselves.

At this point you may be hearing two words in your head:

YES, BUT ...

About now the *YES, BUT* area of the brain is kicking in. We all do it. It's actually an identifiable part of the human psyche called the *safekeeping self* (see Ned Herrmann's book *The Creative Brain).* The safekeeping self is the senior committee member who faithfully attends every meeting in your brain and says:

- We've heard all this stuff before;
- It'll never fly;
- We tried that once and lost money on it;
- This isn't for you;
- Don't give up your day job;
- It's risky;
- It's embarrassing;
- It's just not me;
- It might work for somebody else;
- Show me the statistics;
- Well, it might work in London, but ...
- Everything that can be invented has been invented.

(We should hold a special place in our hearts for the man who uttered that last sentence. His name was Charles H. Duell, Director of the US Patent Office. He said it in 1899.)

The world of business isn't free from *YES, BUT* thinking. At one stage the only way you got to drive a General Motors car was to buy it outright. People were saying 'I want a car. Yes, but I'll never get that much money together.' Alfred Sloan took over the company in 1946 and introduced what was then a novel idea: payment in instalments.

In career terms you will hear even more *YES, BUT* thinking, because saying '*Yes, but*' is a good way of avoiding an issue and avoiding change: 'Yes, but I have to earn a living.' 'Yes, but in the real world ...' It's often a sign that the speaker is not listening positively – it's a classic defence mechanism, a way of avoiding having to face issues.

PROBLEMS FOR THE CAREER DOCTOR

Time to discuss your various '*Yes, But*' symptoms. The Career Doctor will see you now.

1 Too long in the same job

☞ Normal is getting dressed in clothes that you buy for work, driving through traffic in a car that you are still paying for, in order to get to the job that you need so you can pay for the clothes, car and the house that you leave empty all day in order to afford to live in it.

ELLEN GOODMAN

☞ Work is accomplished by those employees who have not yet reached their level of incompetence.

LAURENCE J. PETER, *The Peter Principle*

The 'same job' could have been a 20-year history of change, variety and development. We're not demotivated by being in one job or one organization. We're turned off when things start repeating themselves and we're not learning or changing.

2 Side benefits are good

Helen Harkness, in her book *The Career Chase*, tells of an employee who stayed with one firm because somebody in the office brought in an excellent cake every day. We all have our reasons for staying and our reasons for leaving. The million-dollar question is: are these the *real* reasons? People are very good at finding excuses for avoiding the real issues, or justifying decisions. If you find yourself saying 'the pension scheme/the medical insurance/the gym is so good ...', then the question should be: *but is this why I'm here*? Side benefits go quickly in times of trouble.

Talk to people after they have retired. Do they talk about the salary and benefits, or do they talk about the good relationships, the fun, the excitement, the feeling of doing meaningful work? When you're on your deathbed, are you going to say 'I wish my pension had been just a bit bigger' or 'why did I waste 20 years in that office watching the clock?'

3 I'll stick it out ...

> ☞ Job: what you do to support your vocation.
>
> ANON

'The job's okay, and a lot of things are good about it, but ...' This general sense of dissatisfaction needs focus. Is it really the whole job that doesn't suit, or part of it? Is it just some of the people you work with? Are there problems elsewhere in your life (partner, health, family ...) and work provides a convenient dumping ground for your troubles?

The answer to these questions takes a little time to work out, but you can begin by asking:

- What parts of the job do I enjoy?
- What parts do I really enjoy? When the time passes quickly?
- If I could change something using a magic wand, would it be the people, the place, the rewards, the tasks I do? Make a list, then look at what you can actually change. Remember the prayer known so well to members of Alcoholics Anonymous:

> ☞ O God, grant us the serenity
>
> to accept what cannot be changed,
>
> the courage to change what can be changed
>
> and the wisdom to know the difference.
>
> REINHOLD NIEBUHR

A word of warning: it's all too easy to believe that the *only* solution to dissatisfaction at work is job change. Often all that work dissatisfaction shows you is that there's a mismatch between who you are and what you are doing. That mismatch shows, if not to ourselves, to others. But the real answer is *career growth* – moving towards a closer match between yourself and the work you do. Career growth may be something you achieve exactly where you are already.

4 I'm too old ...

Yes, employers are wrong-headed about age. But time and time again they buy experience, know-how, reliability. Look at the message the employer is sending in the job description: do you hear steadiness, reliability or short-term energy? Try to match who you are and what you have to offer against the job. Look at Table 3.2 for a range of strategies for those who feel that age is a barrier.

TABLE 3.2 Age and work – How big is the problem?

THE NEGATIVE SIDE *The key facts on age and employment*	*THE (MORE) POSITIVE SIDE* *Ways of compensating by changing* *your approach or thinking*
Workers over 50 are now less likely to be working than they were 20 years ago. Few people now assume that they will stay in their present job until the age of 65. In 1999, one-third of people between the ages of 50 and 60 were unemployed or inactive, despite being in relatively good health.	The working population is ageing. There are fewer young people around. By 2000, four out of ten workers nationally were over the age of 45. There are just not enough bright young things around.
Men are more likely than women to become economically inactive. About 80 per cent of men aged 55–65 were employed in 1979. By 1997 this figure had reduced to 58.3 per cent (source: *Labour Market Trends*). Approximately 50 per cent of men aged between 60 and 65 are not working.	... And how many of those men relied simply on physical fitness to achieve a living, and allowed themselves to be passive flotsam in the job market, employed one day, unemployed the next ...? Even in times of recession you can find stories of older workers who got back into doing worthwhile work. Seek out those people. Find out how they did it. You'll discover it was a mix of determination and positive thinking. Percentages? A proportion of people are always doing something or not doing something. Don't be a statistic.
A high proportion of workers are retiring before their company's normal retirement age.	... often because they have become tired, unhappy and because they have stopped learning.
Employers think that younger people are more adaptable, learn more quickly and have more energy to dedicate to work.	OK, and statistically they will be more likely to drink to excess, have hangovers, and decide to go off backpacking round Australia. Older workers are more reliable, steadier – and, if they package themselves right, better able to offer a blend of learning and common sense. Adaptability is something you claim and show evidence to support. Learning can be demonstrated by your current interests. All too many older workers are happy to say 'All this computer stuff is beyond me ...' and don't hear the door slamming shut. If you are truly a technophobe (and you

owe it yourself to train yourself as far as you are able), then concentrate on qualities which make you different from younger workers – your ability to cope in a crisis, your huge range of contacts ...

There seems some evidence to suggest that older people are likely to be out of work if (a) they are in the bottom 25 per cent of earners or (b) they are in the top 50 per cent of earners and also in an occupational pension scheme.

... which shows that some age problems are simply economic, and some are caused by employer pension policies, which can encourage early retirement as a comfortable way of 'downsizing'.

Many areas of work are perceived as 'young' jobs.

Age discrimination is still, technically, lawful in the UK, but a great many employers conform to equal opportunities policies. It's worth asking, explicitly, 'what is the likely age range for this post?'

Other research reflects a widespread belief that those close to retirement have less to lose through redundancy and job loss, and that the risk of displacement from work is higher among people who are older. In other words, workers over 45 are more vulnerable to job loss, and find it harder to get back into work.

Employers gain all kinds of irrational, negative pictures about all kinds of people: students, single mothers, vegetarians. The key thing is not to feed the flames of prejudice, but to concentrate on what you have to offer. Sometimes it's helpful to specifically address the age issue: 'What kind of experience are you looking for?', 'How long is this project?', or even asking specifically 'What's the *minimum* age/ experience requirement for this job?'

Remember this: employers who discriminate on the grounds of age are either too young to appreciate that anyone can have an original idea over the age of 30 (*so show them ...*) or old and tired and assume that everyone over 40 is equally old and tired. If the employer wants a 21-year-old he can burn out in 2 years, do you want to be there anyway?

KEY ADVICE FOR OLDER WORKERS

First of all, acknowledge that age discrimination is real. The reason for beginning there is that if you know something is real, you can begin to compensate. If you're not a natural with numbers, you compensate by finding tools to help. Concentrate on who you are, and what makes you special.

Employers value a number of things that older workers have in abundance: experience, reliability (a 'safe pair of hands'), credibility, maturity, financial stability (you won't be asking for a pay rise every 6 months).

Here's some of the best advice around, from John Courtis, head of the executive search and selection firm John Courtis Associates. He wrote this in his Candidate Newsletter:

Too young? Too old? Does your age matter?
- *Only if you keep on about it;*
- *Only if you look it;*
- *Only if you bring it up and apologize for it in your covering letter;*
- *Only if the photo you've attached to your CV makes you look significantly older/ younger than the chronological date would suggest;*
- *And last – only if you don't distract the reader from it with all the **good** things you have to offer – recent relevant achievements, USPs, etc.*

5 I don't have the qualifications . . .

Formal qualifications are often far less relevant than people think, particularly in flexible environments like Britain and the USA. There are now so many young people obtaining degrees, diplomas and certificates that employers can't tell one from another and have no idea whether the qualification equates to workplace performance.

If the qualification is a legal or safety requirement, then get it, or a recognized equivalent. But it's always worth investigating the alternatives. Find out what other ways there are to get in. Can you train on the job? Can you buy the training somewhere? What kind of parallel experience might be accepted?

Where an employer mentions a specific qualification you don't have, don't despair, and don't send in your application anyway, saying nothing, hoping your lack of a Certificate in Astrological Science won't be noticed. Ask yourself 'why do they need this? – *what problem will it solve?*' – and then address the issue directly by communicating what you know and what you can do: your answer to the problem posed by this job.

6 I'm not IT literate

Do something about it. At one time using a PC, the Internet and email was a specialized skill. Now it's common currency. And it's not rocket science either. As a minimum target, get yourself connected and acquire an email address (get a friend to set it up – that part is a real headache, but using email is *much* easier than setting the timer on your video).

7 I'd need to go back to university/college

This is a great *YES, BUT* – because it's a logical brick wall: the only way I can get a great future is by if I stop working (to study full-time). Not so. There are a million and one choices in education today: part-time study, open and distance learning. Bookshops have miles of texts telling you how to do things. Find a motivated

person and they will be learning something all the time: about computers, about gardening, wine, music, maps ...

I don't have the time or energy to study. Is that true? If the job you do takes so much out of you and leaves nothing left for learning, maybe it's the wrong job, or maybe you're doing the right job the wrong way?

8 I'll never earn what I earn here ...

☞ The trouble with the rat race is that even if you win, you're still a rat.

LILY TOMLIN

This one's the kiss of death, because it's really saying 'I'm overpaid here and nobody else will pay me this much'. This is usually very wrong-headed. Very few people are overpaid for more than a short period of time. Whatever you're earning (or have earned) is a reflection of what someone, somewhere, feels is the justified cost of your presence and activity.

It's surprising how many people in senior jobs share one huge fear: that one day they'll be found out. Their boss will say: *OK, we know it's been a big pretence. Just leave now and we'll say nothing more about it.* Insecurity is everywhere.

If you hear yourself saying 'I'll never earn what I earn here' it means that you have forgotten *why* you're being paid, and you've lost sight of the value you are adding. Get this straight and you'll see what message to convey to your next employer: 'I've earned this because I'm worth it, and you'll want to pay me even more.'

9 I don't interview well ...

What does *not interviewing well* really mean? If it means that you're negative, that you talk yourself out of every job you apply for, then this isn't a matter of technique, but just a trick you play. The trick is this: you think you'll fail, so you set the game out to ensure that you do. That way you won't be disappointed. Employers in general buy experience, but they also love enthusiasm. That's not the same as false confidence, but conveying a simple message: *I like what I do. I do it well. I can do it here, for you.* Chapter 9 has more tips for you.

10 I'm just waiting for the phone to ring

It's your life. If the phone rings, it's because somebody needs you to solve a problem. Their problem. Getting your career right is nobody else's problem.

EXERCISE 3.1 TURN THE PROBLEM UPSIDE DOWN

When businesses get stuck in a rut, they sometimes use specific tools to generate new ideas to solve problems. One of them is *Assumption Reversal*. For example, a company might assume *Next-day home delivery is expensive*. With the growth of Internet shopping, a number of companies have looked at that idea again. They begin by reversing the assumption, therefore: *Next-day home delivery is cheap*. That might lead to the idea that the only way of making it cheap is to use somebody who is already making the journey. One firm hit upon the idea of using milkmen to deliver parcels ordered by Internet shoppers. Not only is there an existing distribution network that comes to your door, but it's a service that's been environmentally friendly for years, using electric floats.

What's your major worry? State the assumption, then turn it around. If your concern is: 'I don't have the experience', what happens to your world view if you begin with the assumption '*I have too much experience*' – in other words, I can't possibly use everything I know in this job.

Try with other assumptions, even if the results are initially off the wall. If you're assumption is 'You can't teach an old dog new tricks' try inverting it: '*New tricks teach old dogs.*' You might find yourself reflecting on the way learning opportunities throw themselves at you every day, from all directions. In today's world you have to actively avoid learning. What matters is recognizing and recording what you learn, so even old dogs learn to blow trumpets.

'MUST DO' LIST

☞ Career problems are sometimes concrete, but usually strategies for avoiding the issue of change. What are *your* favourite *YES, BUT* defences?

☞ You can be happy at work. What would be the first step you could take to achieve that? How would your friends and colleagues notice the difference?

☞ Look at your CV, your interview style, your attitude to work. You complain that employers see negative things about you. How many of these messages are actually composed and delivered by *you*?

☞ Don't assume that the real problem is the one staring you in the face. Turn the problem around. Look at it from other angles. Don't accept any problems or limitations as fixed, and see what happens.

YOUR CAREER HOT BUTTONS

☞ Measuring your career satisfaction.

☞ Looking at money and motivation.

☞ Discovering your career hot buttons.

> ☞ Work consists of whatever a body is obliged to do ... Play consists of
> whatever a body is not obliged to do.
>
> MARK TWAIN

'I NEED THE MONEY'

Psychologists will tell you that money is rarely the primary motivator in changing jobs. People are often persuaded to take only a minor increase in salary, or even a pay cut, in order to get the 'right' job. Money only motivates in the short term: once you've got your fast car and the key to the executive washroom, the buzz fades pretty fast.

What research does tell us is that poor rewards can quickly demotivate, particularly where there is a sense of injustice: the thought 'I'm worth more than this' starts from somewhere; either a comparison with someone else or a natural sense of injustice. How do you have any sense of what you are worth? I have known people being interviewed for jobs at £40,000 and £80,000 in the same week – with little real difference in responsibility or complexity. Markets often do very odd things with salaries. Have you ever calculated what you really cost your employer, including overheads, and then calculated what value you add to the bottom line – whether actually in terms of profits or metaphorically in terms of your invisible contribution?

> ☞ You ask what is the proper limit to a person's wealth?
> First, having what is essential, and second, having what is enough.
>
> SENECA

One interesting piece of research tells us a great deal about human psychology. When asked 'How much money do you need to feel that you have *enough*?', most people double their present income, whether they earn £5,000 or £105,000 a year. Yet at the same time most careers books ask you to work out the minimum you

TABLE 4.1 What do you need to earn?

When I have added up all my monthly bills, travel, insurance, health and food costs:	Forget what you have written down on the left hand side. Ask yourself, looking at your whole life:
What do I need to (just) live on?	*What would be ENOUGH?*
	(Another way of asking this question in a less philosophical way is 'What figure would I need to earn so that I was relaxed about what I spend each month?'
Taking account of the value I can add to an organization, my skills, my knowledge, just being me . . .	What do other people like you earn in your chosen field? If you know the earnings range, what do you have to do to be in the top 25 per cent?
On a good day, what would the market pay for someone like me?	On the basis that you have a greater chance of achieving something if you write it down:
What am I worth?	*What do I really want to earn within the next five years?*

need to pay all your bills and to eat. Unfortunately far too many people confuse this figure with what they are *worth*.

Without prejudice, as the lawyers say, write down a figure (somewhere, even if you don't write it here) to answer each question in Table 4.1.

TURN-OFFS IN THE WORKPLACE

Think about your hate list: the ten things you would like to change most (about the work you do, or the way you are at work). Write them down in Table 4.2, then write the positive, opposite value next to it. For example, if your No. 1 is 'My skills are not appreciated', then the positive mirror value might be 'A place where what I know and do is appreciated' – but your precise wording will be unique to you.

You might find it helpful to categorize some of your dissatisfactions: physical work environment, team feeling, intellectual stimulation, opportunity to grow or learn, variety, praise from others, management style. Make sure you cover the full variety of negatives, and come up with a full range of positives.

What recruiters know is that everyone has career hot buttons – factors which motivate, but that most of us are not good at identifying them. If you're asked why you want to leave a job, it's convenient to use shorthand: 'the job stinks' ... 'the money's rotten' ... 'it's the way they treat you'. We all have our convenient shorthand for dissatisfaction, whether in work, car, house, or marriage. To build on experience it helps to ask 'What went wrong? What parts did I find uncomfortable or unhelpful?', and then actively seek the positive.

TABLE 4.2

	Top ten areas of dissatisfaction	I'm positively looking for . . .
Remember to think broadly, e.g.:		
Working environment		
Location		
Status		
Recognition		
People		
Tasks		
Work values		
Other		

Knowing what you *don't* want is helpful, but only as a first step. This book is here to help you discover what you do want in your career, and to help you get it.

WHAT *REALLY* MOTIVATES YOU?

Recruiters will tell you that the first answer to that question is usually 'money'. The reason is – it's easy, convenient shorthand. In my interview training pro- grammes I always try to get interviewers to probe to the next level. You may not be motivated by money at all, in fact. Throwing money at a problem does not make satisfied workers. Here are some of the other motivators which probing interviews can reveal:

- Being respected for what I know;
- Being valued by my boss and my colleagues;
- Being a professional;
- Team buzz;
- Being my own boss;
- I feel I belong;
- Setting my own goals;
- Getting letters after my name;
- Seeing the job through to the finish;
- Variety;
- Working outdoors;
- Getting my head round a problem;
- Doing something to help my community;
- Being able to choose my own working hours;
- Making a difference;
- Learning something new every week;
- Getting that sale!

EXERCISE 4.1 DISCOVER YOUR CAREER HOT BUTTONS

Here's a profile to check what motivates you in your career choices. When you use this, think about what you would like to achieve in the next five years, not what has driven you in the past.

First read the category title and questions. Against each category, circle a score on the scale of 1 to 10. Try to use the full scale rather than bunch all your scores in the middle.

1 Financial Rewards

How important is the money, really? How much would you be re-energized if your salary increased by 10 per cent? 20 per cent? How long would that feeling last?

On the other hand, how diminished do you feel if the money is less than you are worth?

If you could do more of the great things about your job and less of the dull things, would you be just as happy with less money?

When you're at a party and listening to people talk about their jobs, do you always want to know how much they earn? Does it really matter?

Financial rewards are:

1	2	3	4	5	6	7	8	9	10
Unimportant				Moderately important					Very important

2 Influence

Do you consciously enjoy exercising the skills of leadership, persuasion, or motivation (high influence)?

Do you hate it when you feel powerless over people, situations, problems?

You know how you like things done. Do you prefer to be in charge? (High influence) or are you happy to follow a good leader (low influence)?

A high degree of influence is:

1	2	3	4	5	6	7	8	9	10
Unimportant				Moderately important					Very important

3 Expert

Do you like that feeling of being knowledgeable, skilled, an expert?

Are you happy knowing a lot about a focused area of knowledge?

Do you enjoy a reputation as a specialist (high expert) or a jack of all trades (low expert)?

Being an expert is:

1	2	3	4	5	6	7	8	9	10

Unimportant	Moderately important	Very important

4 Independence

Do you like to have control over what you do (high independence) or are you happy to accept intelligent supervision? (mid to low independence)

Do you prefer a mentor to a supervisor?

Are you a self-starter? Do you like to set your own deadlines?

Do you like to decide, ultimately, how you spend your time?

Independence in my work is:

1	2	3	4	5	6	7	8	9	10

Unimportant	Moderately important	Very important

5 Relationships

How important are close relationships at work to you?

Are you more productive working in a team (high relationships) or quietly on your own (low relationships).

Do you enjoy getting to meet new people through work?

Do you operate best when you trust and are trusted?

Relationships at work are:

1	2	3	4	5	6	7	8	9	10

Unimportant	Moderately important	Very important

6 Security

How far do you need to feel you are financially secure?

That you have a nest egg, a safety barrier – a cushion against ill fortune (high security)?

Do you like to live to the limits of your overdraft limit (low security)?

Do you spend more time planning your retirement than enjoying the present moment?

Security in work is:

1	2	3	4	5	6	7	8	9	10

Unimportant	Moderately important	Very important

7 Status

How much of you is contained in your reputation?

Do you seek recognition from your colleagues, your profession, your community (high status)?

Are you happy working in the background – as long as the job gets done, what matter who gets the credit (low status)?

How strongly do you feel about the job title printed on your business card?

Status is:

1	2	3	4	5	6	7	8	9	10

Unimportant	Moderately important	Very important

8 Meaning and fulfilment

How strongly do you feel about the value your work adds to your community, the world?

How aware are you of the damage your work might be doing to others, or to the environment?

Do you hear yourself saying that your work should be *meaningful* (high meaning)?

Are you happy to seek meaning outside your working life (low meaning – as far as work is concerned)?

My search for meaning through work is:

1	2	3	4	5	6	7	8	9	10

Unimportant	Moderately important	Very important

9 Imagination

Are you good at discovering new ideas, new ways of doing things?

Do you prefer to let others come up with the good ideas while you do the detailed planning?

Do you prefer to follow a system or set of rules (low imagination)?

Or do you like to invent new solutions to problems (high imagination)?

Using imagination at work is:

1	2	3	4	5	6	7	8	9	10
Unimportant				Moderately important					Very important

Your total scores

Career hot buttons	Total	Rank order
1 Financial rewards	⇨	⇨
2 Influence	⇨	⇨
3 Expert	⇨	⇨
4 Independence	⇨	⇨
5 Relationships	⇨	⇨
6 Security	⇨	⇨
7 Status	⇨	⇨
8 Meaning and fulfilment	⇨	⇨
9 Imagination	⇨	⇨

Write down your total scores, and then work out a rank order for your career hot buttons. This is particularly important if you have given equal scores to more than one button. If you find you have one or more categories where the scores are equal, balance one against the other. For example, if your scores for 2 Influence and 7 Status are the same, ask yourself 'Would I prefer a job where my ability to influence or control others was *marginally* more important than my status?' If you have 3 or 4 equal, play 1 off against 2, then 3, then 4. It works, but if you insist on having equal scores for some headings, no matter.

What are the implications? Match your top three career drivers against your present or most recent role. What is the degree of overlap? What is missing that you would like to add into your present job, or you will be actively seeking in your next post?

'MUST DO' LIST:

Now you have identified your *Career Hot Buttons*, look back at what you discovered in the last two chapters about:

☞ Your world picture.

☞ Your list of the Good, the Bad and the Just Plain Awful.

☞ What might move you up the Career Satisfaction grid?

☞ How will you deal with *YES, BUT*, and the limits it puts on your life?

☞ How far does your present job match your top three or four career hot buttons?

YOUR HOUSE OF KNOWLEDGE

☞ Tap your hidden knowledge.

☞ Understand how your preferred interests provide huge clues about career satisfaction.

☞ Make new connections between what you know, and what you can do.

WHAT DO YOU KNOW?

Just as we all have hidden skills, we have concealed but vital areas of knowledge. What's powerful about your hidden knowledge is not just what you know, but *why* you know it. A certain amount of knowledge is inflicted upon us in school, but from the age of 14 or so we begin to make choices even about our academic subjects. All the subjects we read, learn and think about in our own time tell us a huge amount about personality, aspirations and interests.

However, one point to beware: don't ignore the possibilities of new areas of knowledge you have yet to discover. One of the benefits of a demanding and eclectic education system is that it forces students to be exposed to subjects, materials and ideas that, at first sight, don't seem to be interesting at all. It's one of the reasons why exercises focusing on skills and knowledge don't tend to work with young people – they just haven't explored enough yet.

YOUR HOUSE OF KNOWLEDGE

(An adapted and extended version of Richard Bolles' excellent Memory Net exercise, as featured in various editions of *What Color Is Your Parachute?*)

This exercise helps you to identify, record, value and communicate the things you know about. It is also a vital step to help you to identify your areas of interests that may provide strong links into fields of work. What we choose to learn about is a vital part of who we are.

What do you know about? Ask that question of someone you meet on a train or in a pub, and most people talk first of all about the areas of knowledge most frequently used by their current job. They will often talk about their educational specialization. Therefore: *My degree was in Spanish, but I'm an accountant now.* This is merely scratching the surface.

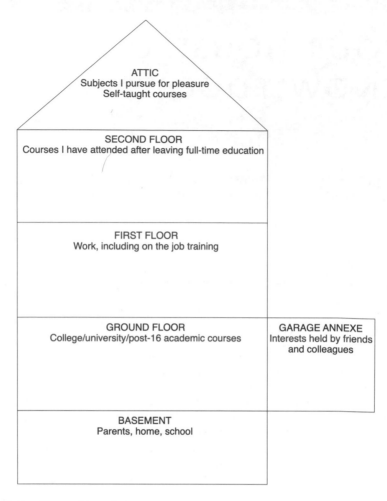

FIGURE 5.1 House of knowledge.

Look at the three-storey house in Figure 5.1. It has a ground floor, first floor and second floor. It has an attic and a basement, and a garage at the side. Each level of that house represents something of what you know.

The exercise runs as follows. Like most exercises in this book, it works better if you have one or two people to ask you questions as you go along.

1 Begin with the *basement* of your house, the firm foundations provided by your home and school. What did your learn from your parents? This might be described in skills or values as well as just knowledge – that's fine, but try to concentrate on what you know (e.g. carpentry, gardening, looking after a pet, being a champion swimmer).

2 Complete the list for the *ground, first* and *second floors*. If it helps, write the obvious ones first, just to get them out of the way. These are the ones you have no trouble recording. They may already be on your CV. Now try to

remember *the things you forgot you know about*. Here are some prompts that have worked for others when looking at education, work, and training:

- What did you enjoy best at school (never mind the subject titles on your certificates)?
- Which teacher did you like best at school? What was the subject?
- What was the first thing you wanted to read when you put aside your textbooks? What was that about?
- What interests do you have that your work colleagues know nothing about?
- Think about the training courses you attended that you got most out of. What were they about? What did you learn?
- What subjects have you ever enjoyed training others in?

3 Move on now to your leisure pursuits, areas of personal interest and things you have taught yourself. This is your *attic* – the part of your brain where you store all that old junk you've forgotten you have, stuff you never thought you would find a use for. What areas of knowledge are hidden in those dusty trunks? Some prompts again:

- Given a free choice, what would you choose to talk about over a relaxed meal?
- If you could teach a workshop on any subject in the world, given unlimited preparation time, what would that subject be?
- If you could learn about any subject in the world, from any teacher, what would that subject be?
- When your Sunday newspaper arrives, fat with different sections, which part do you turn to first? Which part second?
- When do you find yourself reading, talking or thinking about a subject and others have to shut you up? When do you find yourself so engrossed in an article or book that the time passes unnoticed?
- What do your friends talk about? Think of a time when you have enjoyed learning about someone else's field of interest. Who could tell you more?
- Look at your old photograph albums. We usually arrange for our picture to be taken at times when we're happy. What were you doing when the pictures were taken?
- If you are an Internet user at home, which pages do you have book-marked?
- If you were accidentally locked into a large bookshop for the weekend, in which section would you camp out? Once you got bored, where would you go next? And next? Write down the headings which would appear on the bookshelves.
- Think of the junk mail you receive. Which items do you *not* put straight in the bin? What fields do they refer to?

- If you were offered an unlimited travel budget to visit trade fairs and conferences across the world, which ones would you pick? Do not confine yourself to the real – imaginary fairs will be even more productive.

4 Last but not least, the *garage*. It's on an annex at the side because it's about vicarious interests – living life through the eyes and minds of other people. Think about close friends whose interests you share. My friend Peter Maybank has a long-held interest in the First World War. I've joined him on battlefield trips to both Verdun and the Somme, and I realized through this experience how important the knowledge of others can be in shaping my own.

5 Look at your complete house. What have you missed out? It'll probably be things you consider 'trivial' like cooking, homemaking, family history. If you enjoy it, include it. My colleague Jane Bartlett wants to extend the house picture so there's a garden as well – a place where interests may be dormant, like dry seeds, waiting for the day when you water them. You can add rooms, too, for other areas of your life. When the well of ideas runs dry, use one of the prompts below to extract more from your hidden resource bank.

- Subjects you had nearly forgotten about (remember how you were a relaxed French speaker at one time?).
- Subjects that led you to turning points in your life (that pottery class at night school that made me change degree course ...).
- Areas of knowledge that once made your pulse beat faster, and made time zoom by.

This isn't idea generation but recovering parts of your past which you undervalue, and interests that will give you energy and enthusiasm in the future.

'MUST DO' LIST

☞ Use the House of Knowledge to discover things from your past that once filled you with energy. Where is that energy today?

☞ Sit with someone else while they explore their own House of Knowledge, and your partner's ideas will probably jog your memory.

☞ If you've caught yourself saying 'Ah, I *really* used to enjoy ...', then look at why you dropped the activity or interest. Is there a *YES, BUT* in there somewhere?

THINKING AROUND CORNERS

☞ How you normally solve problems.

☞ Moving beyond A–Z thinking.

☞ Aiming for career breakthrough.

☞ Making sure you really know what problems you're tackling.

> ☞ To my mind it is a mistake to think of creative activity as something unusual. A man becomes creative whether he is an artist or a scientist, when he finds a new unity in the variety of nature. He does so by finding a likeness between things which were not thought alike before ... The creative mind is a mind that looks for unexpected likenesses.
>
> JACOB BRONOWSKI

PROBLEM SOLVING, AND WHAT GOES WRONG

It's time to address the big issue: *your career.*

As with so many problems in life, what you need is new ways of approaching old problems.

How do you normally solve problems and make decisions? You may take an unstructured or a structured approach. Unstructured ways include talking it over with friends, letting the idea mull over, waiting to see what life brings along, tossing a coin ...

How can you solve the problem of your career? Well, if you use the strategies you have learned so far in your life, you'll probably try a structured approach such as undertaking research and working out possibilities logically and systematically. Such *structured* approaches usually rely on what you have learnt about organizing information and ideas. We categorize problems. We write out lists. We prioritize. We time plan. We write out pros and cons. That's a sound, business-like way of working things out, isn't it?

A–Z thinking

Very few of us are taught that there are many different ways of thinking. In the sixteenth century the minority of the population fortunate enough to receive a

university education were taught the traditional disciplines of logic and rhetoric – thinking and speaking. These they inherited from the Greeks and Romans. However, the industrial revolution focused on what might be described as *straight-line thinking* – the logical progression from A to Z. In philosophical terms this is the process of analysis, hypothesis and synthesis. In everyday terms it reflects the mindset that every book must be read from front to back, from page 1 onwards, from A to Z.

From problem to solution: this was the language of a great deal of post-1945 management training: analyse the problem and work out a logical sequence of actions to form a solution. This kind of thinking is embedded in most management courses and training. At its most extreme, it sees everything in terms of a sequence of tasks: boil kettle, take teabag, put teabag in cup . . .

Without A–Z thinking you would never be able to plan a journey, cook a meal or decorate a room. But it isn't the only kind of thinking.

Businesses all over the world are discovering that this kind of either/or thinking doesn't help in every situation. It is possible to be structured and creative. In fact, survival often depends on it. It's certainly possible to be *un*structured and *un*creative – many business meetings win on both counts.

Sometimes the most important question is not how but why. The process of Value Engineering keeps asking this question: Why do we do it this way? Why are we doing this at all?

For Inspector Morse, Colin Dexter's Oxford detective, the right questions come out of a change of thinking:

☞ Obviously (Lewis knew it!) innate intelligence was a big factor in understanding; the speed of perception and understanding, the analysis of data, the linkage of things. But there was something else: the knack of *prospective* thinking, of looking ahead and asking oneself the right questions, about what was likely to happen in the future; and then of coming up with some answers, be they right or wrong.

COLIN DEXTER, *The Remorseful Day*

Some businesses have taken even more dramatic steps towards non-linear thinking. They turn problems on their heads. They seek innovative solutions. They invent new concepts, not just new products. In the twenty-first century, this is the kind of thinking to apply to our working lives. First, it opens up a whole new range of possibilities. Second, it puts us in tune with new business thinking itself.

So, if you are not going to try a logical, step-by-step approach, what options are open? That one takes a little while to unpack, but it falls within the general category of *inspiration*. When you are inspired something larger than you moves within, whether that's the spirit of God, the spirit of life, or something untapped in the human mind. You breathe not just air, but *meaning*, meaningful ideas.

How are you going to plan to be inspired? Sounds absurd – a bit like an idea of my teacher friend Geraldine Page: *planned spontaneity*. You *can* plan inspiration – in the sense that you can open yourself up to possibilities, and you can learn to

use both conscious and unconscious techniques to teach you how to open channels for inspiration.

If you know where you are going, you only go where you know

You probably want to read that one again. Scratching your head is permitted. Your first reaction to that statement might be 'fine, so I know where I'm heading'. Read it again. It's a sentence that describes something about the way most people and most organizations think: in straight lines.

☞ Nothing is ever accomplished by a reasonable man.

GEORGE BERNARD SHAW

VARIETIES OF CREATIVE THINKING

Chapter 1 introduced you to the fact that everyone has their own form of creativity. However it's important to remember that there are several kinds of creative thinking. Some of them come naturally to some people, but most can be nurtured or actively learned, as Table 6.1 shows.

COMBINE AND CONQUER
· ·
It's important to realize that these kinds of creative thinking are not exclusive; they work best in combination with each other. Brainstorm possibilities using freestyle creativity. Use provoked thinking if you get stuck. Explore the range of positive practical outcomes using straight-line creativity. Reflect on a problem unconsciously by doing something which engages other parts of your brain: jogging, listening to a piece of music, stripping down an engine ... (See the exercises in *discontinuous thinking* at the end of Chapter 10.)

Finding new life in the old clichés

One of the sad aspects of creative thinking is the way it is misused in work contexts. A friend of mine in one large corporation tells me that in every meeting he and his colleagues used to play Buzzword Bingo – scoring a point every time a phrase like 'thinking outside the box' or 'pushing the envelope' was used. Even the word 'creative' can be overused, particularly where lip service is being paid to the benefits of genuinely open, creative thinking.

Clichés have their usefulness. 'Thinking outside the box' was a term used in the advertising industry to think outside the rectangular frame of an advertising billboard. 'Pushing the envelope' comes from the field of aviation. The 'envelope' is the box-like shape on a graph representing an aeroplane's maximum speed/range. Behind the tired language are two very real business concepts.

TABLE 6.1 Different styles of creative thinking

Straight-line creativity

Is step-by-step, detailed, methodical –
it's fairly close to A–Z thinking, but
ensures that you don't jump to one
immediate conclusion. It's about
defining a problem and looking for a
variety of effective outcomes. This
kind of creativity is great for questions
such as 'who can I talk to about
physiotherapy?' or 'what should I
remember to take to the interview'. It
can be done alone or in groups.
Used in career decisions it ensures that
you use research, investigation and the
full range of tools and techniques
available to you.

Provoked creativity

Derives largely from the work of Edward
de Bono who even invented a new word
for the purpose: *po* (read *Serious
Creativity*). The idea is that you can use
an unexpected and unrelated prompt or
provocation to make the mind switch gear
– this may be an analogy, a metaphor,
a word chosen at random, a picture. For
example, think of your favourite pop
song. What do the lyrics of that song
make you think about? How can that
help solve your problem/create a new
approach? Provoked creativity can be
learned, and can be used by individuals
or groups.
Used in career decisions it helps you to
make unexpected connections. It's great
for exploring fields, and for overcoming
the *YES, BUT* barriers described in
Chapter 3.

Freestyle creativity

Is free-flowing, fast, exciting. It relies on
open-ended, *discontinuous thinking*.
What else? What other ways are there of
looking at this? What happens if I turn
the problem on its head? Examples
include brainstorming and idea
creation. This kind of thinking tends to
work best with other people to bounce
your ideas off. This is the kind of
thinking found in organizations which
really are 'creative'.
Used in career decisions it generates
positive possibilities and connections,
and great ideas for researching jobs,
fields, possible employers ...

Flash creativity

Sometimes known as 'Aha!' or 'Eureka!'
moments, these are times when you get
a sudden insight or moment of
illumination. These often happen when
we are doing or thinking something
entirely unrelated to the problem at
hand, possibly having a bath or digging
the garden. Flash creativity results in
totally new ideas, approaches, products
and ideas that did not exist before.
There are no steps, no rules, no
predictable outcomes. One way of
aiding the process, however, is to feed
your favoured natural intelligences
(*see Chapter 8 – Who Are You?*)
Used in career decisions this kind of
thinking occurs rarely, but the vital
thing is to recognize the possibilities in
the daydream, and test them out using
one of the other forms of creative
thinking.

SOLVING CAREER PROBLEMS

How do we usually solve career problems? Many people rely on *tests*. There is a whole armoury of tests which claim to help you analyse your skills, your talents, your likely fields of work. Psychologists will help you to analyse your personality traits. The big problem with tests is that far too many people use them passively. You believe, deep down, that the test will magically *tell you what you should do for a living*. The best tests, however, add to your self-knowledge and give you a wide range of options for further research. Career changers in the UK have particularly benefited from Adult Directions and CareerBuilder (details in Appendix 2).

David took a computerized careers test that told him he should probably be a teacher. The problem is, he is already a teacher. Where does he go next? Another client, Jim, is a plumber. A standard careers test told him that he should be a joiner or work with fish. Other colleagues have taken career tests and then dutifully followed courses leading to the prescribed occupation. The outcome is usually that their dissatisfactions continue. Although most careers counsellors say that tests are only a tool, their clients don't see it that way. They see a test as the Oracle of Delphi, giving *the* answer.

Getting unstuck

First, see if you recognize any of the symptoms you identified in Chapter 3: A sense of dissatisfaction at work. Knowing you could do more, or be valued more. A feeling that you don't quite match the life you're leading. A vague sense that there is more to life than this, that your work should have some meaning ...

☞ What happens when there is a mismatch between your talents and your work? For creatures other than us humans, the answer to this question is extinction. Because we are so adaptable, we survive, but at a terrible cost.

What gets extinguished is the pure joy of doing something that comes perfectly naturally. The further you get from fully expressing your talents and abilities, the less likely it is that you will enjoy your day on the job.

NICHOLAS LORE

Having got to this point, it's quite common for people to feel stuck in a rut. The worst kind of rut is the 'velvet rut' – you hate its confines, but it's just too comfortable.

You may get channelled or stuck in your ways, not just in work, but stuck in your thought processes, your career planning. You know that something needs to change, but what? What's needed is *breakthrough thinking* – something to take you from where you are to the next stage. You need to think up ideas.

☞ The best way to get a good idea is to get lots of ideas.

LINUS PAULING, *Nobel prizewinning scientist*

TABLE 6.2 Flow

You find 'flow' in your work when . . .

1 There are clear goals every step of the way
2 There is immediate feedback to our actions
 (i.e. we know how well we are doing)
3 There is a balance between challenges and skills
 (our opportunities and our skills are well matched)
4 Action and awareness are merged
 (our concentration is entirely focused on what we are doing)
5 Distractions are excluded from consciousness
6 There is no worry of failure
7 Self-consciousness disappears
 (we are too absorbed to worry about protecting our ego)
8 The sense of time becomes distorted.
 (hours may pass in what seems like minutes)
9 The activity becomes autotelic
 (autotelic means 'an end in itself'. What Csikszentmihalyi means by this is that, as our skills increase, we begin to enjoy whatever produces this experience. With most artistic, sporting or musical activity, and some projects in all fields, the activity is an end in itself. We do it because we enjoy the feeling.)

(Adapted from Mihaly Csikszentmihalyi's *Creativity: Flow and the Psychology of Discovery and Invention*).

Look for where the fun is

Psychologist Mihaly Csikszentmihalyi coined the term *'flow'* to describe a state of existence you reach at times when you are totally absorbed in an enjoyable and fulfilling task. Csikszentmihalyi describes nine characteristics of enjoyment, outlined in Table 6.2.

☞ The most successful people are those who do all year long what they
would otherwise do in their summer vacation.

MARK TWAIN

WHERE DOES THE CREATIVITY GO?

In Chapter 1 you read about different kinds of creativity, and new ways of thinking about life and work planning.

When computers were first used regularly in business life, everyone predicted that our lives were going to become simpler and easier. Automation would give us more leisure time, more thinking time. Machines would do the donkey work while humans planned and dreamed new possibilities. There would be more time than ever to come up with ideas. For most of us the opposite is true. Remember the idea of the paperless office? Paper is now supplemented by

backlogs of email and voicemail messages needing answering. Downsizing and restructuring meant twice the work for the same money. Yet the world is changing so fast that we need to be constantly creative.

> The acclaimed poet and novelist Benjamin Zephaniah performed his first poetry reading at the age of 11 and had his first book of poems published at the age of 19. This first book was extremely well received, but Zephaniah felt very uncomfortable being acclaimed as one of Britain's new black writers. His problem? – He could not read or write. All his poetry readings had been done entirely from memory, and he dictated his first book to his girlfriend.
>
> Benjamin Zephaniah knew from a very early age that he wanted to be a poet, and did not let the most significant barrier of all get in his way. After his first successful publication he attended adult literacy classes. He is now one of Britain's most popular and successful poets.
>
> In his choices of work locations as a poet he has been firmly creative: he was recently a poet in residence in a barrister's chambers in London – a long cry from his roots.

The good news is that there are many kinds of creativity. The second piece of good news is that there are tools available to help you think your way out of your career block.

There are one or two ground rules:

- Believe that the solution to your career block exists, either within you or somewhere out there;
- Allow yourself to generate a range of ideas, without self-criticism;
- Learn how to focus on both questions and solutions;
- Don't restrict yourself to tools that you find easiest or the most comfortable – stretch yourself;
- Believe in your ability to succeed.

> ☞ Getting an idea depends upon your belief in its existence. And upon your belief in yourself. Believe.
>
> JACK FOSTER, *How to Get Ideas*

Self-belief is vital:

> ☞ Whether you think you can or you can't, you're right.
>
> HENRY FORD

Behaviour follows belief. The greatest barriers between you and an inspired career are not in the marketplace or on your CV, but in your mind. And if getting your ideal career requires positive thinking, then getting the ideas to put your career plan together takes even more; it's vital that you learn to accept your brain's own ability to create ideas, possibilities, connections. Accept that this is not only a

natural gift for the chosen few, but (as millions of businesses have discovered over the last 30 years) something you can practise and train your mind to do.

CAREER BREAKTHROUGH TOOLS

☞ In order that people may be happy in their work, these three things are needed: They must be fit for it. They must not do too much of it. And they

must have a sense of success in it.

JOHN RUSKIN

Here's a range of tools from different sources that work well to help you achieve career breakthrough.

1 Know where you're going

No – this isn't a reversion to straight-line thinking – all that objective-setting stuff. But it is about setting goals, sometimes 'big hairy audacious goals' – goals that are larger than life. Stephen Covey's book *The Seven Habits of Highly Effective People* advises us to 'begin with the end in mind' – set long-term goals you intend to reach.

Distinguish between goals and dreams. Millions swooned over Tom Cruise and Michelle Pfeiffer, but how many of us actually took the first step and tried to invite one of them to dinner? We're all great at having 'safe' dreams – ideas we like to play with, assured that we will never have to do anything about them. Goals are things we can do something about. For some people dreams become goals when logical/planning thinking is applied to them – what do I do next? However, it's important to remember the dream as well, or the original impulse is lost.

2 Set real goals

Real goals are ideas that require a first step. Your goal might be to be self-employed within 3 years. It can remain a goal until you retire, or you can take the first step – an informational interview, perhaps.

It's a remarkable fact that goes against all logic, but every motivational trainer in the world will tell you the same thing: once you have decided on a goal, write it down. It increases your chances of achieving your aim by several hundred per cent.

3 Take happiness seriously

If you have reached career crisis, you'll already be in tune with this point. It's fairly central. If you don't believe in being happy, you probably don't believe in enjoyable work.

The writer Sarah Maitland talks of the importance of *joy*, suggesting that the word 'joy' comes from the same source as 'jewel'. We all seek some kind of hidden treasure in life – that missing 'something'.

☞ How do we prepare young people for the future world of work; and the
first answer, I think, must be, we should prepare them to be able to
distinguish between good work and bad work and encourage them not
to accept the latter ... They should be taught that work is the joy of life
and is needed for our development, but that meaningless work is an
abomination.

E. F. SCHUMACHER

4 DIY

A huge jump in understanding demonstrated in career clients is that they, and
only they, are responsible for their happiness.

Try a change of vocabulary. Describe the glass as half full, not half empty.
Practice a register shift – from No to *Yes*.

The Language of NO	The Language of YES
It'll never work	Let's look at our alternatives
It's how I am: I was born that way	I can try a different approach
They make me behave like that	I control my own feelings
It's against the rules	I'll invent a new rulebook
I'm forced to	I will choose
It's just not me	What shall I try next?
In the real world ...	I make my world real by ...
Another mistake	How interesting ...
If only ...	Let's try ...
Never	It's all experimental

5 Stick to your guns

The key word here is 'integrity'. In this context, this isn't a matter of ethics, but
wholeness. Once you know who you are and what you have to offer, try to resist
offers that really don't match that discovery. I work with clients on the 70 per cent
principle. This is measured by drawing up your wish list in terms of work values,
career hot buttons and the skills you would like to exercise, and then comparing it
with the employer's stated wish list in the job description or advertisement. If
there is a 70 per cent overlap between their list of needs and wishes and a job
opportunity, there's enough for it to be a healthy stepping stone. If not, watch
out.

6 Look for synergy

It's a habit of life: look for connections. Carl Jung talked of *synchronicity* – a sense
of things coming together in a pattern of significant coincidences. Those of faith
call them *Godincidences*, but you don't need to have strongly defined beliefs to

become aware of synchronicity. Once you start to make connections, patterns in life start to emerge, and you become more aware of synergy. At a most basic level, the more you discover about yourself, the more you discover that many others around you are on a similar journey, with anxieties very similar to your own. Such people make good support partners.

7 Be a transition person

We've seen how the concept of transition is useful when it comes to dealing with change. *Transition* is about making the right mental adjustment. Instead of each generation repeating the mistakes of the old, you can change the master script. The theory is that problems that have run through your family for generations can stop with you.

By becoming conscious of transition and capable of managing it, you become more aware, more conscious of our own role in relationships and more sensitive to the impact you have on others in the world. You can learn to be an influencer of change in other people – largely by deliberately reflecting back to them a clear and positive vision of themselves. On the other hand, if you're one of life's complainers, try asking for the manager to praise a particularly good service or piece of work. It's worth doing just for the surprise value.

EXERCISE 6.1 PROBLEM DEFINITION

Creative thinking is a form of reflective entertainment unless it is directed towards a problem. In this book you will find a number of ideas and exercises which invite you to look at a career problem. To make these exercises meaningful and useful, you need to decide what problems you need to address.

First of all, how do you define the problem? The problem to you is a mix of vague but negative feelings and statements: *I'm unhappy in my job ... I don't know where I'm going in life ... I feel unsatisfied ... I want to do something useful.*

Read Chapter 3 'What's the Problem', and work out what the key problems are for you. Write them down. You may start with something vague like '*I want to feel valued at work*'. Great. Now talk it through with someone, or turn the idea over in your head. Figure 6.1 gives you a method to help you focus on the essential problems.

BROAD PROBLEM: I want to feel valued at work

1 YOUR FEELINGS NOW
What makes you feel undervalued right now? *I do good things but nobody notices, or someone else takes the credit.*

2 OTHERS AROUND YOU
What do others need to do to help? *They would volunteer compliments. They would remind me of my strengths.*

How will you respond to your colleagues? *I will encourage other people around me, and make sure they feel valued.*

What kind of people would help you? *Observant, supportive, caring.*

3 TASKS
What sort of things would you be doing at work that would be valued? *Organizing people and things . . .*

What could you do that would *really* be valued? *Good planning, to save money and help people work better.*

4 ORGANIZATIONS WHERE YOU WORK
What kind of organization will be necessary to achieve this? *An employer that trains, supports, values a range of people, styles and skills. An organization that cultivates talent of different kinds.*

How will you feel if you are successful? *Valued.* And? *Important. A member of the team.*

5 THE NEW YOU
How will this change the way you work? *I'll be happier to take more difficult jobs because people will support me. I will learn more.*

So, how will that change the way you work? *I will become more competent. I will try more things. I will go on courses.*

How will your job change your life in other ways? *This job will be good for family life.*

How will people tell? *I will feel better about my skills. I will look more confident. I will smile a lot more.*

6 YOUR GOALS
You know where you want to go. How does the problem in question stop you achieving an inspired career? *I don't have the confidence to try new things, to grow.* So what first step will you take?

The above process leads you to *DEFINED PROBLEMS*, e.g.
- How do I find a job where I can work for an employer that values the talents of its staff?
- How can I get to work in a team where I am supported?
- What kind of skills do other people value?
- How can I find work that will help me grow and learn?
- What kind of work will actively improve my family life?

FIGURE 6.1 Defined problems.

EXERCISE 6.2 THE IDEAS GRID

Once you have generated a number of ideas, you'll need to find some way of focusing on the ideas that will really work for you.

This idea originates with the 7×7 technique, developed by Carl Gregory. It helps if you can use blank postcards or small index cards. What works even better is to put a strip of Velcro on the back of each card and stick them up on a piece of material pinned to a wall or notice board.

Actively reward yourself for off-the-wall ideas (real rewards, not metaphorical slaps on the backs: a coffee break, or time off to do the crossword). Don't worry about making them practical just yet.

1 Begin with all the ideas you have come up with in response to your problem. Write them all on separate cards.

2 Check for near-duplications. Combine ideas that are virtually the same. You might have both 'serving the community' and 'putting something back into society'.

3 Discard anything that seems irrelevant – but don't discard ideas just because they seem impractical or off-the-wall.

4 For the moment, discard anything that you can't achieve within a reasonable timeframe. So 'Find time to write my novel' *might* have to go on the back burner for a year or two. It's up to you.

5 Read through your discarded pile again. What new connections or insights can you make?

6 Classify your ideas by putting them into columns. Use as many columns as you need.

7 Give each column a heading. Try to come up with headings that are obviously different. Use blank cards as column headers.

8 Rearrange your columns with the most important on the left, the least important or critical on the right.

9 Put the ideas in rank order within each column, with the most important at the top.

Now stand back and look at your results. Better still, go away and do something else for an hour, then come back and look. You will probably want to make further rearrangements, but what you have now is a *prioritized* grid, with the most important, critical or immediately relevant ideas in the top left-hand corner.

'MUST DO' LIST:

☞ Look at the descriptions of *'Flow'* in Table 6.2. How many of these are present in your life somewhere? Write them down next to your House of Knowledge.

☞ Take dreams seriously, and see which ones will translate into goals. Write them down, somewhere, but tell someone you've done it.

☞ Write a Plan A for the next 12 months. Things to include: first steps on the journey, measurable goals, the critical steps you need to follow to make things happen (writing articles, going to conferences, talking to people, getting your CV rewritten, writing that book . . .).

WHAT DO YOU HAVE TO OFFER?

THIS CHAPTER IS HERE TO HELP YOU TO:

☞ Map your hidden skills – the parts of your experience you took for granted.

☞ Discover your potential, undiscovered, uncharted skills.

☞ Find creative ways of looking at your toolkit.

☞ Communicate your skill set to your colleagues, managers or potential employers.

> ☞ Every man's work, whether it be literature or music or pictures or architecture or anything else, is always a portrait of himself.
>
> SAMUEL BUTLER

WHY IS LOOKING AT SKILLS SO IMPORTANT?

If you feel inclined to skip this chapter (*I know my skills, I've done this skill analysis before, this is all obvious …*), don't. You might as well give the book away now. Because you use and observe skills every day, you might think you're expert at cataloguing your own skills. Ask most people, and they'll tell you 'it's obvious … it's just a matter of knowing what you are good at'.

Your interests arise from what you *know*. Your skills are what you can *do*. Let's get one thing straight. One of the greatest reasons people fail to achieve motivated careers is that they only ever see half the skills they actually possess. They only really know and develop 25 per cent of those skills, and they only ever communicate a fraction of what they can really do when seeking work. If you want to make sure you never get a great career, one of the best strategies is never to reveal your full set of gifts. If you're determined to continue doing work that fails to stretch you or match your aspirations, that will do the trick.

SKILL CATEGORIES

Most ways of looking at skills are, fundamentally, left brain. These methods analyse, categorize, record. They put skills into headings and boxes. Some of these methods are helpful. However, the problem with all of these left-brain, categorizing and listing approaches, is that you end up with what look like

definitive, closed lists: this is who I am, and what I can do. None of us are fixed like that: you grow, change, adapt all the time.

First-impression list

However, if you've never done it, it's worth writing out your initial impressions. Divide a piece of paper into four boxes: *Things, People, Information, Ideas*:

- People who work mainly with *things* (and animals) – this includes engineers, machine operators, nature-reserve wardens, carpenters, car designers and gardeners.
- People who work mainly with *people* – this includes teachers, social workers, counsellors, telesales staff, salespersons, personnel officers;
- People who work mainly with *information* – this includes scientific researchers, librarians, auditors, archivists, editors, systems analysts;
- People who work mainly with *ideas* – this includes e-business pioneers, marketing professionals, novelists, lobbyists, campaigners, fashion designers.

Now write down the skills you think are most evident in yourself. As you get stuck, ask yourself: *What sort of skills do I use most often? In what style or context do I enjoy using them? What do I do that most impresses people? Which skills am I being paid to use at the moment? What skills do I have that no one is paying me to use right now?*
Now put that list aside and revisit it at the end of this chapter.

UNWRAP YOUR GIFTS

☞ When love and skill work together, expect a masterpiece.

CHARLES READE

You have a rich set of talents. We all do. If you're spiritually minded, you may have discovered that God, life or the universe has sent you a particular set of *gifts*. It's useful to think of our skills as gifts, because it reminds us that what we do with those skills really matters. You live once, so make the most of what you've been given.

The Hopi Indians believe that every person is born with a gift, and the purpose of our lives is to realize that gift in some tangible way. Unwrapping your gifts – exploring and celebrating the talents you have been given – is not just about work, or fun, or duty. It's about discovering why you are here. This chapter offers creative ways of shaking out that toolbox, taking a second look at some neglected instruments and discovering new ways of using qualities you've forgotten or neglected.

Few of us see what a well-equipped skills toolbox we've been given. We use skills without recognizing or crediting them, and we fail to bring out our latent talents, blinking, into the light.

Start with your mental picture of what comes to mind with the phrase *your skills*. Do you see a hero with a chestful of medals? Are you the 9-stone weakling getting sand kicked in his face? Are you multi-competent, or jack of

all trades and master of none? Your self-image will probably swing between both. But somewhere in there you will have a fixed picture: *These are the things I can do . . . These are the things I can't do (yet) . . . These are the things I'm not cut out to do . . . I wish I could . . . I can do this, but I'm not qualified . . . This is something I can do, but no-one would be interested . . .* In other words, a series of defining statements of what you can do, and the limits on your skills.

☞ The only happy man is a man whose work permits him to function to

the full extent of his ability.

OLIVER WENDELL HOLMES

You have been given a unique set of talents. Unique not because of one, primary, virtuoso skill that commends you to the world, but because of the way all your skills are uniquely combined in you. Unique because you are the only person with your skills, exercised through your personality, your history, your viewpoint. No one else can be you, in your particular situation in life. You can always find somebody who can exercise one particular skill better than you, but they can't be *you*.

STEPS TO SKILL AWARENESS

The experience of helping career-changers suggests to me that most of us have skills that we know well, and are comfortable with, but there are huge areas of unmapped territory. You may find your own personal categories, but *how many of your skills are*:

- Unconscious;
- Undiscovered;
- Undeveloped;
- Unloved;
- Undervalued;
- Unsung;
- Unfulfilled;
- Unpolished.

The cautious, naturally conservative brain itches to add one further category: *unachievable*. However, there are very few skills that are unachievable. You may not become a concert pianist, but you can learn to play the piano. If your hands and fingers just won't, physically, do the walking, then there are absolute limits, but how many people do you hear say 'I could have been a professional writer/ musician/maths teacher/architect *but*' . . . ? – And that 'but' has nothing to do with physical restriction. Your brain is far better at producing skill barriers than your body.

An overheard pub conversation between two middle-aged women. 'I think Elizabeth has an inferiority complex', said one. The other agreed: 'That's because she's no good at anything.' Be careful whom you allow to influence your picture of yourself.

Unconscious skills

Unconscious skills are unseen skills – used so often that we hardly ever see them. Another way of describing them is 'wallpaper skills' – they're ever-present, unnoticed, like wallpaper.

Example: Amy's great skill is making people feel better about themselves by talking to them. Others see her do it – it's oiling the wheels, increasing a sense of community. She does it so often she's unaware of it. She had never thought of it as a skill until a friend said, 'Do you know what you do most of the time? – You're the cement between the bricks of our community.'

Key: You might become conscious of your 'wallpaper' skills when others point them out to you, which is fine if you have observant friends who notice that you're not aware of the thing you do best. A more active route to discovering unconscious skills is to measure what you do against your environment: how do I make a difference, regularly? Ask your friends 'What are my *wallpaper skills*?' (then you'll need to explain the term!).

Undiscovered skills

Undiscovered skills are skills you use only occasionally, perhaps under pressure or in special moments. You often don't notice exercising these skills in the heat of the moment, or you don't claim ownership – things *just happened*. In an emergency, for example, there is often someone present who has great clarity of mind, organizing people, calling an ambulance and preventing panic.

Example: Maureen's great skill is untangling messy personal situations. She works quietly in the background, helping people see things clearly, encouraging the parties to put anger aside and seek common ground. She never gets the opportunity to use these skills at work, so the opportunity only comes along very occasionally.

Key: Remember that sense of surprise – something changed because of your involvement. Why? What did you do? Ask yourself (or someone who saw you operating), not 'what happened', but 'what did I do?' and 'how could I use this skill more often?'

Undeveloped skills

You possibly may see only the beginnings of *Undeveloped skills* in yourself. Look for potential in clues, small seeds that may grow into something stunning.

Example: Norma has never been able to walk past a piece of fabric without touching it. She has a good eye for texture, colour, pattern and for matching materials simply

and cheaply to make a room look great. She has a knack of walking into a room and knowing how to make it look more welcoming, more 'together', by making a few simple changes. Last year her friend brought out these 'wallpaper' skills and found a set of undeveloped and marketable skills underneath – becoming a 'house doctor', helping other people to sell their homes quickly by reading the mind of the buyer and offering a series of low-cost, high-imagination solutions to make a home look great, and sell quickly.

Key: Look at what you do, even in a small way; look at the component parts. Think about materials you love to work with, words you love to hear. Think of your skills as building blocks creating a structure you can't define yet. What can you build on? What can you learn more about? What skills can you use in a different way? Stretch yourself. Read books about subjects that seem of little interest. Go on courses on subjects you know nothing about. What do you do that might be a substitute for the real thing (e.g. buying art postcards when what you'd really like to do is fill your house with paintings ...)?

THE STUDENT WHO THOUGHT IN CARTOONS

Other people are great at discouraging us from exploring our undeveloped skills.

Simon was a youngster who was never expected to reach university: wrong school, wrong background. But he did, through hard work and determination. He had an unusual approach to his subject, which was physics. He wrote his first university essay about Einstein. He was inspired to write about Einstein using cartoons, graphics and speech bubbles, in the style of a recent set of books popularizing great thinkers. He was hauled over the coals. The message was: you are *not* here at university to do this kind of thing. He left the same week, and did not resume his studies for another five years.

Simon's tutors failed to see things that were just beginnings in Simon. As a result, some of his most important skills became *unloved*. In a rush to conformity, his teachers failed to see a potentially great popularizer and teacher of complex ideas. They forgot that Einstein (considered a failure at school) often preferred to think in images rather than words.

Unloved skills

Unloved skills are things that you do, often very well, but with little energy or enthusiasm. Sometimes these are skills you don't enjoy using because they are just not *you*. One of the most powerful revelations is discovering that you spend most of your time efficiently doing things that you hate. My greatest

career breakthrough was discovering that I spent most of my time using a skill which I was proficient at using, but on tasks that I hated.

> *Example*: Bill uses his computer every day, but his real interest is natural history. He gives time freely to his local school, who asks him to come in to fix computer problems or advise on software. If he is invited to do anything with the children, it usually involves explaining something about computers. He's great at it: probably the best person the school can find. But what he really wants to do is to talk to the kids about pond life.

Sometimes these skills have become unloved because they are totally unappreciated by others.

> *Example*: You're great at making a calm, tidy space in your home. But does anyone appreciate what you do? So you tidy, clean and dust with heaviness. How would you feel if your work was appreciated? If your job was to make a reception area look comfortable and welcoming – if your efforts made a difference? Are these skills you would love if someone else loved them, too?
>
> *Key*: You should look in any skill you exercise for one essential component: passion. To find an inspired career there should be a metronome ticking inside you, repeating *These are the things I love to do and can do well. These are the things I'd love to do more of.*

If you are in demand for skills you don't enjoy using, either learn to love them or learn to say no. Tell people what you enjoy doing, and ask for opportunities so you can learn by doing. If you want a middle way, train someone else who will *really* love to do the things you can do well. Pass the skills on.

What if your skills are unloved by others, and that has changed the way you feel about them too? If you do something regularly, and do it well, ask yourself *Do I need to do something else, something differently, or do these things somewhere where they will be appreciated?* Our skills, particularly those you are only just discovering, are tender shoots that need love and attention.

Undervalued skills

Undervalued skills are skills you are aware of but you feel are of little value. You will hear yourself say 'I can do this, but who would be interested?' You enjoy using these skills, but you feel they have little currency, so you don't put any energy into cultivating or broadcasting them to the world.

One of the things I have always said while training recruiters is that there are no unmotivated people out there. There are those who show their motivation at work, and those who are motivated by exercising skills which they feel are of no value to employers. Often they will think of these as 'hobby skills'.

Example: Sue's hidden passion is ballroom dancing. She has never put it on a CV and keeps it quiet at work because she feels it is entirely irrelevant. One day she heard of a college lecturer who taught business skills through ballroom dancing. Formal dancing teaches timing, responsiveness, leading and following, reading signals, anticipating change, paying attention to personal space. Sue realized that using these skills at work was what made her a brilliant PA. Now she proudly refers to ballroom dancing as a chance to list her primary skills.

Example: Jim runs a Beaver colony outside work. He's good at organizing fun activities, but he excels at getting the youngsters to sit still and listen. He can't see any wider relevance in this skill until he looks at it in another way: gaining attention, creating focus, setting the agenda, creating interest. He's learned a great skill for making exciting business presentations: *create silence, then grab their attention*.

Key: These skills are often ones that you value highly, and you often use your personal time to find people who feel the same way about genealogy, antiques, fly fishing, whatever. If it's valuable to you, make it valuable to others. Look again at your undervalued skills – they are probably there somewhere in your working life in an unconscious or undeveloped state. Imagine what the world would be like without your contribution. Think of other places you might use your skills.

Use the creative process of *analogy*. An analogy compares two things that are not obviously the same on the surface. You might, for example, want to explain the weather by describing a machine with inputs and outputs as an analogy to explain the world's weather system.

Now take an area of interest, or a key skill. You might, for example, be great at resolving hostility within your family. Table 7.1 shows how you can think freely of analogies by looking at *areas of knowledge* and make interesting connections into your own skills.

Unsung skills

Unsung skills are skills you have identified and valued, maybe skills you feel do have some relevance to the world, but you don't broadcast. You haven't yet discovered the right language to talk about them in a way that communicates them to someone who 'matters'. Clients will often say 'I talk to my friends about this stuff all the time, but I don't know where to begin to tell an employer'.

These are often so-called 'soft' skills. This is a fine example of split thinking in the business world – hard skills are directly useful (like selling, making, pushing, doing), soft skills are ten a penny and there in the background (imagining, feeling, training, sharing). We are often frightened that our 'soft' skills sound vague or prissy.

TABLE 7.1 Using the power of analogy.

Topic: RESOLVING HOSTILITY

Area of Knowledge	Analogy	Feature	Connection
Law	Arbitrator	Establishing the needs of both parties	Formalize – counselling training?
Science	Catalyst	Neutral but key element	Observing – writing about what I know?
Medicine	Practice manager	Keeping anxious people calm and informed	Dealing with complaints
Forests	Fire break	A still space to prevent the problem getting worse	Early intervention in conflict resolution?
Buildings	Living room	Creating a space where people can get along	Home-making – hospitality industry?
The news	Peacekeeper	United Nations, bringing people together in difficult circumstances	What other bridge-building roles are there?
Clothing	Repair	Invisible mending	Working in the background – planning events?

Example: Sally has held a number of voluntary positions connected with school, church or girl guides. In the last 10 years she has acted as treasurer, leader, resource manager, transport co-ordinator, catering manager, team leader. She condenses this into a throwaway phrase on her CV: 'voluntary interests'. It's true that employers often suspect that work done in a voluntary environment is pressure free, unconnected with the real world. Show them it isn't: give examples of working to deadlines, under pressure, to budget. Communicate how difficult it is to manage volunteers where you have to rely on persuasion and example rather than threat or coercion. Voluntary work often grows brilliant managers and self-starters.

Key: Look for those moments when you say 'things just happened ... it all came together at the last minute'. Who made it come together? If it was you, how did you do it? Finally, spend time discovering your skills; it's an inner journey worth taking.

☞ The minute you begin to do what you really want to do, it's really a
different kind of life.
BUCKMINSTER FULLER

Unfulfilled skills

Your *unfulfilled skills* are the skills you dream about using, things you instinctively feel you might be good at if you only had the chance. Listen to those dreams calling you. I always wanted to … paint watercolours, ride a horse, write my autobiography, run a soup kitchen, build my own aeroplane, sell houses.

Don't confuse longing with fancy. You might dream fancifully about becoming a test pilot, but the test of longing is that the idea won't leave you alone until you do something about it. The crunch comes when you find an *activated desire* – in other words, a desire you can act upon. Dreaming about becoming Prime Minister? Activate your desire: join a party, achieve some kind of elected office, take the first steps towards becoming an MP.

Watch particularly for tasks you dream about. I sailed as a boy and often dreamed about sailing again. At the age of 40, I did. It was everything I'd dreamed about, but better – because I had practised sailing so often in my head, I was actually *better at it*. I've heard this phenomenon called *learning to ski in the summer, learning to swim in the winter*. All kinds of sports research has also confirmed that training by visualization is almost as good as the real thing. If that's true, then imagined skills are more powerful than you think.

Example: Exploring imagined skills can lead you down unexpected pathways. Chris dreamed for years of learning the clarinet. He began lessons, and enjoyed what he learned, but found it wasn't quite what he was looking for. However, he found himself enjoying the musicality of it, the sense of hitting the right note, enjoying a score. Some 2 years later he found his real passion: singing. For years he had struggled, uncomfortably, with the melody line. No one had ever told him he had a bass voice.

Example: Steve knew he was a great ideas man. He worked in advertising as a copy-writer and account executive, but what he did best was to get clients to really think about why they were advertising, and buy into a great campaign. His dream, half-formed at first, was to leave advertising and become a full-time motivational speaker and trainer. He kept at it, observing his own latent skills, picking up tips, gathering ideas, but his breakthrough came once he was sure of his potential, by telling others his dream. One client guaranteed him his first week's work should he ever go freelance. He took the chance, and has never looked back.

Key: Go for it! Nothing is as damaging as a ruthless policy of ignoring your unfulfilled dreams, either in terms of skills or fields of work. Try things out. Test how activated

your desires can become in stages, if that helps – try a job on a short-term basis. Work for nothing just to get the feel of it. Shadow someone doing the job to find out if it's what you'd really like to do. Take a short course rather than a 3-year degree.

Warning: these skills are most easily dampened by opposition or lack of support from others. People will try to steal or suppress your dreams. The strongest opposition can often come from your life partner, because you're threatening a complete change of lifestyle. Encourage your partner not to strangle your unfulfilled skills, and to give you space to experiment, but try to offer something back: time, explanation, feedback on what you are learning, maybe a deal (If I do my nurse training for 2 years, then you can work fewer hours once I'm earning and restore that motorcycle you love so much but never have time to finish …).

Encourage others to encourage you. My wife Jan gives people a script to follow:

'I want to build a summer house'.
'Hmm. Sounds expensive. Not this year'.
'No, let's start again. I say *I want to build a summer house*. You say *What a great idea. Working outdoors will do us all good. When are we going to start? Got it?'*

Teach your nearest and dearest how to be supportive, and reward them when they are – with affection, enthusiasm for their pet projects, breakfast in bed – whatever it takes.

While skills are still at the imagined stage, nourish them with care. Find at least two fellow travellers who will not shoot your dream skills down in flames. If you hear 'you'll never earn a living' or 'be realistic', then ask someone else. Finding friends who can tell you the downside is easy. They've tried it, they've been there. Brutal honesty is in oversupply in this world. Seek out positive support until your unfulfilled skills can breathe unassisted, and only check for realistic boundaries once you know where you're going.

Unpolished skills

Unpolished skills are rather like unloved or undeveloped skills, but with one important distinction: you are fully aware of these skills, you value them and communicate them to others, but you have settled for competence when you know you are capable of far more. The skill is stuck at a fixed level. It's not growing, and nor are you.

Example: Kate learned enough to get by in customer services: how to deal with different kinds of complaints, who to pass the calls onto, when to refer difficult calls to managers. She had learned the procedure inside out, but hated any change: new products, new support services. She had learned enough to describe her complaint-handling skills, but had failed to stretch herself, to see what she was really capable of, because she had never looked at the underlying master skill: *keeping customers happy*. Once she learned to develop that skill, to invent new ways helping people, she began to grow and was promoted to supervisor.

Example: When you learn to swim, you begin by thinking of it as organized movement. Somewhere, you think, there's a special combination of movements that will keep me above the water and move me forward. The barely competent swimmer achieves that, and no more. *That'll do. I can swim.* Bill broke through that stage when he realized that swimming wasn't about movement or power, but a form of *guided floating*. With that idea in mind, he progressed to swimming several lengths. Then he discovered that it was also about *timed breathing*. Control the timing and breathing, and you can continue swimming just like you can continue walking. The first skill breakthrough will rarely be the last.

Key: Look for the underlying principle. Why are you doing this? What's the overall concept behind it? If your skill is selling, is the underlying principle profit, people, adding value, sharing a good idea ...?

Think about this classic model for skill development, using the ability to use a *mobile telephone* as a working example:

- *Unconscious incompetence*
 I don't know what I don't know. Looks straightforward enough.
- *Conscious incompetence*
 It's all complicated buttons and functions. The handbook's half an inch thick!
- *Conscious competence*
 I'm getting the hang of this now. I've mastered the basic functions – just got to work out how to use the memory to store numbers.
- *Unconscious competence*
 I don't think about it any more, I just use it. Don't know what I ever found a problem ...

The problem with this model is that people often get stuck in the final stage, allowing their skills to plateau and remain unpolished. Look for skills that are stunted, underfed, in need of your time and attention.

BEYOND SKILL IDENTIFICATION

How do you begin to identify your hidden skills? The obvious ones are easy – but check your assumptions. Creative thinking is about quietly *un*assuming what you thought was a given, about asking 'And ...? And ...?'

The unique mix – you

The problem with looking at skills individually is that you can lose a sense of the way they combine in a unique combination. Skills become powerful in combination – for example, your skill at organizing people becomes even more effective when you combine it with your skill at encouraging people to try things out for

themselves. What you have to offer the world is a unique combination of your motivated skills, your preferred interests and fields of knowledge, and the wrapper holding it all together is you – your personality (more on that in Chapter 8).

Graded skills

In many ways it's a value judgement to think that any skill is 'better' than another. What adds more to the world – the ability to read a balance sheet or cabinet making? However, it's common for selectors to think, consciously or unconsciously, about *complex* and *simple skills,* or about *high-order* and *low-order skills.* It's not too important to get hung up on this, but it *is* important to understand how your skills are perceived by decision makers. More of this in the section below, but for now it's useful to be aware of how skills are generally categorized and understood by selectors:

LOW-ORDER SIMPLE SKILLS	COMPARATIVE HIGH-ORDER COMPLEX SKILLS
Counting	Analysing
Making	Designing
Instructing	Coaching/Mentoring
Working to plans	Project management
Transacting	Negotiating

By definition, the higher the skills you exercise, the more freedom you have in general. For example, a university professor does not usually have to have his lesson plans approved, nor does he have to clock in when he arrives at the lecture hall.

SKILL CLIPS

In my teens, my oldest friend Andrew O'Hanlon and I passed the time trudging round prehistoric sites in North Wales, but all the time behaved as if everything we were doing was part of a movie. We composed shots, chose great locations, characters, tested out bits of dialogue. Well, we were young ...

Think of your life as a movie. Your personal movie contains everything you've ever done, every moment when you've exercised any kind of skill.

When you want to communicate who you are and what you can do, you will tend to *edit.* You will show only short, quick scenes to your viewers. You edit your life like a movie editor, disposing of whole scenes, cutting, abbreviating.

The *skill clips exercise* sends you back to the cutting-room floor, and fine-tunes your skills as a movie editor. When a distributor wants to persuade you to watch a movie, you get to see a trailer – the whole plot condensed into 30 seconds. That's your CV, if you like: a condensed, all-action version of you.

When a film critic wants to convey the character of a film, he will show you a film clip: an extract that shows a key scene, a special moment. In the movie of your life, what are the key moments? They may be the kind of events that you

recorded in your photograph album. Go back and look through them. Do any of those occasions tell you anything about skills you have exercised in the past? (Incidentally, use your family photo album to remind you of areas of knowledge and interests – if you enjoy doing something, there's probably a photo of you doing it, somewhere.)

Using this technique with persistence will bring out the eightfold range of skills outlined in this chapter and provide you with your top-ten list of motivated skills.

Let's try a practice run first. Fix on one event, one moment. Start with an occasion when you felt a great sense of success or achievement. Think awards, medals, prizes, competitions, coming first. Picture your 'clip', and give it a title. Then ask yourself as many skill-discovery questions as you can. Here are some prompts for this kind of high-achievement story:

- What did I have to do to achieve this?
- What was the task or challenge?
- What skills did I see myself use?
- What did I do personally?
- What was my best moment?
- What planning did I need to do?
- What obstacles did I have to overcome?
- What skills did others see me use?
- How did I work with others?
- How did I surprise myself or others?

Figure 7.1 shows you a *skill-clip* example, and Table 7.2 gives you some 'home movie' rules to help. Your skill clip begins with a title, like any good movie, but it also has a concise storyline, the 'pitch' – rather like the 'pitch' a writer has to make to a Hollywood studio to get an idea accepted.

Now flex your mind and think of *a skill clip* – a brief episode that immediately says something about your *motivated skills*: the times when you achieved something and enjoyed the skills you used. Picture your *skill clip* in Table 7.3.

Some prompts for your skills clip:

1 Think of times when you achieved something you are proud of. This doesn't need to be a work-related achievement. How did you do it? What difference

TABLE 7.2 Home-movie rules for editing and composing your skill clips.

1 *Zoom in as tight as possible* – avoid long sequences. One day is good. One hour is better. Keep it concise. Like a movie clip, it's got to convey a lot in a short space of time.
2 *Use slow motion* – reveal the action as it happens by thinking about what you did and how you did it.
3 *Use a good screenplay* – does this scene convey a message about skills, about overcoming obstacles?
4 *Keep the star in shot*: Make sure this scene is about the hero – you.
5 *Make sure the clip has a happy ending!* – an achievement or skill revelation.

Title: 'Top of the World'			
PITCH I've always been frightened of heights. I was pretty unfit. My work team challenged me to climb Cwm Clogwyn in Snowdonia. This is how I succeeded.			
[Scenes] *Opening shot –* *The Problem*	*First scene*	*Main action*	*Ending*
Panic! Fear of failing. Sponsorship for a good cause convinced me to go ahead.	Weighing up the problem. Deciding what I needed to learn and practice.	Setting off – the real thing. Putting theory and training into practice. Scary!	I made it! Photograph at the summit. Elation.
SKILLS I USED	*SKILLS I USED*	*SKILLS I USED*	*SKILLS I USED*
Recognizing my limitations. Overcoming fear.	Learning from friends, practising on a climbing wall. Learning to climb, belay, understanding equipment. Risk management? Anticipating/ measuring problems.	Working as a team, learning to rely on others. Responding (fast!) to instructions. Helping others cope with their fear. Keeping people's spirits up with humour!	Celebrating – enjoying what we had achieved as a team, and my special role in our success. Reflecting on what I had managed by overcoming fear and relying on my colleagues. Insight: new ways of working together . . .

FIGURE 7.1 Example skill clip.

TABLE 7.3 Your skill clip.

Title:

PITCH:

[Scenes] *Opening shot –* *The Problem*	*First scene*	*Main action*	*Ending*
SKILLS I USED	*SKILLS I USED*	*SKILLS I USED*	*SKILLS I USED*

did *you* make? Turn the event over in your mind until you see the skills, particularly those which are *unconscious* or *undeveloped*.

2 Now look at your achievements from your non-working life. Times in the past when you overcame the odds, did something which surprised yourself. Look in particular for skills that are *undervalued* or even *unloved*.

3 Think about both *activities* and *accomplishments*. Sometimes in a modest activity like mending a chair or writing a letter you can reveal skills that are central to you.

4 Think about work-related clips that demonstrate the full range of skills: things, people, information, ideas.

5 Do your clips bring out both complex and simple skills?

6 Finally – what's your favourite skill?

Keep drawing up these skill clips, either alone or – even better – with a friend or fellow career developer. If you still need a reason why, remember that this exercise will give you key *assertions* and *evidence* to build up your CV and use at interview. Think about composing great skill clips on the train or while driving home, but always write them down. After five or six skill clips you'll start to notice something interesting. First of all, skills will be *revealed*. You will become far more aware of your unconscious skills. Second, you will notice a pattern of skills. If you show a series of movie clips from the work of Alfred Hitchcock, you see similarities of style and content. The same applies to your skill clips. Key skills will begin to emerge, and – just as importantly – *you'll get a strong sense of what you are really good at AND enjoy doing.*

SKILLS PLUS – HOW EMPLOYERS SEE SKILLS

How do recruiters measure skills? Actually, most of the time, they don't. There are some tests around that measure skills (typing, driving, manual dexterity), but most of the time employers employ a special investigator to find out exactly what skills you have to offer, where and with what problems you have used them, and what results you have achieved. Who is that special investigator? You. The primary source of information about your skill set is not an external test, but you: the claims you make in your CV and at interview, and the evidence you can find to back them up.

 Remember, however, that employers see skills in terms of a context: how, where, when, why? An employer is not interested in skills that are unattached to anything else: *I am a good communicator.* What kind of communication? What do you mean by good? Give me an example ...

☞ I feel that if a person has problems communicating the very least he can

do is to shut up.

TOM LEHRER

Employers look for SKILLS PLUS. Each relevant skill, *plus*:

● An *object* e.g. *problem solving* becomes *solving financial problems*;

- A *context* e.g. *solving financial problems* becomes *solving financial problems experienced by small companies;*
- A *feeling* e.g. *I get a buzz out of staff appraisal;*
- A *belief* or e.g. *I feel it's important to tell people when they're doing a good job,*
 attitude *so I always make a point of encouraging teams to work at their best;*
- A *history* e.g. *I am good at convincing people to accept change. Let me tell you about the time when ...;*
- A *direction* e.g. *I'm a natural progress chaser – I'm good at keeping projects moving forward;*
- An *outcome* e.g. *my ability to think up flexible solutions saved the contract;*
- A *problem* e.g. *I'm good at organizing conferences, especially where things go wrong last minute;*
- *Other skills* e.g. *I am really good at juggling lots of projects at the same time, managing, troubleshooting and anticipating problems.*

EXERCISE 7.1 SKILLS FOCUS

What skills do you really enjoy using? Think about the time you have been so engrossed in a task that you lost all track of time, moments when you felt completely at home, yourself.

Write down the skills you remember. They are golden skills, the keys to a great career.

Look at skills you have identified and fit them into the boxes in Table 7.4.

TABLE 7.4 Skills focus.

	Skills I love using	Skills I quite enjoy using	Skills I don't enjoy using
Skills I perform well			
Skills I perform reasonably well but need to develop			
Skills I do not perform well			

Skills in the darkest grey box are those you should be using and developing. If not, watch out for the consequences ...

EXERCISE 7.2 SKILL AWARENESS

Go back to the *first impression* list you wrote at the beginning of this chapter to refresh yourself what your initial list of skills looked like. What happens to these skills if you ask yourself these questions:

1 Where and when are these skills exercised? Do you use the same skill in all situations?
2 What thing, person, piece of information or idea do you prefer to apply these skills to? This question helps you avoid vague terms like 'organizing' or 'being a manager'. It's more helpful to write down 'organizing voluntary teams' or 'organizing work flow', or 'managing social events and conferences'.
3 Are there any two or more skills that are actually the same?

EXERCISE 7.3 SKILL CIRCLE

Take your identified top twelve skills and write them in a circle, like the twelve points of a clock, as in Figure 7.2.

Then try to work combinations of skills at random (use dice to create random number combinations if this helps).

You might, for example, get a random combination of 2 and 7, *Managing people* and *Inventing solutions*. How might these two be combined for you? Perhaps in inventing new management systems, new ways of solving people problems, inventing new ways of looking at management issues, like giving people the tools to solve their own problems.

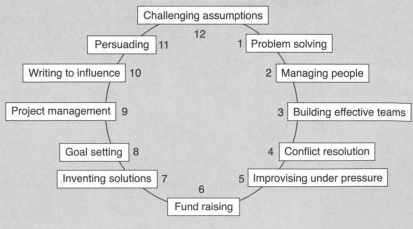

FIGURE 7.2 Skill circle.

Combining 12, *Challenging assumptions* with 6, *Fund raising,* might make you think about turning the whole idea of fund raising on its head. You might look at the question, *how can we persuade more people to give us money?*, and turn it around: *how can we get people to persuade us to take their money?* Your fund-raising campaign might find a way of empowering people to select charities that exactly match their values . . .

In addition to generating ideas for new skill applications, try looking at your combinations and asking yourself:

- When have I ever used these two skills together in an exciting or impressive way?
- What would I achieve by combining these skills?
- What sort of work would benefit from a combination of these two skills?

MUST DO LIST:

☞ Find the best way for you of discovering your hidden skills. Enlist the help of a good listener, a patient friend, or a professional careers counsellor.

☞ Look at the connections between your dreams, your interests and the skills you love using. There's a magic combination somewhere . . .

☞ Try at least six skill clips. Write out the skills you discover. Look at the skills that keep coming up time and again – what are your *master skills* – in other words, the skills that are central to you as a person?

WHO ARE YOU?

☞ Explore your work and life values.

☞ Understand what motivates you.

☞ Introduce you to methods of assessing your personality.

☞ Think about a whole-brain approach to life.

☞ Discover your different intelligences.

> ☞ A happy life is one which is in accord with its own nature.
>
> SENECA

We've already looked in Chapter 3 at your *world view* and the way it affects your career decisions. Now we're going to explore some of the ways to help you become more self-aware. In my experience the people who are most successful in their careers are:

● Aware of who they are, and happy in that knowledge;
● Conscious of their motivated skills;
● Clear about the way these skills will be helpful to the world.

Someone once said that the modern world operates round the philosophy of 'happiness is getting what you want', well the truth may in fact be 'happiness is wanting what you get'.

Table 8.1 looks at a typical menu of options that a career might bring you, and looks at possible points of comfort/discomfort. Table 8.2 lists a range of typical *personal barriers*, and creative strategies to overcome them or get round them.

DISCOVERING THE BEST YOU THERE IS

In the spirit of lateral thinking, I want to look at personality not in terms of classic assessment measures such as Myers–Briggs, 16PF or another recognized personality instrument, but in terms of some recent thinking about the way businesses operate. In their exciting book *What If? How to Start a Creative Revolution at Work*, Dave Allen, Matt Kingdon, Kris Murrin and Daz Rudkin have come up with a number of specific creative behaviours. Taking some of their thinking further, here are a few ways of starting a small revolution in 'You Plc'.

TABLE 8.1 Your personality in the workplace.

	Comfort	Discomfort
WORK ROLE	The majority of the tasks you undertake and your overall role is a good match to your skills, temperament and areas of enthusiasm.	You find yourself doing too many things that seem meaningless, trivial or boring.
WORK VALUES	Your work relates closely to your wider life ambitions, your beliefs and your sense of purpose. You receive more than a short-term buzz. There is a sense that you are doing something important or meaningful, and your small part of the world is improved by the fact that you're doing it.	You feel that there is something missing. Maybe you're almost there, and what you need to do is to add other voluntary activities to your work portfolio. Or maybe there is something hollow about you – efficient on the outside, but empty in the middle?
SKILLS	You do things well, and enjoy what you do. You have a sense of *flow*: time passes quickly, and you are absorbed in your activity, and proud of the results.	There is a significant mismatch between what you know, can do well, and enjoy doing and what your work role actually demands of you. You are doing some things extremely well, but discover that you really don't enjoy doing them.
WORK CONTEXT	Where and how you exercise your skills matters. Do you prefer to work with people, things, information or ideas?	A good benchmark of your discomfort is the question *do you actually enjoy talking about your job?* This is not the same as the question *do you enjoy complaining about your job?*
ORGANIZATION	Do you respond best to a small organization which offers variety and challenge or where you need to be self-reliant, or are you happier in the more defined structure of a larger organization?	Do you feel constrained by too small a firm, or an anonymous cog in a large concern? Perhaps you have struck the wrong balance between growth and security, between variety and structure.

Table 8.1 *cont.*

CAREER DRIVERS	See Chapter 4 for your *career hot buttons* and compare your primary career drivers to what your job has to offer. How far is your present role in tune with your primary drivers?	If there's a mismatch, what would happen if you addressed your strongest-scoring driver first? How would your present job change? What would be your next move?
WORKING CONDITIONS	Think about how your working life is affected by the following: location, travel, the kind of building you work in, what you can see from your office window, where you spend your lunch hour.	Now look at the same list in terms of the things that irritate and rob you of energy.
GROWTH, VARIETY, LEARNING	Does your job keep feeding you? How are you different now from 12 months ago?	How do you begin to manage your career if you are in a job which does not offer growth or learning opportunities?
CAREER POTENTIAL	Is your present role a useful stepping stone to the future? Do you have a clear plan for the next 5 years? Do you need one?	How would a recruiter see your present role – as a dead end, a side alley or a building block in your career?
PACE	Every job has its own sense of pace and speed. Does your organization make things happen quickly enough for you?	Are you being pushed at a speed which is faster than your natural or comfortable rate? How do you feel about leaving things half-completed?
CHANGE	Change, development and new opportunities fill you with energy.	You find change frightening or threatening.

1 A fresh look

Look at Table 8.2 and ask what your working life would be if you assumed a completely different mindset for each box. If you normally spend a large amount of time criticizing yourself, see what happens when you give yourself a pat on the back every 10 minutes. What difference does it make to the way you present yourself? What difference would it make to the way you work?

TABLE 8.2 Personal barriers, and creative ways to overcome them.

LACK OF CONFIDENCE	The key to getting an ideal job lies as much in your confidence as your skills, job-seeking abilities or the state of the labour market. Seek out positive feedback, and record it somewhere so you can retrieve it when you feel low. Resist every temptation to put yourself down.
LIVING UP TO YOUR CV	You would be surprised to realize how many very senior people feel uncomfortable once they have prepared their CV. They feel that an employer will 'see through it'. They are worried about all those positive claims, and feel they are exaggerating. The reality is that employers, just like you, are good at latching onto negative pieces of information. So, don't give them the opportunity to do so. In your CV and at interview you should be the *best possible version of you that you can be.*
FEAR OF MAKING MISTAKES	The world's greatest inventions are the result of mistakes. Mistakes are simply feedback on our performance. Winners make far more mistakes than losers – they get more feedback as they continue to try out more possibilities. The more timid mind stops after one mistake. Thomas Edison failed to invent the light bulb several thousand times before coming up with a version that worked. IBM chief Thomas Watson once said *'the way to succeed is to double your failure rate.*
FEAR OF REJECTION	Statistically you will be rejected more times than you are accepted. This is a fact of life, not a reflection of what you have to offer. The positive career-changer looks at every interview, every discussion, as a learning opportunity. The most important question is 'what did I learn from this?' If you find yourself thinking 'All I learned was that people don't want me', then look again.
I DON'T KNOW IF I WANT IT	Research, and find out. Compare your 'I wish' list to the employer's 'We want' list. If it seems right, throw yourself at the opportunity with enthusiasm. If there are difficult decisions to make about moving house, or whatever, don't worry about them until the job offer is actually in your hand.
NO ACHIEVEMENTS	Everybody has achievements. It's all relative. It is part of human nature to have goals and to overcome obstacles. The point is to recognize your achievements and to celebrate them, rather than assume they are of little worth and of no interest to others.
NO CLEAR DIRECTION	Not a problem, but a continuing opportunity. It simply means you have not yet finished exploring. Remember, though, that an employer is not interested in hearing about your areas of uncertainty. Do not use the job-search process

Table 8.2 *cont.*

	as a way of seeking answers to the questions you hold most deeply – all you will do is increase an employer's perceived risk.
IMAGE	Find as many ways as you can to improve your own self-image (see the note of self-confidence above), but also learn to see how the world sees you. Ask your friends how they and others perceive you; most people find this feedback rather surprising.
MODESTY	Many European cultures see the skills-discovery process as boasting or self-aggrandizement. It's not. Boasting is when you come to the conclusion that you have something better than everyone else, and ram it down their throats. Discovering your true skills, talents and attributes is following a road to contentment (i.e. wanting what you have got). Objective self-criticism can be helpful, and is sometimes painful, but should be a short-term burst of activity not a way of life. The human brain is finely attuned to living out negative messages, and we all gravitate towards our dominant thoughts. If you keep telling yourself 'I'll never be a Manager' you will subconsciously use every ounce of energy to make sure that it becomes a self-fulfilling truth.
THE SHOCK OF THE NEW	It takes courage to make dramatic career changes, and courage to throw yourself into an entirely new job. Try to remember times in your past when you made similar leaps. How long, in fact, was your adjustment period? We are actually quite good at adjusting to new conditions. Even the most demanding and strange environment can become familiar and routine within a matter of months.
THE EXPECTATION OF OTHERS	Don't let other people live your career for you. Everyone does it – parents, teachers, friends and colleagues. They paint a picture of the future and you feel obliged to live it out. They often do so on scant information. You need two kinds of people to make these decisions properly: (a) skilled professionals who can help you to identify where your career is going, and (b) a core team of supporters who can positively encourage you to make it happen.
LACK OF INFORMATION	I talk to a great many people who try to imagine what new fields of work will be like. Imagination can be a helpful step in reaching a goal, but in an age full of information we can take solid steps towards finding out a great deal more. Talk to people who are currently doing the job. Find out what a job feels like from the inside.

EVERYONE I KNOW IS IN THE SAME BOAT	This particular mental block is common among school leavers and graduates. They effectively take a small sample of the population, which is the group of friends they socialize with. Every step forward or backward is judged in relation to that small peer group. There is often an interesting dynamic which holds back everyone except the very strongest individuals. An antidote is to broaden your perception, increase your network and try to find people who are living successful and balanced lives. Role models can be informative and inspiring.
BE CAREFUL WHAT YOU ASK FOR	One peculiarity of the brain is that we attract what we fear. If you see a small child carrying a glass of water and then say 'be careful you don't spill that', what happens? The child's focus goes from carrying to spilling. The drink is spilled. If you concentrate on the things you fear, you unconsciously put energy into a negative outcome. It sounds corny, but there really is power in positive thinking.
NO GOALS	Set goals. Write them down. It makes a huge difference. If you can't set huge goals, then set small goals. Plan your week ahead; apply for a course, read a book, get an appointment with someone who works in a job that interests you; increase your typing speed.
IT'S A DOG EAT DOG WORLD	*'Competition brings out the best in products and the worst in people'* David Sarnoff
	Don't make the mistake of thinking you're in competition with everyone else. You're not. You're up against the requirements of a particular job, and the needs of a particular employer. Co-operation is far more productive than competition. Pass on the lessons you learn about your own career explorations, and help others on their way. There is a school of thought that believes that rejoicing in the success of others brings us success in turn. Whether that's true or not, beginning a network based on co-operation is the secret to a successful career.
COMMITMENT	You need to think about what you really want. You need to think about the dreams that are simply dreams, and the dreams you can act upon.

To take a fresh look is to see things as if you just landed on the planet, or as if you were an inquisitive child: 'What does this do? Why do you do this?' It breaks you out of your habitual ways of thinking. Look at what normally energizes you in life. If you obtain your energy from contact with others, then look at ways of finding your own company more enjoyable and productive. Just as you should get out of your normal physical environment from time to time, it helps to step outside your own personality. If you find yourself drawn to intellectual problems and factual information, place yourself in a situation where you are asked to respond to intuitions and feelings. If you are the sort of person who likes things to be carefully planned, allow yourself to do something spontaneous. Spend one day a month doing things as they occur to you or as the world requires of you, rather than attempting to stick to Plan A every time. Take time out of yourself. Take time to reflect.

2 Protecting your ideas about your future

What If? talks of 'Greenhousing', which is very close to Edward de Bono's Green Hat Thinking (see 4 below). When we have new ideas sometimes the worst thing we can do is to share them with others. It's all very easy for someone else to shoot down your brilliant new idea in flames. New ideas are like fragile seedlings; they take time and nurturing to get to the stage when they can survive unprotected.

We need to do this with our own dreams and ideas. Cultivate them quietly. Seek information and support rather than exposing them to the cold light of day.

We should be more relaxed about ideas and possibilities. We're all very good at jumping to swift conclusions: *that'll never work ... I don't have the qualifications ... no one would ever employ me to do that.* We all need rather more 'what if' thinking. Just let the idea ferment undisturbed for a while, and stir the pot occasionally. Keep thinking up alternatives, possibilities, extensions. Suspend judgement for a while, remembering that every brilliant new idea in the world at some stage needed gentle encouragement.

Then move on to apply a positive but practical approach. From 'what if' move on to 'how could I make this work ...?' Instead of focusing on reasons why your idea wouldn't work, list the benefits. What would you get out of it? What other ways can you think of making it work? This has a very powerful effect on your career possibilities. You don't shoot ideas down too early because they are not 'practical', and you explore both possibilities and outcomes.

3 From imagination to reality

Captain Jean-Luc Picard, second generation *Star Trek* Captain, executes his commands with three simple words: *make it so.*

A great imaginative leap is to spin ideas into the real world. There comes a point where we have to make it happen.

The key to thinking here is in terms of prototypes, pilot schemes and experiments. In businesses these provide effective safety valves for introducing new ideas. We can apply the same thinking to our own careers by finding opportunities to try things out, to bounce ideas off others, and to experiment for short periods. One way is to extend yourself by going on courses, studying in your own

time. Another is to take up some form of voluntary activity outside work in order to experiment with your career longings. Short-term or temporary employment can sometimes help provide a useful 'laboratory' for your career plans. There is one useful principle here from the *What If!* Team: *'don't think, just leap'* – don't give up, just do it and see what happens. Do it now.

4 Keeping the energy going

Companies find that habit, inertia and passivity effectively combine to make sure that new things do not happen. You can see the same forces operating in your own life. You need to recognize that your initial energy will start to fall away and inertia, or sometimes apathy, will take hold. You need to control and harness momentum by setting goals, and planning for ways to re-energize yourself when you feel flat. If you get a brilliant idea for career investigation, anticipate that in some 3–4 weeks' time you will start to lose enthusiasm or feel a lack of confidence. Plan *now* to talk to someone positive at that critical time. Think of ways of committing yourself. Tell other people what commitments you have made so that they can help you stick to them.

Better still, get a careers coach to help you. Another way is to find two other people who are in a similar position to yourself – idea crunching, checking out possibilities, floating ideas. Three people work better than two because it makes it more difficult for one person to entirely dominate another's thinking. With two people listening to your ideas you get a more balanced response. Two people actively supporting your plans, checking your results, and applauding your achievements, is like a portable fan club.

5 Learn how to think

Expand your range of thinking styles. Edward de Bono offers us *six thinking hats* which work well in the context of career planning.

White hat	The information collector. What more facts do I need?
Red hat	Emotions, feelings, intuition. What do I really feel about this? How far do I let these feelings affect my behaviour and my decision making?
Black hat	Judgement, caution, conformity, truth. Will it work? Is it safe? Is it allowable? Black hat thinking can easily become '*YES, BUT*' thinking and suppress new ideas.
Yellow hat	Advantages, positive benefits. How can I make this work? Why would it be good for me?
Green hat	Seeking alternatives, exploring, extending the art of the possible. How can I look at this differently? How can I generate new ideas?
Blue hat	Thinking about thinking. The blue hat controls all the other hats (e.g. 'Isn't it time I used some yellow hat thinking here now?')

6 Deep breath ...

We all need courage to deal with the real issues. In business terms, it's about having the bravery to take a creative leap, or act upon an uncomfortable reality. Corporate bravery is sometimes about making decisions that carry a greater potential risk than perceived alternatives.

Businesses generally prefer to take calculated risks. Or that is what they would like you to think. However, relatively large businesses are often swayed by fear, by a false picture of the future or by sheer inertia. For example, there are those who say that the UK banking industry was dealt a severe blow during the 1980s but instituted changes over a decade later. Barclays Bank was criticized for closing smaller branches across the country. The reality in fact was that Barclays attracted criticism because it was among the *last* of the clearing banks to close branches in smaller towns.

It takes bravery to take time out to think laterally and flexibly about the way your life is going. It takes even greater courage to tell other people about your discovery. It takes maximum courage to begin to put your discoveries into action. Part of this is to do with trust. We need to unlearn some of the rules we were given as children to live with – rules to do with planning, risk, and outcomes.

> ☞ It takes courage to be the author of your life.
>
> NICHOLAS LORE

Somewhere there is a strategy that will work for you that will help you to overcome fear. It may be some new technique for looking at your personal effectiveness – find the book or course or coach that works best for you. Another equally important key is to know who you are at the heart of all this uncertainty and experiment. Those with higher self-esteem find it easy to adopt and explore new ideas, because those new ideas are not threatening our core selves. But don't make the mistake of trying to do it alone. Ask yourself this question: did you buy this book in order to avoid a conversation? In order to avoid talking to a career coach? In order to avoid networking? In order to avoid picking up the phone and finding out about a field or job opportunity?

CELEBRATING OUR DIFFERENCES

> ☞ He that is good with a hammer tends to think everything is a nail.
>
> ABRAHAM MASLOW

Understanding your personality can be a self-centred and unproductive activity if it simply affirms an *I am what I am* mentality. We're given clues about our personality types not in order to fence ourselves off from the world, but in order to build bridges.

PERSONALITY TESTS

There are a number of standard tests available. If you are tested using the Myers–Briggs Type Indicator (MBTI) or similar instruments this should be conducted by a

qualified practitioner. You should be given a clear introduction to the nature of the test, how it is to be used and who sees the results. You should be given objective, independent feedback.

The important thing with all personality tests is that they can only give an approximate diagram, an outline sketch of your complex personality. Some people find that their test results provide valuable insights into the way they think and react. Others feel that the descriptions they are given are too general, or that they don't fit conveniently into any of the boxes described.

It's vital that you should not feel pigeon-holed by your results. Career explorers are vulnerable people, and will attach a great deal of significance to any job titles which are generated by career-related personality tests – you should certainly not conclude 'because I am an ESFJ, I should become a ————'. In any occupational group you will find many personality types. You will also find a wide range of different types who achieve success, senior positions or demonstrate leadership. Circumstances, opportunity and need all play their part as well as human personality.

When you are given your test results (e.g. with MBTI), give attention, first, to where each score fits on a scale. For example, no one is entirely an extrovert or an introvert. Second, reflect on your test results in terms of the way that others see you – how are you different from others? Finally, you will learn to 'read' other types around you and begin to see their preferences and the way they respond to situations. This gives you better strategies for communication and bridge-building with people who see the world very differently to you.

Take advantage of any opportunities you are given to take personality assessments or questionnaires, but be wary where these tests are being used as in the process of staff selection. Many psychologists believe that tests such as the MBTI should not be used for this purpose. There are, in any event, few recruiters skilled enough to use this data objectively or imaginatively enough. If test results are used alongside a variety of other assessment measures, including well-structured interviews, then you can generally feel more assured about the way your results are being used. As far as career exploration is concerned, however, you are better off receiving your results from an independent practitioner who has no axe to grind.

EMOTIONAL INTELLIGENCE

The concept of *emotional intelligence* has provided an important contribution to the understanding of the human mind. Where there was IQ, we now also have EQ. EQ is a measure of your emotional intelligence, and it is such an important principle for most modern business environments that it should possibly be taught as a compulsory module on any educational programme. The theory suggests that much of the world mistrusts or downgrades our emotional intelligence:

☞ People with well-developed emotional skills are ... more likely to be content and effective in their lives, mastering the habits of mind that foster their own productivity; people who cannot marshall some control over their

emotional life fight inner battles that sabotage their ability for focused work and clear thought.

DANIEL GOLEMAN

The ideas of EQ derive from the work of Yale psychologist Peter Salovey, who develops and expands on Howard Gardner's ideas of interpersonal and intrapersonal intelligence (see Exercise 8.1 at the end of this chapter). Measuring emotional intelligence can provide important clues about self-awareness and the way we respond to others:

1 *Knowing one's emotions* – being able to monitor and describe a feeling as it happens;
2 *Managing emotions* – handling feelings as they arise, coping with our emotional reactions to setbacks and upsets;
3 *Motivating oneself* – marshalling emotions in the service of a personal goal;
4 *Recognizing emotions in others* – the fundamental people skill of empathy, being attuned to others' needs and the way they express them;
5 *Handling relationships* – managing and responding to emotions in others and displaying various forms of social competence; social skills, communication, and leadership;

There are several EQ measures available. The following list of characteristics is taken from the 'EQ-I' model developed by the Israeli psychologist Reuven Bar-On[1]:

INTRAPERSONAL
- *Self-regard* – understanding and accepting yourself, your strengths and weaknesses
- *Emotional self-awareness* – recognizing and understanding your own emotions
- *Assertiveness*
- *Independence*
- *Self-actualization* – realizing your potential – doing what you enjoy

INTERPERSONAL
- *Empathy* – recognizing emotions in others
- *Social responsibility*
- *Interpersonal relationships*

STRESS MANAGEMENT
- *Stress tolerance*
- *Impulse control* – the ability to resist or delay an impulse, drive, or temptation to act

[1] Distributed by Multi-Health Systems Inc., Toronto.

ADAPTABILITY
. .
- *Reality testing* – comparing what you experience and what exists in reality
- *Flexibility* – adjusting your emotions, thoughts, and behaviour to changing situations and conditions
- *Problem solving*

GENERAL MOOD
. .
- *Optimism*
- *Happiness*

Checking and building on your EQ has powerful implications. For example, research has shown that business managers are generally strong in five particular areas. Here they are:

Top five EQ characteristics for successful managers

- Self-regard;
- Reality testing;
- Happiness;
- Self-actualization;
- Interpersonal relationships.

USING YOUR WHOLE BRAIN

Research into the complex area of *brain dominance* has greatly assisted our understanding of intelligence and personality. Like all fields, there are misconceptions and oversimplifications. You will sometimes hear people talking about 'left brain' and 'right brain' personality types. In reality, no healthy individual is entirely left-brained or right-brained. A more useful model has been given practical application in the work of Ned Herrmann who puts forward the idea of the four-quadrant brain, described in Figure 8.1. Your personality draws to some extent on each quadrant. In some personalities one or more quadrants may be dominant – we are all a complex mix of all parts of our brain. The important thing is to discover your natural inclinations and build on them. At the same time become more aware of how others see your 'type', and learn how to communicate with those who see the world very differently.

As with other personality models, perhaps the most useful thing we can learn from this is the way other people perceive us. D-quadrant people are often considered to have their head in the clouds. C-quadrant people might be seen as touchy-feely and incapable of making decisions. A-quadrant people are sometimes seen as cold and analytical, while B-quadrant people are sometimes perceived as staid and reluctant to change.

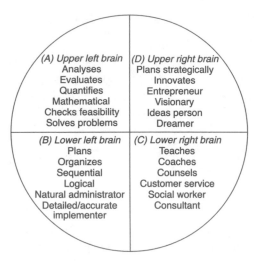

FIGURE 8.1 The four-quadrant brain.

EXERCISE 8.1 DISCOVERING YOUR STRONGEST AREAS OF INTELLIGENCE

Howard Gardner is a Professor at the Harvard Graduate School of Education. In his 1983 book *Frames of Mind* he developed the idea of multiple and complementary intelligences. Gardner's ideas have received widespread attention and acceptance, particularly in the education sector.

Gardner argues that intelligence is not a single faculty that can be accurately measured, for example, by an IQ test. He believes we have several separate but related intellectual capacities, each of which deserves to be called an intelligence.

Gardner argued that his seven kinds of intelligence seldom operate in isolation – we all have some ability in each area of intelligence, but what makes us unique is the way intelligences combine and blend. Sometimes we draw on one kind of intelligence more than any other, but most of the time we combine intelligences to help us learn something or to perform a particular task. Most people have two or three strong intelligences and a few weak areas.

Gardner's seven intelligences

1 *Linguistic intelligence* – using and loving language, whether written or spoken;

2 *Logical–mathematical intelligence* – using or interpreting numbers, data, facts, sequences, scientific research;

3 *Visual–spatial intelligence* – seeing things in pictures or images, map reading, making 3-D models;

4 *Bodily–kinesthetic intelligence* – sometimes known as 'physical intelligence' – the ability to control our body and handle objects skilfully;

5 *Musical intelligence* – an 'ear' for music, a talent to interpret or produce music;

6 *Interpersonal intelligence* – communicating with and responding to other people;

7 *Intrapersonal intelligence* – valuing personal growth, independence reflection, meditation – the inner world.

More recently Howard Gardner has added a *'naturalist'* intelligence which covers our responsiveness to nature.

The following inventory helps you discover your strongest intelligences, and matches them to your preferred style for developing ideas or managing problems.

Completing the seven intelligences inventory

Please note carefully: the inventory which follows has been designed specifically to assist career explorers. Howard Gardner and others have devised tests to assess your multiple intelligences far more accurately than this profile. It is not a psychometric test. The results are not intended to limit your occupational choices or give you a distinctive personality 'type'.

To understand more about your personality in the way that it will be measured by formal psychometric tests, you should arrange to be tested by a qualified practitioner.

The inventory is an open-ended experiment which aims to add to your understanding of the way you see the world, and suggest further areas of exploration in terms of:

- The way you learn;
- The way you interact with others;
- The way you respond to different personality types (e.g. in a team);
- The skills you enjoy using;
- Interests which might develop your 'weaker' intelligences;
- Fields of work where you might develop your primary intelligences

One note before you begin. Completing an inventory on your own is essentially, in Gardner's terms, an *intra*personal activity – in other words, a process of reflection. You may find it easier to discuss your preferences with someone else (i.e. drawing on your *inter*personal intelligence), or choose some other strategy to achieve a result (sketching, analysing the numbers, physically arranging the options on cards ...).

Under each of the seven headings are a list of characteristics. Put a tick next to any sentence which *describes what you are like most of the time*. There are no right or wrong answers – if in doubt, put a tick. Then give yourself a score between 1 and 5 after reading the longer description of each intelligence.

Add up your total score out of 15 for each category, and transfer your scores to the final panel. At the end of the inventory write down your three strongest intelligences (you are allowed four if your scores are very close).

The results are expressed in numerical terms, but don't get hung up on the precise scores or the rank order.

When you have finished the inventory, read the panel which follows on *Interpreting your Primary Intelligences*.

LINGUISTIC INTELLIGENCE

		TICK
1	I can lose myself in a book very easily	
2	I enjoy crosswords or other word games	
3	I like telling stories or jokes	
4	I enjoy reading for pleasure	
5	I enjoy choosing the right word	
6	I like listening to spoken word programmes on the television	
7	I enjoy intelligent debates	
8	I hear words in my head before I speak or write	
9	I can often remember exactly what was said to me	
10	I rehearse things verbally in my head	

SCORE ⇨ ⇨ ⇨ []

LINGUISTIC people enjoy reading and writing, love word games, and are responsive to the spoken or written word, and the richness of language. They often have a good memory for names. They possess a wide vocabulary and speak and/or write fluently.

Give yourself a score between 1 and 5 in terms of how well this paragraph describes you

Not me at all Spot on

 1 2 3 4 5 SCORE ⇨ ⇨ ⇨ []

LINGUISTIC INTELLIGENCE TOTAL COMBINED SCORE/15 ⇨ ⇨ ⇨ []

LOGICAL – MATHEMATICAL INTELLIGENCE

		TICK
1	I am good at mental arithmetic	
2	I enjoy games or puzzles which require logical thinking	
3	I enjoyed maths and/or science in school	
4	I enjoy practical experiments	
5	I enjoy strategy games like chess	
6	I like things to be clear and well organized	
7	I am logical	
8	I am interested in new developments in science	
9	I like to have prioritized lists	
10	I believe that most things have a rational explanation	

SCORE ⇨ ⇨ ⇨ ☐

LOGICAL–MATHEMATICAL people respond well to patterns and structures, and prefer to do things in a sequential order. They organize experiments to test theories, and enjoy opportunities to solve problems. They reason things out logically and clearly.

Give yourself a score between 1 and 5 in terms of how well this paragraph describes you

Not me at all Spot on

 1 2 3 4 5 SCORE ⇨ ⇨ ⇨ ☐

LOGICAL–MATHEMATICAL INTELLIGENCE
 TOTAL COMBINED SCORE/15 ⇨ ⇨ ⇨ ☐

VISUAL–SPATIAL INTELLIGENCE

		TICK
1	I like things to be colour-coded	
2	I quickly understand symbols on signs, instrument panels/equipment	
3	I enjoy cartoons	
4	I like to draw, sketch or doodle	
5	I enjoy photography	
6	I have a good sense of direction	
7	I prefer books with illustrations and diagrams	
8	I am good at giving road directions	
9	I am good at reading maps	
10	I feel strongly about the layout and 'look' of a document	

SCORE ⇨ ⇨ ⇨

VISUAL–SPATIAL people tend to think in images and pictures. They enjoy visual puzzles and mazes, and tend to organize ideas visually in their heads, drawing maps or networks to connect ideas.

Give yourself a score between 1 and 5 in terms of how well this paragraph describes you

Not me at all Spot on

1 2 3 4 5 SCORE ⇨ ⇨ ⇨

VISUAL–SPATIAL INTELLIGENCE

TOTAL COMBINED SCORE/15 ⇨ ⇨ ⇨

BODILY–KINESTHETIC INTELLIGENCE

		TICK
1	I would rather drive than be a passenger	
2	I prefer it when my hands are occupied with something practical	
3	I find it difficult to sit still and relax for long periods	
4	I am well co-ordinated physically	
5	I am good at building or repairing things	
6	I enjoy hobbies which have a physical result like carpentry, wood carving, knitting, model building, gardening	
7	I enjoy physical sport or exercise	
8	I like to spend my free time outdoors	
9	I enjoy human touch and use expressive body language	
10	I would rather play than watch	

SCORE ⇨ ⇨ ⇨

BODILY–KINESTHETIC people like to interact with the world physically. They have an ability to control their bodies and handle objects skilfully. They respond best to work that is physically active, 'hands-on' and practical. They often enjoy sports and the outdoor life.

Give yourself a score between 1 and 5 in terms of how well this paragraph describes you

Not me at all Spot on

1 2 3 4 5 SCORE ⇨ ⇨ ⇨

BODILY–KINESTHETIC INTELLIGENCE
 TOTAL COMBINED SCORE/15 ⇨ ⇨ ⇨

MUSICAL INTELLIGENCE

		TICK
1	I have a good 'ear' for music	
2	I can hold a note	
3	I sing or play a musical instrument	
4	I often remember tunes in my head	
5	I would rather listen to music on the radio than discussions	
6	I can follow a musical score	
7	I have a good sense of rhythm	
8	Music speaks to me emotionally	
9	I am very aware of an 'off' note or an instrument which is out of tune	
10	I enjoy rhymes, poetry and limericks	

SCORE ⇨ ⇨ ⇨

MUSICAL people respond well to sound, music and rhythm. They often have a talent to interpret or produce music. They will often find it helpful or soothing to listen to music while studying or reading. Music will often 'speak' to them in terms of colours, emotions or themes, even when there are no lyrics.

Give yourself a score between 1 and 5 in terms of how well this paragraph describes you

Not me at all Spot on

1 2 3 4 5 SCORE ⇨ ⇨ ⇨

MUSICAL INTELLIGENCE TOTAL COMBINED SCORE/15 ⇨ ⇨ ⇨

INTERPERSONAL INTELLIGENCE

		TICK
1	I would rather be in company than on my own	
2	People say I'm a good listener	
3	I prefer group sports like football or badminton to solo sports like swimming or running	
4	I generally talk about my problems with my friends	
5	I enjoy parties and other social events	
6	If I learn a skill I am happy to teach it to someone else	
7	I can pick up the moods of other people	
8	I can express an idea best by talking about it	
9	I have a number of close friendships	
10	I am often called on to manage teams or organize social activities	

SCORE ⇨ ⇨ ⇨

INTERPERSONAL people are interested in others around them, are good listeners and communicators. They prefer to be in company, and like to share with others. They are naturally inclined towards teaching, caring or nurturing roles.

Give yourself a score between 1 and 5 in terms of how well this paragraph describes you

Not me at all Spot on

1 2 3 4 5 SCORE ⇨ ⇨ ⇨

INTERPERSONAL INTELLIGENCE TOTAL COMBINED SCORE/15 ⇨ ⇨ ⇨

INTRAPERSONAL INTELLIGENCE

		TICK
1	I enjoy my own company	
2	Learning and personal development are important to me	
3	I have some.strong opinions	
4	Spending time alone reflecting is important to me	
5	I have a strong sense of intuition	
6	I enjoy a quiet space in order to meditate and reflect	
7	I keep a journal that records my thoughts and feelings	
8	I have a strong sense of independence	
9	I normally solve my own problems	
10	I would probably enjoy being my own boss	

SCORE ⇨ ⇨ ⇨

INTRAPERSONAL people value time spent alone and are very aware of their own personality, strength and weaknesses. They tend to solve problems alone. They are often highly independent and self-motivated. They value the inner self, personal development and spirituality. They may be entrepreneurs or interested in becoming self-employed.

Give yourself a score between 1 and 5 in terms of how well this paragraph describes you

Not me at all Spot on

1 2 3 4 5 SCORE ⇨ ⇨ ⇨

INTRAPERSONAL INTELLIGENCE TOTAL COMBINED SCORE/15 ⇨ ⇨ ⇨

SEVEN INTELLIGENCES **Total**

1 LINGUISTIC INTELLIGENCE ⇨

2 LOGICAL–MATHEMATICAL INTELLIGENCE ⇨

3 VISUAL–SPATIAL INTELLIGENCE ⇨

4 BODILY–KINESTHETIC INTELLIGENCE ⇨

5 MUSICAL INTELLIGENCE ⇨

6 INTERPERSONAL INTELLIGENCE ⇨

7 INTRAPERSONAL INTELLIGENCE ⇨

Your three strongest intelligences

Interpreting your primary intelligences

What do the results mean? First of all, they should make you look again at the work you do in terms of:

● The way you think;
● The way you best handle information and ideas;
● The way you respond to others;
● How you respond to people whose intelligences are very different from your own (e.g. it can be very difficult for visual–spatial people to understand what those with high linguistic intelligence are explaining in such a long-winded way. They will say 'just draw me a diagram!').

How can the results help your career choice?

It will be rare that you will see a direct correlation between one strong intelligence and one occupation (e.g. 'I should be a mathematician!') Your intelligences combine with your preferred areas of knowledge, your motivated skills, your upbringing and personality. Exercise 8.2 shows how you can relate your seven intelligences to your

experience, and also suggests some of your preferred methods of learning and exploration.

Here are some pointers in relation to strong scores. In each case what you may be spotting is an opportunity to expand your natural intelligences.

- *Linguistic intelligence* – Does your work give you opportunities to express yourself clearly in writing or in speech? Where can your organization improve its communication? How can you adapt messages so that they are better perceived by those who have strong intelligences in other areas?
- *Logical–mathematical intelligence* – Your preferences lie with numbers, statistics, data or scientific investigation. How far is this intelligence being stretched? Do you have difficulty communicating what you see in numbers to others?
- *Visual–spatial intelligence* – Where in your job is this intelligence used? Can you learn how to use software to design slides and presentations? Can you make signs or posters?
- *Bodily–kinesthetic intelligence* – What happens if your work is entirely intellectual and desk-bound? Can you translate your work into another context (e.g. move from management training to outward-bound leadership training)?
- *Musical intelligence* – Can your musical intelligence be used in any way other than a career in music – for example, in sounds, jingles, rhymes (perhaps in advertising copy or rhymes to help people learn and remember things – 'an apple a day . . .')?
- *Interpersonal intelligence* – Your skills 'handling' people and relationships are much in demand in the modern workplace. Which aspects of interpersonal intelligence are strongest for you, and which need nurturing?
- *Intrapersonal intelligence* – Do you take your inner world seriously enough, and apply reflection to your work? Some managers consciously set aside thinking time when they can reflect. Don't always take work with you on the train. Sit and think. Advice to this group might be 'Don't do something, just sit there . . .'

So what . . .

What do you do if you come out with musical intelligence at the top but you can't immediately see how music could play a part in your career? (The other six intelligences are somewhat easier to look at in terms of relevance to careers.) Whatever your current job function, if you have an absolute passion for music but you're not a good enough performer to be a professional, perhaps you might consider music as a general field and then look at possible functions within it – instrument manufacture, managing or fund-raising for an orchestra, administration for events at concert halls, recording, teaching, etc. On the other hand, it might be better to recognize that you can always have music in your life as an interest outside work. Performing in an amateur choir or orchestra teaches you interesting things about working in teams . . .

EXERCISE 8.2 BUILDING ON YOUR PRIMARY INTELLIGENCES

Table 8.3 allows you to focus on your strongest intelligences. In Column 2 write down examples of achievements or career high points related to each intelligence type (in your weaker areas you may find it difficult to think of anything, but keep pushing!). Then look at Column 3 to see the implications for the style of idea generation and career exploration which will probably work best for you. In Column 4 write down your own ideas of methods which would work for you.

TABLE 8.3 Building on your primary intelligences.

Types of intelligence	Linked achievements/great experiences	Primary method of handling new ideas or problems	Things that would work for me . . .
Linguistic intelligence Using and loving language, whether written or spoken		Put things in your own words. Find your own way of saying things. Write things down. Tell stories.	
Logical–mathematical intelligence Using or interpreting numbers, data, facts, sequences, scientific research		Devise a formula to explain a concept (e.g. 'Awareness times Behaviour equals Mastery'.)	
Visual–spatial intelligence Seeing things in pictures or images, map-reading, making 3-D models		Draw a mindmap of your ideas. Create a diagram or flow chart. See your problem as a maze or jigsaw. See things in your mind like a movie.	
Bodily–kinesthetic intelligence The ability to control our body and handle objects skilfully		Design and use cards to arrange and shuffle your ideas. Walk or jog while you think. Act out a situation.	

Musical intelligence An 'ear' for music, a talent to interpret or produce music	Compose a jingle or rhyme to remember something important. Listen to music you like as you think about a problem.
Interpersonal intelligence Communicating with and responding to other people	Find a coach. Discuss the subject, talk about your discoveries. Teach an exercise to someone else. Turn a task into a team activity.
Intrapersonal intelligence Valuing personal growth, independence, reflection, meditation – the inner world	Find quiet to reflect. Draw on your past experiences to validate what you are learning or how you can use it. Take time to draw analogies between one exploration and other parts of your life.

'MUST DO' LIST:

☞ What brings you to life? When or where do you become *energized*?

☞ What has a deadening effect on you?

☞ Do you live most in the past, the future or the present?

☞ Are you drawn more to the inner world of reflection, analysis or dreams, or the outer world of things, problems and people?

☞ Do you prefer to think in concrete or abstract terms?

☞ Do you prefer clear plans or open-ended possibilities?

LEAP INTO A NEW FIELD

☞ Discover the importance of fields in career choice.

☞ Find a range of ways of identifying fields.

☞ Increase your range of possibilities.

FIELDS OF WORK

☞ What work I have done I have done because it has been play. If it had been work I shouldn't have done it.

MARK TWAIN

What is a field?

A *field* is a way of categorizing work not by skill but by kinds of knowledge. Think of medicine – a large and very general field. Within that large 'job family' are several smaller fields, including nursing. But even if you choose nursing, you will soon have to decide whether you want to be a general-hospital nurse, a nurse dealing with mental health, children, old people, an operating-theatre nurse, or perhaps a community nurse, a nurse in a health centre, or an occupational nurse in a factory environment. Qualified nurses can also find themselves acting as teachers, counsellors, managers, expert witnesses. ... So within any field there are a huge number of occupations, but what unites them all is a concern with one primary activity.

The trouble with most of the careers advice we receive as young people is that most of it revolves around the question 'What do you want to *do* when you grow up ...?' We are supposed to look thoughtfully, and then come up with a job title: 'Er ... A ... Chartered Accountant!'

One of the problems we have is that some jobs are more visible than others. You know what a surgeon, a barrister or a firefighter does (or you think you do – how much of your perception is based on TV roles rather than the way people really do their jobs?). Some jobs are highly visible because you interact with professionals regularly (e.g. your family doctor or dentist). But do you know what a systems analyst does, or a risk assessor, or a behavioural psychologist, or a voice coach? In our modern economy, new types of jobs are created every day. Most will be invisible to us, and we have to rely on hunches, insider information or assumptions to choose between them.

Many careers counsellors believe that your choice of occupational field is one of the most powerful factors in taking you to an inspired career. So, to take our accountant as an example, ask yourself – if I were an accountant, what field would I like to work in connected to accountancy? In other words:

1 Would I be happy as an accountant working in a city or in a rural setting?
2 Would I like to spend as much time with people as I do with numbers?
3 Would I like to teach others to become accountants, or teach clients how to make the most of their accountant?
4 If I could be an accountant in any industry, would it matter? Think about the enormous range of work available to people in this occupation: from working for a charity to working in movies ...

Why fields are powerful

☞ Work is much more fun than fun.

NOEL COWARD

The interesting thing about fields of work is that this is an issue which is hardly ever considered by employers when they are recruiting. Employers know what field they are in, and hardly ever make explicit the complex range of assumptions and cultural factors contained in any one field. Job seekers have to make educated guesses: What will it be like working in this industry? What kind of people work in this field? Employers tend to focus on the job in terms of its responsibilities and outcomes that will be achieved, and job adverts tend to press the same buttons. Many careers counsellors believe that choice of field is a remarkably powerful factor in career satisfaction.

Let's take one job title: *Teacher*. We think we know what a teacher does. But this role can appear in a number of fields in interestingly different ways; for example:

● A teacher of sign language to parents of deaf children;
● An education officer interpreting a nature reserve to the public;
● A gallery officer making art and sculpture exciting for children;
● A salesperson demonstrating the potential of new software;
● A business consultant specializing in team building;
● A motor mechanic supervising apprentices.

The essential truth is that human society needs to find some way of categorizing everything, and this includes ideas and activities. This begins at school. You didn't have classes titled *thinking, speaking, imagination* or *wisdom*. Actually, you might have attended such classes if renaissance ideas about education had continued to the present day. In the Victorian age educators reclassified what was taught into much narrower boxes (and at the same time invented new subjects including English and physics). The subjects you are taught in the classroom lead naturally to educational and career decisions. We have all got used to putting knowledge into separate boxes: *music, history, French, chemistry*. These boxes shape the way you imagine your adult life will be, following a simple construct: 'I'm good at science so I should be a scientist' ...

This is the basis of much of our early careers advice. You see a box with a label on it that looks attractive. The label shows somebody doing things which look rather like activities you have enjoyed at school, whether this involves grooming animals or handling test tubes. You are attracted towards that box because of the idea that this field will be like something you have already enjoyed or shown some talent in before.

This approach falls down in a number of ways. First, your secondary education narrowed your studies down to no more than about a dozen subjects, but there are literally thousands of fields of knowledge and work out there. Anyone working with school or university leavers needs to explore this thinking carefully: there are few people practising 'pure' geography, history or mathematics in the world.

It's also easy, particularly for career changers, to choose a field which is too safe. At times of crisis you will tend to gravitate towards fields where you can operate inside protective boundaries – your comfort zone. It's common among career changers to hear people say *'I would really like to work in a field which inspires me, but I will find it much easier to get a job in the field I have been working in for the last 20 years'*.

Fields and motivation

> ☞ Find a job you like and you add five days to every week.
>
> H JACKSON BROWNE

Why does choice of field matter? Think back to the *House of knowledge* exercise in Chapter 5. The key behind this exploration is what energizes and *motivates* you. You can perform a variety of skills, but *motivated skills* are the ones that achieve results, both for yourself and the world.

Talk to people who love the field they are working in. You will hear in their voices enthusiasm, love of detail, a willingness to share what they know with others and a wish to encourage others to follow the path they have taken. Once you find a field which gives you the same 'buzz', you will approach both your job search and the work you do with a far more positive spirit. The spin-offs, both for yourself and any organization which employs you, are important:

- You will retain what you learn and enthusiastically pass it on to colleagues;
- Your love of your work will communicate itself to clients and increase their loyalty;
- You will be more enthusiastic during your job search and at interviews – and employers love enthusiasm;
- You will find it far easier to fit into an organization where others share your passion;
- Efficiency and productivity will come naturally to you;
- You will be forever interested in new ideas, new connections and increasing your learning.

Psychologists sometimes refer to 'domains' as well as fields. Mihaly Csikszentmihalyi, who has spent many years looking at the way individuals apply creative energy to work, writes:

2 Fields where your friends, family or contacts work ...;
3 Jobs you've ever imagined doing ...
4 Lists of job categories/guides to occupations/*Yellow Pages*.

Other prompts:

1 If you could try someone else's job for a day, what would it be?
2 If you could do any job in the world for a week and still receive your normal salary, what jobs would you try?
3 Who are your role models or champions, and what fields are they in ...?
4 If you won a million pounds and you didn't need to work, what activity would you happily do for nothing?

Resources

Finally (and don't ignore this one because it seems too obvious) use lists of occupations and books about work as ways to add to your list of possible fields. In the UK the guide *Occupations* is published every year by COIC. Other versions are available online (see website recommendations at the end of this book). An alternative method is to go through the *Yellow Pages* for your nearest city and mark any field that interests you. Look at Vivien Donald's *Offbeat Careers*. Find books about specific fields of work – there are hundreds on the market, and many trade bodies publish guides giving entry requirements, prospects and key information for their own sectors.

Read the careers pages of general newspapers (tip: sections on graduate careers often contain career tips and company information useful to the full range of job seekers). One rule: don't worry about your level of expertise, and certainly don't at this stage give into the kind of thinking which begins 'yes, but in the real world ...'

Put your fields in Table 9.1. The ones appearing in the top left-hand corner are *probably* the ones which will make most connections for you.

TABLE 9.1 Organizing your field discoveries

	Red-hot interest	Luke-warm interest
Knowledge level Already high or I would like it to be so		
Knowledge level Low or declining		

Pushing field alternatives

The search for alternatives is a powerful thinking skill in all aspects of life. The
natural tendency of the mind is to move towards certainty and security. Most
career changers love tests, boxes and checklists because their mind is saying '*I feed
the data in here, and the answer pops out here*'. We all love that idea of a magic
button, which is why formal testing is so dangerous in career development. It's so
easy to sit back passively and wait for a computer or test to tell us the job you
should do next.

Most dangerous of all, in my estimation, are computer programs which sample
your interests and aspirations and then give you a list of job titles. First of all, this
kind of test cannot identify what really motivates and interests you. Second, it can
only refer to very limited categories: jobs and occupations. The key to career
development is to match motivated skills, fields of interest and a range of other
factors including personal values. Finally, no test program can keep track of the
huge range of jobs which are available in the workplace. The test should only ever
be used as a way of seeking alternative possibilities, and never as a way of
narrowing choices.

The way people are educated in the Western world means that we often shun
alternatives. My training colleague Roger Lansley gave me an unforgettable catch-
phrase: *Don't confuse me with facts, my mind is made up.*

We often feel that our thinking should follow a logical, analytical sequence:

$$\boxed{\text{problem}} \rightarrow \boxed{\text{diagnosis}} \rightarrow \boxed{\text{solution}}$$

This might look a little like scientific investigation, but science is a rather slippery
model for thinking. In the twentieth century scientists learned that there are few
certainties and an infinite number of strange possibilities. Light appears to behave
as both a particle and a wave. Heisenburg's uncertainty principle means that we
can no longer say where something is and what it is doing at the same time.
Quantum theory blurs notions of common sense and logic, while relativistic
thinking merges those of space and time.

Yet on a pragmatic level, too many alternatives seem to lead to indecision and
vagueness. One of the great tools in business creativity is the process of brain-
storming, but this is often in fact misused because the process is cut off halfway
through. Brainstorming is a good way of generating a large number of ideas in a
free-flowing, non-critical environment. The effect is rather like a shotgun blast –
both broad and inaccurate. What any brainstorming session needs (and this will

apply to your own creative thinking about the career process) is a secondary tool to help you prioritize, test ideas, group ideas together and focus on the next step.

The reality is that you are faced with an enormous and unimaginably large number of alternatives when it comes to ways of making a living. Lists of occupations have grown dramatically since they were first begun in the last century. Guides giving specific information about occupations are often significantly out of date by the time they get to bookstores.

Stretching your thinking of fields

At the end of this chapter you will find a range of tools which will help you come up with new ideas about fields and make new connections between them.

If you want to achieve a career breakthrough it's vital that you commit some time to exploring your fields of interest. If some of the following exercises make you feel uncomfortable or seem unconventional, then it means they're working. Field exploration is about putting aside the rulebook and discovering new ways of thinking.

What will you find satisfying in your ideal field of work? There is only one keyword here and that is *fun*. There is no textbook definition which is helpful here. You may have fun playing five-a-side football down a corridor at work, or you might find the greatest stimulation from making a scale model of the Houses of Parliament with matchsticks. When you're looking at the kinds of things people do in the field, or considering your field in terms of features and attributes, then don't forget to look for times and places where you might possibly catch *yourself having fun*. If you can't see any possibilities at all, then you either haven't asked enough questions or you're looking at the wrong field.

Fields and occupations: an explosive combination. Your aim in working through this chapter is to develop a list of between five and ten fields that you have prioritized as fields where you would like to work.

Ideally, at this stage, you need the help of another person. Put together, either in list form or as two sets of coloured cards, your top fields and your top occupations. Now play with the possibilities.

It's worth bearing in mind a few simple truths about career change:

1 It is relatively straightforward to switch fields, but remain in the same occupation. You may want to remain an accountant, and switch from manufacturing to the hotel trade.
2 It is relatively straightforward to change occupations, but remain within the same field (e.g. you may remain in secondary-school education but become an administrator rather than a teacher).
3 The hardest shift is to change both occupations and field at the same time. Sometimes it is worth thinking about a stepping-stone approach – change one element now, and another in, say, 12 months' time when you have gained some relevant experience.

> ☞ A passionately lived life is not always comfortable.
> NICHOLAS LORE

JANE'S STORY

Jane had spent 10 years building up a successful computer consultancy. Her quality of life was excellent, her products cutting edge. However, Jane recognized that there was something missing.

Jane has now sold her business and runs two restaurants. When I asked her why she eventually decided to switch from the field of computing solutions to the restaurant trade, she answered, 'I love food, and I love being in restaurants. But the real reason was that I wanted to work in a field where customers most visibly *enjoy themselves*. My computer clients were satisfied, but the service I provided hardly ever brought a smile to their faces'.

EXERCISE 9.1 MINDMAPPING POSSIBLE FIELDS

You have already come across this method in Chapter 1.

Begin mindmapping by turning an A4 sheet sideways into landscape format. Write one field in the centre of the page, and draw a circle or box around it. Then draw lines out from that word as you generate ideas, and along each one write out any other words or phrases which come to mind as a result.

One technique which is often forgotten is to push the mindmap as far as it will go in terms of any conventional connections you can make, and then use some form of provocative technique to send your brain off in another direction. There are several exercises in this book that will help with *provocation* (see Exercise 10.2 – *Discontinuous Thinking* in Chapter 10).

EXERCISE 9.2 SORTING YOUR FIELDS USING THE IDEA GRID

(This adapts and extends the Idea Grid technique outlined in Exercise 6.2).

Step 1: WRITE OUT YOUR FIELD IDEAS

Think of as many fields as possible, and write down your *field ideas* on blank postcards.

Step 2: COMBINE SIMILAR IDEAS

Reduce the number of cards by discarding anything which is essentially a repetition of something else. Combine any duplicated or very similar fields. You may have *Product Design* and *Design* – perhaps they would be better as one card.

Step 3: MODIFY OR ADD TO YOUR FIELDS

You may feel that some of your fields need modifying. Add any new ones you think of. Check: are your fields too big? If so, they will not be helpful to you. People tend to select too wide a field assuming that this will lead to a wider range of opportunities. In fact what it leads to is a vagueness which quickly communicates itself to recruiters. Some fields are just too vague: 'Management' or 'Administration' or 'Company Director' – these are roles which can be exercised in virtually any occupational field. Discard anything vague, convert anything too big into several different cards.

Try to narrow down your field, or list subfields. For example, if your field is marketing, ask yourself if there are any particular fields where you like to exercise marketing? Are you more interested in marketing products or services? Do your interests lie in advertising, direct mail, brand development or at a strategic level? Are you more interested in marketing one kind of product or service than another?

Step 4: CREATE NEW POSSIBILITIES

Now try grouping cards together temporarily, even if they seem unrelated. Pick any card at random and bounce the idea it contains off another card. For example, you may have *fitness coaching* and *catering*. Maybe a fruitful combination for you would be *food supplements* or *dietary advice* or *corporate hospitality in sport*.

Step 5: DOUBLE CHECK/FEEDBACK

Now check through all the cards you have removed, which may include cards you have combined or modified, to see if they give you any additional insights in combination with cards on the table.

Step 6: CLASSIFY INTO RELATED COLUMNS

Put your cards into columns, and give each column a heading. Perhaps *INFLUENCING PEOPLE, DESIGNING, SELLING. . . . Again, add more cards if you make new connections.*

Step 7: RANK THE IDEAS IN EACH COLUMN

For each column in turn, put at the top field ideas which you find most exciting, inspiring or most fruitful, with the less provocative or interesting ones lower down the column. Again, do *not* apply any kind of received wisdom about which options are 'realistic' or 'practical'. No one jumps out of bed in the morning to achieve things which are merely 'realistic'.

Step 8: FINALIZE YOUR COLUMN HEADINGS

Refining your column headings is important, because you are essentially using 'step up' thinking (i.e. asking yourself what do these ideas have in common?). What is the

underlying principle? If you have the column headings *building* and *engineering* you might merge these into one field, *civil engineering*, or you might want to go for a broader field, *construction*. It's quite common at this stage for you to throw all the cards in the air and begin again ...

Step 9: RANK THE COLUMNS

Put the most interesting column on the left, the least interesting on the right. Copy out your grid or paste it up on the wall. This is a working model for selecting *your* potentially satisfying and challenging fields of work. The fields appearing in the *top left-hand corner* are your priorities for further research.

EXERCISE 9.3 FEATURES AND BENEFITS

In order to warm yourself up for this exercise you need to think about an ordinary object like an alarm clock.

What are your alarm clock's *features*? It shows the date perhaps, or lights up in the dark. You might begin by thinking about its *physical* features, the tasks it is used for, what it is made of, where it is used, then how it might have *alternative applications*. You might use it during the day to remind you of appointments. Maybe you could use the clock light to find a missing contact lens ... Think about the *benefits* to *you*. Your alarm clock gets you up and out of the house on time, it's reliable so you sleep more easily. In advertising terms, this is known as 'sell the sizzle, not the sausage'.

Now pick a *field* that has come up on your list of possibilities. Write it down. Ask yourself what *features* you can identify in it. Think about alternative ways of looking at it: you might, for example, look at the kind of *people* in that field, or the *things, information* or *ideas* handled in that field. Look at it in as many ways as you can, and list all the features you can think of. What kind of work is done? What is achieved? There are *psychological* features, too: the image of the work to the general public, the excitement it generates, whether it contributes to the well-being of others or building the community.

If you don't know enough to write down any features, do some homework, or be direct: ask someone in that field to tell you.

You then look at each of the features in terms of the *benefits*; in other words, what those features say to *you*. *What would that field provide for you?* However, *benefits* take things a step further, by spinning off towards other fields.

Table 9.2 looks at the field of *broadcasting* and comes up with a number of features, linked benefits, and then spin-offs making connections to other fields.

Feature and benefit listing is useful because it requires you to focus on features which are otherwise invisible within the field. It's also a great way of helping you build up a wish list of what you want out of a career.

Finally, look at your list of benefits and spin-off fields, and if you see a *refined* field (i.e. a field that is much more clearly focused), write it down. You're probably at the stage where you need to research it in detail.

TABLE 9.2 Listing the features and benefits of fields.

FIELD: BROADCASTING

Features	Benefits	Spin-off fields
Social	Outgoing, exciting, professional	Consultancy?
Travel	Plenty of opportunities. Location work, overseas?	Other national organizations?
Knowledge	Wide base, vital, learn new methods	Journalism?
Work process	Strict deadlines, methodical but also creative	Publishing?
Tasks	Fact-finding. Objectivity. Liaison	Academic Research? Consumer Organization?
Achievement	Wide recognition. In the public eye	National organization needing a spokesperson?
Contribution	Help people understand their world. Making a difference. Crusading. Entertaining	Community organizations? Theatre?
Image	Glamour? Especially if on air/front of camera.	PR Public speaking?
Community involvement	Local, relevant. Powerful influence	Lobbying? Local politics?
Technology	New problems every day. Up to date technological skills	Recording/music industry Product development – broadcasting equipment?

Refined field: Working in local radio with a strong community involvement.

Entertainment	Media	Writing
Community advice	**LAW**	Mergers and acquisitions
Resolving conflict	Negotiating	Property

FIGURE 9.1 One field into eight.

EXERCISE 9.4 THE LOTUS BLOSSOM TECHNIQUE

(Developed by Yasuo Matsumura, and sometimes known as the MY method.)

In this technique, you place your idea in the centre of a grid. Using your own creativity or that of a group, you find eight possible connections. In this case, you would start with one field at the middle of the grid, and think of eight parallel, related, contrasting or complementary fields – add anything which feels exciting or useful. Each of those new fields then becomes the centre of another 'petal' (see Figure 9.1). This works well on a very big sheet of paper.

Each of your new connections then becomes the centre of another web of ideas, as indicated in Figure 9.2, which shows a new petal starting with 'Resolving conflict'. Each grey cell can now be opened out to generate eight new possibilities, generating eighty from your original single thought. It is, of course, possible to open the petal out even further and create hundreds of connected ideas, but it's also productive to begin again with one key word at the heart of a new 9 × 9 grid.

	Entertain-ment			Media			Journalism	
			Entertain-ment	Media	Journalism			
	Community advice		Community advice	Law	Mergers and acquisitions		Mergers and acquisitions	
			Resolving conflict	Negotiating	Property			
Team building	Violence at work	Counselling						
Marriage guidance	Resolving conflict	Personality assessment		Negotiating			Property	
Industrial relations	Risk assessment	Arbitration						

FIGURE 9.2 The Lotus-blossom technique.

MUST DO LIST:

☞ Don't ignore the power of fields when searching for a job you'll love.

☞ Don't allow *YES, BUT* thinking to prevent further investigation of a field that interests you.

☞ Look back at your working life. What fields have you found most satisfying? Why?

☞ Draw up a list of fields which appeal to you. Set out a plan to investigate more about them.

☞ If you can't think of possibilities, use an exercise to generate ideas and connections.

USING THE FIELD GENERATOR

THIS CHAPTER HELPS YOU TO:

☞ Use lateral thinking to help you identify new fields.

☞ Explore field combinations.

☞ Map out fields you would like to actively research.

> ☞ Your imagination is your preview of life's coming attractions.
>
> ALBERT EINSTEIN

USING THE FIELD GENERATOR

EXERCISE 10.1 Moving from Interests to Fields

As Chapter 2 indicates, sometimes it is necessary to use provocative thinking to generate ideas and make new connections. The *Field generator* in Table 10.1 begins with what you know and your primary areas of interest, and then moves you through a thinking process that should help you to generate unexpected ideas about potential fields of work.

Go back to the *House of knowledge* exercise in Chapter 4. Use a highlight pen to mark up your preferred interests.

Now refer to the *Field generator,* Figure 10.1.

TABLE 10.1 How to use the Field generator.

Step 1	Take copies of Figure 1 – the Field generator – and try this exercise out using as many interests as you can. This exercise works best with someone else working with you, prompting and asking questions.
	Make sure you have completed the *House of knowledge* exercise in Chapter 4. Pick five or six of your strongest interests.
	Write one of your interests in *Box 1* (e.g. *boats, sailing and the sea*).

Table 10.1 continued

Table 10.1 *cont.*

Step 2 In *Box 2* write down a keyword from your area of interest (e.g. *sailing*).

Step 3 Look at your keyword and in *Box 3* write down three fields of work where this word appears (e.g. *sailing instruction, sailing-boat design, sailing restoration*).

Step 4 Now that you have expanded your field a little, think of fields of work which use *similar* words, and write them in *Box 4* (e.g. *shipbuilding, naval architecture, merchant navy, navigation*). Make a note in the margin of any new fields that you hadn't thought of before that are maybe connected in some way with your interest (e.g. *outward-bound training, water safety*).

Step 5 This is where you have a chance to use a technique which in idea-building terms is called 'going up a level'.

Look at your fields in Box 4. Is there any overriding category that describes them? If you are finding these ideas together in one drawer, what label would you put on the front of the drawer? (e.g. *nursing* and *osteopathy* can be placed within the general category of 'medicine' or 'physiology'). This may take a while to work out, or you may think of several alternatives. The answer will be unique to you. In this case you might come up with *weather, racing, healthy competition, low technology, getting away from it all, being captain of my own boat . . .*

The important question is: What is most important to you? Write down your final answer in *Box 5* (e.g. *healthy competition* might be your preferred *underlying principle* here – the bigger idea behind what you have written).

Step 6 In *Box 5* we moved up a level to the underlying principle. In *Box 6* we come down a level at a different point?

What other, perhaps totally unconnected fields, can you think of where this works equally well as a category heading.

In this case you might come up with something totally unconnected to sailing arising from 'healthy competition' (e.g. *sports coaching,* or *teaching kids about diet and exercise,* or *teaching fund-raising skills to charity staff,* or *selling ethical financial products*. Write down any ideas which appeal to you (making sure you don't try to exclude them at this stage by misguided thinking about what is 'practical'. You may discover fields or new interests here which could one day become part of your House of knowledge.

Step 7 Underline one of the fields or ideas generated in Box 6, and write it in *Box 7*. It's probably best to begin with one that has surprised you most (e.g. in this case you might have come up with *teaching fund-raising skills to charity staff*).

Write down what you feel to be the key skills and knowledge that you would need to work in this field. Begin by putting down what you already know, and add more by putting yourself mentally into the shoes of someone working in this area. The only way to build up an accurate picture is to find out more. Ask someone already working in this field, or do some desk research. Your list needs to be on a separate piece of paper, and might look something like Table 10.2.

If this step was productive and interesting, go back to Box 6 and do the same again with any other interesting fields.

Step 8 *Box 8* allows you to record any new areas of interest that the exercise might have brought up (e.g. *coaching*). Take a new copy of the *Field generator* and put this new interest in Box 1, and begin again.

A completed Field generator is shown as Figure 10.2.

TABLE 10.2 Teaching fund-raising skills to charity staff.

Fill out this list as far as you are able. Put a tick next to any skills or knowledge that appeal to you, and 2 or 3 ticks next to any that *really* appeal.

Knowledge	*Skills*
Direct marketing techniques	Managing telephone sales
Charity fund-raising methods ✓	Communicating ✓✓
Charity law	Motivating ✓✓✓
Proven successful methods ✓✓	Organizing materials
Reporting structures within not-for-profit organizations	Problem-solving ✓

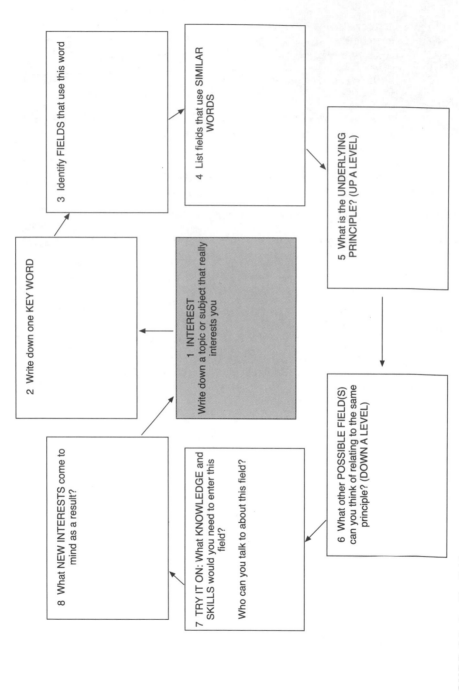

FIGURE 10.1 The Field generator.

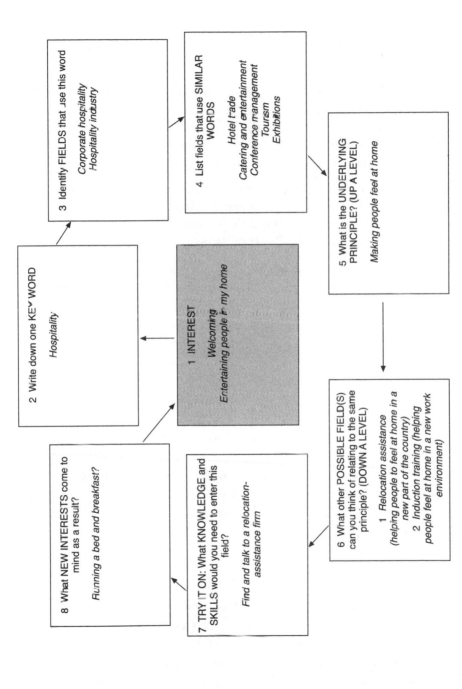

FIGURE 10.2 Completed Field generator.

EXERCISE 10.2 DISCONTINUOUS THINKING

☞ The brain is a wonderful organ. It starts working the moment you get up
in the morning and does not stop until you get to work.

ROBERT FROST

This process is great for times when you are completely stuck for ideas, and works well alongside the Field generator. Discontinuous thinking is about provoking your mind into making new connective pathways. It's the driving force behind Edward de Bono's concept of provocative thinking, and also one of the characteristics of Roger Van Oech's delightfully off-the-wall book *A Whack on the Side of the Head*.

There are few rules with this kind of exercise. One of the principles behind it is that you think about something else entirely, and then allow some kind of connection or comparison between your thought process and your main problem. Here are some ideas that might work particularly well with fields:

1 *Try a provocative statement which sounds deliberately illogical or nonsensical.* For example 'a field which is about persuading and influencing but avoids people'. This might take you into ways of translating your interpersonal skills into text-based or alternative context (e.g. writing to influence, finding great words for websites, writing other people's speeches, designing models for negotiation and conflict management that can be communicated by distance learning). Another one might be 'building houses that nobody will live in' – you might apply your construction skills to buildings used for housing animals or equipment; you might start building models rather than sketching things out in words; you might create 'virtual' libraries, supermarkets or conference centres on the Internet.

2 *Try turning your field upside down.* For example, you may be interested in child development because you're interested in the way young people grow. Turning that upside down might lead you to thinking about the way older people degenerate. This may be a field which interests you in itself, or it may help you to refocus on your chosen field (e.g. by looking at the effects of head injury in young people).

3 *Try some form of random prompting.* Edward de Bono and others promote inter-action with random words, objects or ideas. One method is to take a list of sixty random words as in Table 10.3. Look at the second hand on your watch and make the corresponding word (e.g. word 12 is 'splash'). The field you are looking at is veterinary science. How could you practise underwater in this field? Are there any openings for vets specializing in marine animals? What about fish farms, sea-life centres, marine-research units?

TABLE 10.3 Sixty random words.

1	BLUR	21	BOTTLENECK	41	FUTURE
2	ISLAND	22	INTANGIBLE	42	ECLIPSE
3	COMPASS	23	FENCE	43	ICON
4	FUNNEL	24	SIGNPOST	44	TOOLKIT
5	DIAMOND	25	TOYBOX	45	WHEEL
6	ROCKET	26	RADIATOR	46	CALCULATOR
7	SYMMETRY	27	HERO	47	LEVER
8	ADD-ON	28	MICRO	48	CUSTOMIZED
9	MAP	29	IMPROVISATION	49	FILTER
10	REAL-TIME	30	DESPERATE	50	VIEWPOINT
11	CHEAT	31	DETAIL	51	FLEXIBLE
12	SPLASH	32	BEND	52	CUSHION
13	TRANSMITTER	33	POLICEMAN	53	SCALPEL
14	ADJUSTABLE	34	WRENCH	54	GATEWAY
15	DOWNLOAD	35	GAP	55	LIGHT
16	SIMPLE	36	ELEGANCE	56	DARK
17	KEY	37	PAUSE	57	ARROW
18	RESISTANCE	38	ECHO	58	BOWL
19	SEASON	39	MANUAL	59	DISTANCE
20	DIG	40	WING	60	RESONATE

CREATIVE JOB SEARCH STRATEGIES

THIS CHAPTER HELPS YOU TO:

☞ Avoid the same old same old.

☞ Discover the hidden job market.

☞ Anticipate employer risk aversion.

☞ Research before you search.

☞ Build your personal web.

> ☞ An idea is nothing more nor less than a new combination of
> old evidence.
> JAMES WEBB YOUNG

AVOIDING THE SAME OLD SAME OLD

Sometimes the best way of discovering the best way of doing something is to turn the idea on its head. It's called a negative construct, and it's an essential tool in creative, ahead-of-the-pack thinking. Take a blank piece of paper, draw a line down the middle of the page, and write the question in Table 11.1 in the left-hand column:

TABLE 11.1 Guaranteed failure.

You have been offered £50,000 if, despite an apparently active job search, you *DO NOT GET A JOB*. What do you have to do to ensure that you fail to get a job?	

You can begin with complete blocks, like 'I wouldn't get out of bed in the morning' or 'I'd never speak to anyone and never write to anyone'. Fine. Write them down. Now think of some really creative ways of ensuring you get your hands on the £50K. Here's some I've been offered in workshops:

- I would only ever apply for jobs which specified particular qualifications I don't hold;
- I would always fail to fill in half the application form;
- I would use lots of glowing adjectives and give no supporting facts;
- I would present an overblown, self-congratulatory CV full of gaps and contradictions.

What's fun with a negative construct is that you can play all day at ingenious ways of wrecking your career. You will probably discover that you are able to think far more creatively about ways of ensuring failure than you do about achieving success (incidentally, another great negative construct is: if you were offered £100,000 to ensure that your business failed, what would you do?).

Once you've discovered a foolproof way of never getting any kind of job, you might add to the bottom of your list ten or so ways of ensuring that you never get a job which you find meaningful, rewarding or inspiring. Try it. One suggestion would be: '*always take the first job that comes along, no matter what*'. Unfortunately, this is a beloved strategy for some people.

Complete the negative construct in Table 11.1, and then write in the right-hand column the corresponding positive message. So if your prize-winning negative idea is '*I would never speak to anyone about my job search*', the positive message alongside it might be '*I will let everyone I know into the secret that I am developing my career, learning about new fields, and hungry for friendly contacts*'.

One of my strangest discoveries when I moved from training recruiters to assisting career-builders was that there really are some fairly well-kept secrets about the way people get jobs. If you've been waiting for the moment when you felt you got your money's worth, this may be it. Job-hunting myths and facts are outlined in Table 11.2.

☞ A man becomes creative, whether he is an artist or a scientist, when he finds a new unity in the variety of nature. He does so by finding a likeness between things which were not thought alike before ... The creative mind is a mind that looks for unexpected likenesses.

JACOB BRONOWSKI

THE HIDDEN JOB MARKET

The majority of jobs are not advertised. If you only ever respond to job advertisements, you'll never know about them. This is the hidden job market. I've heard it said that only 10 per cent of job hunters are really aware of this market.

You can look at the hidden job market in two ways – left or right brain.

First of all, food for the imagination. If you want to slow down your job search and limit your options (maybe somebody is paying you to fail?) then act on the

TABLE 11.2 Job hunting: myth or fact?

WHAT YOUR MOTHER/CAREERS TEACHER/BEST FRIENDS TOLD YOU	JOB MARKET REALITY
Jobs are filled by people applying for published vacancies.	About 20–30 per cent of jobs are filled this way (less in executive markets).
It's easier to get a job when you have one already.	True to a point – employers like to bet on certainties, not outsiders, so they want a recent track record. If you have 'problems' with your CV, you need to have a good narrative ready to cover gaps, reasons for change, 'unemployment' (is it really unemployment if you are extending your skills or learning?)
It's *who* you know, not *what* you know.	Making human connections will increase your chance of being seen. Employers buy experience and potential, so when they get to see you they will be far more impressed with what you can do than who you know, unless it's the kind of job where you're supposed to bring contacts and clients with you.
Qualifications count.	Employers often have a blinkered view of what qualifications they need. The key question is: What is the standard for the job or industry that you are interested in? If yours are a little light, don't over-highlight them on your CV, but stress the intellectual standards you have achieved through your work experience. If you have constantly turned your back on opportunities to extend your knowledge and training, you need to have a pretty good reason why.
You need good references.	Very few employers use reference checking to screen applicants before interview. Mostly references are a final check. Most job applicants worry too much about references. They should not be included on your CV unless requested.

Send as many CVs out as you can.	Do you know how many employment agencies push out CVs every day? How much time do you think a busy manager will give to a speculative CV where there is no obvious connection to the company's needs? 15 seconds? Speculative letters and CVs *do* work (far better with employers than with recruitment consultants) and give you access to the hidden job market, but only if they are extremely well targeted and followed-up by personal contact.
Sometimes you have to push yourself forward.	'Sometimes'? It's the idea of 'pushing' that puts people off, as if you are advertising something shoddy. Don't claim to be what you are not, but in everything you do, present the best version of yourself, and a clear message of what you can do for others. Try it as a way of life, not just job search.
Only pushy people get jobs through networking.	Not true. Networking works for everyone as long as they do it positively and honestly. See below for more on networking.
A job's a job. Think of the money. Good jobs are hard to find.	OK, red card. Go back to Chapter 3. Do not pass Go. Do not collect £200.

negative myths in Table 11.2 and limit your job search to advertised positions. You'll miss out on most newly created jobs, all unadvertised positions, and most jobs with small, energetic companies. You'll miss out on all those companies that are just on the edge of thinking about creating a new job. You'll never have a chance to be recommended by a friend or colleague.

Second, for all you people who need to see the numbers, Table 11.3 records the way people in the UK find jobs. This data is based on a UK survey of workers who had been with their employer for 3 months or less at the time of interview.

In local markets job advertising is more prevalent. Even so, the proportion of workers achieving a position by applying to an advertisement is low, particularly for men. In the USA, the success rate for replying to published vacancies is judged to be no higher than 25 per cent at best. If you only ever reply to advertising, you will spend far more energy than you need to get just one interview. What's more, you will dramatically reduce the odds of getting any job, and severely hamstring your chances of getting a job you'll love.

TABLE 11.3 How people find jobs.

Method	Men	Women
Reply to an advertisement	21%	30%
Hearing from someone who worked there	33%	28%
Direct application	16%	16%
Private employment agency	10%	10%
Jobcentre	8%	7%
Other (careers office, job club, some other method)	12%	9%

Labour Market Trends January 2000.

☞ Insanity is doing the same thing over and over and expecting
a different result.

EVA MAY BROWN

Using job boards and the Internet

Don't exclude any job-search method, because the most effective overall strategy is to use every tool in your toolbox.

The Internet can be a great source of information, but unless you have specific IT skills it's a limited tool for job-hunting. Online recruitment firm *workthing.com* claimed that 4 million people in the UK used the Internet to look for jobs in the first 6 months of 2000, but only 170,000 of those have actually found jobs. The report suggested that 41 per cent of net users have visited a recruitment website at some time, and the number of recruitment website users is likely to double in the next 5 years. Pilot sites in California can both assess a job seeker's talents and aspirations online, and will then refer the user to a range of local vacancies. Appendix 2 contains a list of websites useful for online job-hunting and career development.

EMPLOYER SAFETY HABITS

Anticipating employer risk aversion

Here's another tip that in itself probably justifies the cover price of this book: employers and job-seekers *use totally opposite strategies* to achieve the same result – filling a job. Table 11.4 illustrates how employers prefer to recruit, and why.

Table 11.5 shows the mirrored position for the job-seeker, outlining job-seeker assumptions and comparing them with the market reality.

MAKING GOOD USE OF RECRUITMENT CONSULTANTS

It's vital to remember that, although most recruitment consultants keep a bank of potentially suitable applicants, they are largely vacancy driven. That means that they are most interested in you, right now, if they have a vacancy that you might

TABLE 11.4 Employer risk aversion.

EMPLOYER'S PREFERENCE	RISK LEVEL TO THE EMPLOYER	EMPLOYER THINKING
Almost family Somebody we already know: an internal appointment is ideal, or someone already doing consultancy or temp work for us.	*Virtually risk free*	*We know exactly what we're getting*
Known quantity Maybe someone working for a competitor, someone whose reputation we know even if we haven't met the individual yet.	*Very low*	*A clear track record. This person has done well elsewhere and will do the same for us.*
A friend of a friend – in other words, someone who is known and trusted by someone we know and trust, or someone who comes highly recommended by a trusted colleague.	*Low*	*We have a pretty good idea of what we will be getting. Fred always recommends good people.*
Achiever Someone who may be known to us at a distance, and comes with clear evidence of past success – ideally in terms of a portfolio of work, a fistful of testimonials, excellent and highly specific projects with their names all over them.	*Relatively low*	*Again, clear evidence of past achievement. We can measure what we'll be getting for our money.*
Competence-based recruitment We've accurately assessed what a successful post holder must know and the skills required by the job, and we are going to test or interview to identify specific competences.	*Controlled*	*We're using a careful filter. We would still like to know what they are like in terms of personality and team fit.*

continued

Table 11.4 *cont.*

Unsolicited application This is much more than yet another CV sent out on a 'spray and pray' basis. A well-aimed direct application can sometimes prompt an employer to do something about a new job, or solving an old problem.	*Moderately high (but potentially low risk if it's the right person)*	*We are now talking to strangers, but sometimes it's nice to be surprised by the right people. We're more impressed by people who know something about us already, particularly if we have a problem right now. In fact, if we get to talk to this person and like what we see, we'll reclassify them as 'achievers' or even 'friends'.*
Attractive agency candidate OK, we'll talk to an employment agency or recruitment consultant at this point, because they know where to resource people who have done well in the past, and they can screen for us. They can sometimes contact people directly (i.e. headhunt).	*Risk increasing*	*Agencies aren't always good at finding out what a job actually requires. However, they are good at spotting high achievers, and assessing strengths and weaknesses in applicants.*
Response to specific advertising Who knows if we'll get the right people. *And* we run the risk of buying advertising space without being sure of a result.	*High*	*It's going to be tough to filter out the ones who know what they're doing. Who do we interview? – feels like a lottery . . .*
Response to general recruitment advertising Oh dear. Here we go – hundreds of hopefuls to be filtered out.	*Sky high*	*Nobody reads the skill or qualification requirements, nobody filters these people, and they're all desperate to get a job.*

fill. However, the positive thing about consultancies is that they have an extremely good feel for the market they are in, and where they deal with specialist fields, the information they can give you can be priceless.

Furthermore, a good recruitment consultant will have got to his or her position by knowing a lot of decision makers. A good strategy is to identify about six to ten recruitment consultants dealing with the kinds of jobs you are after, and send in a

TABLE 11.5 Job-seeker thinking.

ACTIVITY	JOB SEEKER'S THINKING	MARKET REALITY
Response to advertising Hours spent filling in application forms, drafting a letter of application, sprucing up the CV. A quiet prayer or a philosophical shrug as the envelope goes in the post, then the waiting begins. It's useful to remember that someone will be shortlisting, probably into three piles: *No, Possible,* and *Yes.* Have you done everything you can do to get on to *Yes* pile?	*My Big Chance* Great, a chance to show off my CV, list my skills. The more information I can give, the more they'll be impressed. Now all I have to do is put a stamp on the envelope and cross my fingers.	*Small chance* How many other applications hit the desk in the same post? How differentiated is your message? How do you convince the employer that you are worth talking to in person – particularly in comparison with internal or recommended candidates? You might improve the odds if you follow up your application with a tele-phone call. Many advisers say you should *always* ring to confirm your application has been seen.
Unsolicited application This is much more than yet another CV sent out on a 'spray and pray' basis. A well-aimed direct application can sometimes prompt an employer to do something about a new job, or solving an old problem.	*Keep shooting* And I'll hit something eventually. At least it gets me noticed.	*Long shot* If you're firing with a shotgun, but effective if you use a sniper rifle. Is the recipient going to be intrigued, pushed to action or irritated at yet another piece of junk mail? It depends on how well targeted your CV is, what the accompanying message says and whether you press the right buttons by knowing about the needs of the company. Far more effective if used in conjunction with personal contact.
Recruitment consultant or employment agency Do your homework – find out which consultants are	*Guiding hands* At last, my chances are in the hands of a recruitment	*Check your assumptions* Agencies make money by placing obvious skills into obvious jobs, not by

continued

Table 11.5 *cont.*

regularly placing staff in your sector.

professional, somebody who will help me develop my career and find me a job. They have all the unadvertised vacancies, don't they?

being career coaches. They receive far more speculative approaches than they can handle. However, an agency interview *can* help you get a feel for your market worth, and check your message to potential employers. Good agencies set up interviews using strong personal contact and recommend you, poor agencies simply distribute unsolicited CVs. See below for further tips on talking to recruitment consultants.

Achiever
In your job, what would be the equivalent of a 'portfolio of work'? How can you present tangible evidence of what you have achieved – brochures, articles, testimonials, records of projects ... ?

My chance to shine
This will really impress them. And it might – as long as what you have to offer matches what the employer needs. The achievement you demonstrate should be a close match to the employer's shopping list, otherwise your prized portfolio is irrelevant.

Collect evidence
It's all too easy to make claims about yourself, but you need to back them up with measurable facts. Your CV, and what you say to support your application, and your words at interview, are all *assertions* which you need to support by *evidence*. Keep good records of what you have done – copies of documents, client feedback, affidavits, good appraisals. The more objective the evidence, the lower the perceived risk for the employer.

Competence-based recruitment
If you are interviewed, be very clear what you have achieved and how you did it. Even if there is no formal testing, use evidence of achievement

A chance to demonstrate what I can do
– but daunting for many job-seekers who are unfamiliar with competence-based interviewing.

Focus
What you know, your skills and your achievements. Be prepared to come up with a range of achievement stories (use the Skill-clips technique in *Chapter 7*).

to demonstrate the same arguments.

Listen for the language that the selector is using so you know which competences are being sought.

Known quantity
I get interviewed because of the work I have done in the industry.

A way in
Keep your eyes and ears open for these opportunities, and make sure people are aware of the contribution you have made as a 'fringe' member of an organization.

How do you get to be a known quantity?
Simple. Shine. Get to be good at your job and let others know it. Keep a record of your achievements. Write articles or circulate good ideas. Talk with energy to customers, suppliers and sister organizations. Be a radiator, not a drain.[1]

A friend of a friend
What I need is someone who can put me on the inside track.

Who, me? I don't have friends like that
I don't know anybody connected/at the right level/in this field/of that age group, etc. Besides, I'd feel awkward approaching them, and they wouldn't really be able to help me ... (See this Chapter's section on *building a Personal Web*.)

Look around you
Yes, you. Who do you know (not necessarily in work) who admires what you do, and would be happy to recommend you to others? Have you enlisted help from these people as career coaches, dummy interviewers, idea factories?
Look around you at family, friends, associates, and find out which ones have pushed opportunities towards others like this. Life has its natural matchmakers and fixers, and they love to be known for their contacts and good judgement.

[1] My thanks to James Newcome for this one. In life there are two types of people. Drains, who absorb the energy around them, and radiators, who push energy out. It pays to spend time with radiators when you are looking for career-development energy. Radiators will say 'go for it'. Drains say 'That will never work'. Drains tell you to be 'realistic', which usually means doing next to nothing in the hope that something good will come along.

Almost family	*Old-school tie?*	*Becoming close means becoming wanted*
I'm happy approaching this kind of company. They feel comfortable talking to me because they already know what I am like.	This old-boy network stuff is unfair OR the internal candidate's got a head start. Anyway, how can I possibly get myself known that well to every company I apply to? Beware of the problems which can arise from informal conversations: the company may not be clear that you are looking for a post, or the conversations may continue endlessly without a clear decision.	This is *not* about old-boy networks – those often produce dreadful appointments. Your research into the *right* fields and companies will get you known as an enthusiast. Work experience, consultancy or simply keeping in touch sending in good ideas are all strategies that can move you into the target's bull's eye. If you're not comfortable getting close to these people, you probably don't want to work with them anyway.

respond well to you if you have something to add to their vault of knowledge. In addition, they may feel you can tell them something useful, or have your own contacts.

If you get a chance to have an informal interview with a recruitment consultant, try to get a feel for your market worth, and how you are currently projecting an image of yourself. My colleague John Eardley of Career Management Consultants suggests five key questions to ask a recruitment consultant or headhunter:

1 What's my CV like? Does it work?
2 What am I worth in the marketplace?
3 What are my unique selling points?
4 How transferable are my skills to other fields?
5 When did you last place someone like me?

BEGINNING A CREATIVE JOB SEARCH

☞ We are what we repeatedly do.

ARISTOTLE

What is a creative job search? It's a term you commonly come across, but is often vague. For me, a creative job search has the following key characteristics:

1 It draws in some way on all of the following methods:
 a. applications for recognized vacancies
 b. speculative approaches to companies in your chosen fields
 c. personal and professional networking, informational interviews
 d. intelligent use of recruitment consultants
 e. using the Internet for both research and job search
 f. encouraging an employer to create a new job where one does not already exist;
2 It combines methods effectively to increase their power;
3 You will consciously target the *hidden job market*.
4 You will anticipate *employer risk thinking*.
5 You will be choosing a different strategy to the majority of job-seekers.
6 As a self-marketing strategy it's clear on what it is selling, and who it's selling to. In other words, you will know who you are, what you are good at and where you want to be. You'll communicate this in a way which broadcasts confidence and a clear message of what you can do for your next employer.

ECONOMIC WEBS, AND PERSONAL WEBS

No, not an excursion into web pages, but an introduction to a vital process and resource bank: building a personal web of contacts.

Stan Davis and Christopher Meyer, authors of *Blur*, use the phrase *Node Thyself*, writing of the individual as a node in an economic web. A node is a point connected in a network to multiple other points. We used to think of businesses as those nodes, but the reality is that each individual is also a point of connectivity. Davis and Meyer talk of each individual having a 'stock price' – a value in the marketplace – which is enhanced not by job-hopping but by the way we grow our skills and our personal webs. We'll all learn to think less about who's in the workforce, and more about who's in our personal economic web.

I continue to be amazed that career changers, whether recent graduates or experienced executives, hate one activity: networking. Let's check some of their assumptions:

- It's pushy. It's not me.
- It's aggressive. It exploits people and loses you friends.
- It's unfair. The best person should get the job, not the pushiest.
- It makes me look desperate.
- It frightens me.

Not networking

We should all respect those fears and doubts. Anyone who suggests networking without addressing those issues is selling you a suit that doesn't fit, isn't your colour and you'll never wear after you take it home.

Networking is something we all do unconsciously. If you move to a new town and want to find a good dentist or know the best local greengrocer, you ask people, casually. If you have problems with your child at school, you ask other parents about their experience.

Networking has been done a huge disservice by people and organizations that exploit the way human networks operate for their own advantage. You know who they are: all those people who want to sell you things you don't really want. The worst kinds use family or professional connections to make you feel guilty enough to buy something.

Personal webs are connections of people. Real people, who care about each other's professional lives, and who enjoy sharing information. It's the soft version of idea brokering, but this time you provide what you know free of charge.

Being connected in the new economy

The twenty-first-century world operates around information, and the way it is communicated. In the words of business writer Kevin Kelly, author of *New Rules for the New Economy*, 'communication *is* the economy'. In both private and public sectors, what matters is the information you hold, and how you communicate it to others.

What's interesting here is that the first approach to the world of the Internet was to try to enforce copyright law, to protect intellectual capital. That worked for some organizations, or at least at first. The prevailing idea in e-commerce is to *give information and ideas away*. Think about it. It's a powerful model, turning most ideas about information on their head. Instead of trying to control duplication through patents and franchises, you stick your ideas on the Internet and give them away. The reason is that giving valuable material away captures human attention, which in turn leads to market share.

Many useful computer software packages are now given away free. How does anyone make any money on them? – Through the personal webs that are created as a result. Microsoft knew this well when it gave away its Internet Explorer web browser. Each additional user, each additional contact, creates an extra 'node' in the web.

How the numbers work

People misunderstand the new economy and the idea of networks because they think it's purely about numbers. It isn't. It's about connections. If four people are acquaintances, there are twelve possible one-to-one relationships among them. If you simply add one more person to the group, you get twenty relationships. Six people means thirty connections, and seven makes forty-two. As the personal web goes beyond ten, the number of possible interactions explodes.

Each point of interaction is an opportunity for change or growth. This principle explains how products are successful. Cellular phones are now given away virtually free, but money can be made from contracts, add-ons, fashion accessories ...

We're talking about the difference between mailing lists and interest groups. A mailing list may be 1,000 separate, unconnected people. An interest group 1,000 strong can overturn a country. Just look at the way a handful of farmers and truck drivers brought the UK to a standstill in the autumn of 2000.

Making career connections

How can we tap the power of the network economy to assist our career development and job search?

First, it's vital to recognize that networking is *not* about getting a job. It's about expanding your range. It's about creating new possibilities. It's about learning more about other jobs, other fields. It's about identifying key people and decision makers.

'Hard sell' networking never misses a chance to convert a contact to a sale. That's an unsophisticated approach that doesn't fly in the new economy. That approach to using people is as different to building a personal web as cold-call telephone sales differs from being part of an investment club. In a genuine personal web, people are interested in the relationships and in new information, new ideas. They are interested in what new members bring.

Most important of all, *it's not just about you.* The careers writer Bernard Haldane described this process as a 'chain of helpfulness'. It begins not with the question 'who do I know that I can exploit?, but 'who do I know that can tell me something interesting?' It may even begin 'who do I know that I can help?' The best personal webs are friendship groups; they are a pool of knowledge rather like the Internet. Everyone puts something in, everyone has a chance to take different things out. Everyone has different needs at different times of their lives. It's often most useful to begin: 'What do I know that would be helpful to others?' It can be something quite ordinary or modest, like useful web pages, book recommendations, telling people about cheap travel deals or free resources. A chain of helpfulness begins with what you are prepared to give, not what you want to take.

Degrees of separation

You may have come across the theory of *six degrees of separation* (coined, or at least popularized, by the American playwright John Guare). The idea is that anyone can reach anyone else in the world in six jumps. Person A leads you to B, and eventually to your 'target'. You begin by talking to someone who is connected, no matter how tangentially, with the person you're after. Often it's quicker than that. I once saw this explained to a room of MBA students by Margaret Stead of Career Design International. She asked for a random example – Nelson Mandela. 'What would be the first step if you wanted to speak to Mr Mandela?' A hand shot up near the back: 'Ah ... my uncle knows him'. You never know who people know. Unless you ask.

Networking books will tell you about 'working the room' and giving your business card to as many people as you can. That's another huge misunderstanding. Anyone who thinks that networking is about exploiting people has misunderstood the idea of relationships and friendship. Very few people really seek friendships to exploit others, and if they do, those friendships are fairly short lived. Despite the tough talk of business, the vast majority of people put friendship groups ahead of business contacts.

Try finding out what you have in common with the people you talk to, and ask what you can add: What contacts, information, ideas do you have? If others can help you, ask for their assistance honestly.

The question that comes to mind to the person on the receiving end of a networking phone call is 'what does he/she want?', quickly followed by 'what am I being asked to do?' In my experience only a small minority of people will respond to an invitation to 'network'. What busy people *do* respond to is:

1 An opportunity to help someone by being an 'expert';
2 An opportunity to learn something quickly;
3 An opportunity to talk about themselves.

One tip: once you get someone to talk to you, *never* leave them feeling that they have been no use to you at all.

Informational interviews

There are many versions of this idea in print; I believe the original appeared in *What Color Is Your Parachute*. The idea is also systematized by Swiss careers expert Daniel Porot (see *The PIE Method for Career Success*). The principle is straightforward: find someone who knows about a field or occupation in detail, and ask to see them for a short interview during which you ask a series of key questions about entry to the field, rewards and pitfalls, and – most importantly – the names of *three* other people who can give you further assistance. Those three contacts then blossom into nine further contacts, and so on.

The key issue with informational interviews is that you are only seeking information. You are targeting people who love to talk about what they know, and who they know. You are adding to your personal database of knowledge and learning a huge amount about the way different jobs 'feel' from the inside. What you never do is to ask for a job, or let the meeting switch into a job interview.

Managing your personal web

It's possible to build up a personal web of between sixty and a hundred useful, curious and interesting people within about 3 months. Some principles that will help:

1 Learn how to conduct informational interviews (see above).
2 Build slowly, and methodically. Put time aside each week.
3 Keep good records. Use an electronic diary and address book to keep the details. Record the 'hooks' (i.e. factors that you have in common). Record

the name of your contact's husband or children. Most important of all, use a system that remembers the connections for you. Beyond forty or so connections your memory will fail. When you're thinking 'who was that designer Bill mentioned?' A program like Microsoft's Outlook allows you to record links: look up 'Bill Smith' and you will see the names of all Bill's connections.

4 Ask yourself all the time: What can I add to this network? How can I be helpful? Be remembered as a source of information, a person who brings others together.

BECOMING A WEB BUILDER

> ☞ People will go to their graves with their music still in them.
>
> BENJAMIN DISRAELI

Because we're using lateral thinking to kick-start this process, let's take a business model and apply it to our lives as individuals. Having looked earlier in this book at what you know and can do, let's give that package a web-building spin and put the same sort of questions we would if you were a product or service.

How can you attach yourself to an existing web?

Remember, one extra member means a huge number of new connections. Tapping into an existing group works, but only if it's clear what you bring to the party. If nothing else, be honest: tell people you're hungry to learn.

How can you begin a personal web?

Can you, for example, begin an information exchange, a club or a directory? Maybe you can act as a facilitator?

How can you become an information broker?

The world is too full of information. Anyone can find anything, but they haven't the time. We need digests of information in easily readable form. We need experts. We need people who may not have the answers, but will certainly know someone who does.

What can you give away?

Look at business ideas and see how they can apply to you, e.g. 'freebies', 'buy one get one free', 'free membership'. Every month, to keep up with my personal webs I send a copy of an article I have written to anyone who won't have seen it but might find it helpful. I pass on great web sites. I recommend membership of organizations that I have found helpful. Most of all, I like to bring friends or contacts together and see what sparks are generated. Other ideas: run a seminar.

Get interviewed on your local radio. Produce a free handbook for others in your situation.

Focus on the points of connection

Every person you meet, in your personal life or work life, is part of your personal web. Remember, this doesn't mean trashing any possibility of friendship for the sake of a quick sale or a job offer. It means displaying a genuine interest in the gifts others have to offer, their enthusiasm, the skills they love using and their problems. Make connections, but get used to making them as productive as you can be – find out what people are looking for, and see if you can be an information broker. Don't be afraid to ask for the names of others who might be able to help.

Invest in the product

The product is you. So add to your brand value: keep on learning. Never suppress your own curiosity. The more you know about, the more connections you make.

Look for short cuts

Take people to lunch. Cultivate experts in the right fields: the people who know what's going on, where and who's doing it. These people are at the heart of huge, productive webs, and can put you right at the centre, straight off.

EXERCISE 11.1　BEGIN YOUR PERSONAL WEB

First of all, decide what record-keeping system you are going to use so that you can build up a personal web methodically. You'll need to retain telephone and fax numbers as well as addresses, both real and email. You'll also need to be able to cross-link records, and keep a note of the areas you discuss, and a diary reminder of any action or follow-up you have agreed.

Can't think of anyone? Begin not with names but with categories. Draw a 2-inch circle on a piece of paper. This represents family and close friends. Who else do you know really well? Draw a larger circle around it: put in the names of any clubs or organizations you belong to. Think of courses you have attended. Who are your suppliers of professional services – how can they help? Next draw an even larger circle to take in business contacts, past or present staff, customers, advisers, anyone who has ever helped you or you have helped. Then ask yourself – who do they know?

Try using Mindmapping (see Chapter 7) to extend this basic list. Next use Figure 11.1, which draws on the Lotus Blossom Technique we looked at in Chapter 8. Put a name or a category in the centre of your first petal, and try to think of eight new names or categories.

Lee – legal services	Alice – computer sales	Jim – web-page designer
Davids wife Sue – local newspaper contacts	**David –** **ex IT manager**	Nigel – management consultant
Mike – new IT manager	Gill – David's mentor	Jo – training consultant (first introduced me to David)

FIGURE 11.1 Expanding your personal web.

EXERCISE 11.2 NEW-ECONOMY PARALLELS

We're going to take a checklist for any business wishing to grow in the new economy, and apply the thought process to making your personal web more effective. Table 11.6 invites you to seek analogies between the new economy and yourself. Column 1 offers a business principle. Column 2 presents one possible parallel. Write your own in Column 3.

TABLE 11.6 New economy parallels.

NEW-ECONOMY BUSINESS PRINCIPLE	PARALLELS FOR INDIVIDUALS	PARALLELS FOR ME – WHY DON'T I TRY ...
Upgrade or die	A learning plan for every year.	
Focus on the intangible	Relationships matter more than facts or pieces of paper. How well do I really know the people in my web?	
Set the new standard	What can I offer that will set standards or benchmarks for others?	
Think 24/7 – offer your service round the clock	Stop thinking in 'work' and 'life' compartments: make	

	connections that cross borders.
Think smart solutions	'Smart' implies that your product or service contains intelligence about the way it's used. Find out how others react to what you have to offer.
Virtual location	How can I keep in touch regularly with all my contacts without travelling every day? What about an e-group (a system for automatically distributing messages among a particular interest group) or bulletin board (an on-line 'discussion group')?
Adapt, adapt	Work's changing fast. Any planning I do has to readjust its sights quickly.
Anywhere, any time	How portable or transferable is what you have to offer? Can you work at a distance? Can you give people on-line assistance?
Customize	What can you offer each individual in your personal web? How do you customize what you offer a potential employer?
Seek novelty for ever	Sounds unbearable. But maybe it's a good reminder that people like to know what's new . . .
Connect everything with everything	How can I generate great conversations between others in my web?
Break the rules	Why can't I run my own breakfast seminar or print my own newsletter or run an interest group as an individual?

"MUST DO" LIST:

☞ Base your job search on reality, not urban myths.

☞ Focus on the hidden job market.

☞ Take account of employer risk aversion in your job search strategy.

☞ Use every job-seeking strategy in the box. Combining them improves their effectiveness and shortens your job search.

☞ Absorb the lessons of the new economy. Keep on rethinking *You Plc*.

INTERVIEWS AND HOW TO SURVIVE THEM

WHAT THIS BOOK DOESN'T TELL YOU

There are thousands of books on the market telling you how to improve your interview technique. If you feel you need advice on dress code, body language or interview behaviour, just take a train journey, find a bookstall and browse through the careers section.

What this chapter does is to encourage you to take a creative approach; it doesn't ask how but *why*? Why would anyone interview you? Why would they offer you a job as a result? It also looks at the main underlying problems which lead to interview difficulties: interviewee fear and misunderstanding.

GETTING TO INTERVIEW STAGE

A senior colleague once told me that getting to the interview stage at all is a matter of luck. He was right up to a point. As this chapter will show, there are a number of tools you can use to increase your chances of being seen. Too many of us assume that our personality, our skills, our shining wit, are all communicated beautifully on paper, and all that an employer needs to do is to see us to reveal to them that it's all true ...

Nothing could be further from the truth. How you appear on paper, and the way a recruiter interprets that information, can often lead to a very different picture. What's more, the problem of getting an interview, and then of performing well once you have got to that stage, responds well to a creative mind. Why bother? Because so many job-seekers approach the whole process passively – waiting to see what the interviewer pulls out of the hat.

Getting shortlisted

What evidence or behaviour gets you an interview?

To answer that, you have to begin to see life through the eyes of a recruiter. This chapter focuses on the main things a recruiter is worried about (this applies as much to in-house recruiters and managers as it does to external recruitment consultants).

Interview preparation

There are hundreds of books around on the subject of preparation. In general they find a long way of telling you the essential truths set out in Table 12.1.

Preparation

What is preparation all about? An odd question, but an important one because so many of us are passive when it comes to interviews: 'I'll just turn up and see what they ask me.' You wouldn't approach your bank for a loan or go into a business presentation in such a passive mode. You'd prepare materials, evidence, statements, anticipate questions. Your career matters even more.

READING THE CLUES

When you are putting yourself forward for any kind of job, even a job that doesn't exist yet, you need to be a detective. You need to read the clues. It's sad how many people go into an interview well prepared to discuss their own virtues, but with very little idea how they will suit the job. Many plan to use the interview to find out more about the job. Don't wait that long. The clues are already there for you in:

- The job advertisement;
- Company brochures;
- Your individualized research;
- The job description;
- The person specification.

(If you don't know the difference between the last two, it's this. The job description describes the post in terms of tasks and responsibilities – rather like an empty desk, with work moving on and off. The person specification looks at the qualities of the human being that will fulfil that job – usually in terms of skills, characteristics, experience, availability.)

What kind of clues? Clues fall into a number of categories. You might think about the overall *purpose* of the role and Key Result Areas (KRAs).

Experience

The old adage among recruiters is that *employers buy experience*. What clues does the advertisement or job profile give about past experience that an employer would like to see repeated?

TABLE 12.1 Interviews – the essential truths.

Preparation	There is no such thing as enough preparation. Do what you can, but try to do at least ten times more than you think is enough.
Dress code	If you dress like a banker, you may be employed as a banker and paid a banker's salary. If you dress like a new-age traveller ... Read the signals, and try to look like you're already on the payroll; it's one time in life when conformity really matters. Dump your coat with the receptionist, maybe even your brief case – it helps to reinforce the feeling that you already work there.
Behaviour	Behaviour, like dress, sends a huge message. If you wanted to wear a sandwich board into the interview, would it say 'Employ me, I'll fit in', or 'Born to be wild. Please subsidize'? Here again, remember that selectors love to minimize risk.
Decision makers	There's little point strutting your stuff in front of someone who has no influence over the appointment decision.
Openings and closings	... should be clear and positive. Think about what you're going to say. Research suggests that interviewers are most influenced by what you say at the very beginning and very end of the interview.
Tough questions	You can learn some pretty good answers from books, but the best answers will be: (a) to the toughest questions you could ever ask yourself; or (b) to the questions that really matter as far as the job is concerned. (See *Tricky Interview Questions* below.)
Prejudice	... which simply means 'pre-judging'. We all do it. If your interviewer is unreasonably prejudiced against you for some reason that has nothing to do with the job (age, skin colour, politics) – do you really want to work there anyway?
CV	If your CV lets you down at interview, that's because you haven't really thought about what it's saying. It should, essentially, suggest that you are the answer to an employer's prayers. If you're using interview time to recover from CV failure, you really have set yourself an uphill battle.
Qualifications	There are probably well over 50,000 different courses and qualifications in the UK. How do employers tell one from another? On the whole, they can't. The employer who wants a 'relevant degree' may just have the kind of ego that is flattered by being surrounded by fawning graduates. Focus on the needs of the job itself in terms of experience and know-how.

TABLE 12.2 Asking questions about key-result areas in a job.

1 What is the purpose of the job?
 Why is the job there at all?

2 How big is the job?
 Is this a big job; does it matter?

3 How does the job fit into the organization?
 How will my work depend on/affect others?

4 Who does the job report to?
 Who takes the flak? Who is my direct boss? What is his/her boss like?

5 What specific skills or knowledge are required?
 Will I be out of my depth? What will I need to learn quickly?

6 What are the main problems to be solved, and how variable (or consistent) are they?
 What can go wrong? What skills will I need to fix problems? How did previous post holders survive?

7 What or who controls the job holder's freedom to act or make decisions?
 Do I need permission for every action I take? Do I need to be a self-starter?

8 What end results does the job exist to achieve? How is performance measured?
 What are the key results? How will they be measured?

9 What kind of people have done well/badly in this job in the past?
 Who thrives, who survives, who sinks?

And now a probing question which you can put to the decision maker: (or something like it – the words have to be yours . . .)
In 6 months' time you might be sitting in your garden or on a train, thinking about this appointment. How will you know if you have been successful? What will have happened or changed?

Key-result areas

Why does the job exist at all? It costs an employer a great deal of money to put somebody behind a desk or out on the road. To justify this cost an employer must have an identifiable *need*, and there must be a problem to be fixed. Look at the sample KRA list in Table 12.2 for more thinking on this one.

The big problem

The key-result list in Table 12.2 is essentially a breakdown of the single unasked question in any conversation between employer and candidate: What problem is this job going to fix?

Problems and opportunities

Where is the company going? Is it in a shrinking market and fighting its corner, or in a growth market and exploiting new opportunities? Look around for background information, using business-related search engines. Recruiters love to talk about their company's successes, and you can prompt this by knowing something about new products or services or brands in development, takeover plans, geographical growth.

Company culture

Every organization has its own personality. Some companies are naturally conservative and cautious, others dynamic. Some companies expect their employees to work long hours, others judge people by results. Many twenty-first-century companies expect their employees to be up to date with this week's trends or technological advances. You will learn a lot about company culture from websites and press articles, but even more by finding someone who can tell you the inside story. Rack your brain: who do I know who knows somebody who works for Bloggs Industries (more on networking in Chapter 11). Given up? Think harder. Try 'knows somebody who knows somebody who knows somebody . . .'

Skills

What will the job actually require you to do? Employers are actually not very good at measuring skills, even if they can identify them. Even relatively sophisticated competence-based interviews are essentially saying 'You say you have the skill of ————— . Tell me when you used this skill successfully.' As above, it's all about working out the skills that will make a real difference to the job, matching those to the skills that you know you exercise with ease and enthusiasm, and then preparing a list of evidence.

The £10-note concept

No, this isn't advice on bribery and corruption, but a way of getting you to read the clues. Think of the job as a £10-note torn in half:

Look at those ragged edges where the bank note has been torn. That's what the job should look like to you: a series of connections. Each of those connections is a key clue to the way a post holder might be successful. Each point in the tear is a piece of information about a key result area.

Now think of yourself as the other half of that bank note. That's the mental image you should have in mind, so you can communicate this to the employer. Everything you do in the interview should be saying, for example 'I understand that you need problem-solving skills. I'm good at coming up with solutions to problems under pressure. This is when I did it'.

Minimum qualifications

Employers are often specific about the qualifications they *think* they need for the job. How far are these requirements justified by the job itself? How many are there just to filter out candidates, or to massage a manager's ego? If you lack the named qualifications, try to get across the idea that your profile is a solution to the problem to be fixed. Second, demonstrate how your experience compensates, and is maybe even more up to date or relevant than paper qualifications. As with any apparent hurdle: address the problem directly, don't avoid it. Recruiters all too often have a simple shopping list of requirements and will happily exclude you if you don't match their pre-set criteria, with one exception: *a strong argument showing how you can meet the requirement by an alternative route.*

Think creatively to tackle this problem. Remember that employers often don't get anything like the response they would like, and generally have to make compromises somewhere. Your message is essentially (but not in these words!): *I've worked out exactly what you need. Me. I'm just changing the language.*

> ☞ At Interview, be yourself, but the best half of yourself.
>
> JOHN COURTIS

Achievement

Employers want to win. Companies are geared to a continuous process of success. So naturally they want to hire winners. People who have achieved something. The secondary message of a job advertisement (the primary message is the *problem*) is the kind of achievement an employer wants to see in candidates. Recruiting organizations are happy to talk about potential – the ability to achieve something in the future – but the primary question about achievement is this: *'Where's the evidence of past achievement? We want someone who has achieved great things in the past and can do the same again for us.'*

Risk

Employers not only want to win, but as you identified in Chapter 11, they want to avoid risks when they recruit. Just think about what's going through the mind of the decision maker:

- What if I choose the wrong person and miss the best candidate?

- What if I offer too much money?
- What if I fail to spot potential problems?
- What if I appoint someone who wrecks the team/brand/company?
- Will I make myself look foolish?
- Am I doing the safe thing?
- Will I be sorry?

The world of work is full of people who want to play it safe. Remember the safe manager's motto: *nobody ever got fired for buying IBM.* In recruiters you can hear a parallel message: *Nobody ever got fired for appointing the safe candidate.*

What does a recruiter mean by *safe*? Think back to Employer Risk Aversion (Table 11.4) and then think about *Key Result Areas.*

Interpreting interview language

Actually, it's not so much a question of interpreting, but listening for verbal clues. The snippets of information the interviewer gives you about the job, the questions that are asked – all these things give you huge clues about the job, but also about the *language to use in the interview.* If the questions are all about targets and performance, your language can shift to take the same emphasis. You can do the same thing with questions about people, ideas, planning – feed the interviewer with the key words he expects to hear.

You might feel that the interview is like a public examination, so let's stay with that analogy a moment. Imagine that the interviewer has a score card in front of her that contains key headings, as in Table 12.3. Listen out for this checklist approach, and make sure you are providing enough evidence, and appropriate evidence, to get a tick in each box.

Be aware of the structure of an interview. Some interviewers want to jump straight in with a question of the 'Tell me about yourself' variety (technically, a high-order, open question). Others will have a game of two halves in mind – a first half where they go through a checklist of the things they want to know, and a second half where they probe things more deeply and get a chance to discover some background. If you sense a 'checklist' approach, don't go into too much

TABLE 12.3 Interviewer checklist.

Experience, know-how	✓
Management skills – evidence?	?
Experience of computerized purchasing systems	✓
Can work under pressure	✓✓
Responsiveness to IT	??
Self-starter	
Right attitude	✓
Good influencer	✓✓✓
Team building	???

detail with each question, since it irritates the interviewer. You can always give a brief answer and then offer more detail if it's helpful.

Time frame

Listen for a change of tense. Most interviews begin by looking at your past. Indeed, some careers counsellors say that's exactly the problem with a CV – it's a historical document. If that's all it is, then it's an *obituary*. It only talks about your past. If you address the needs of the job, the discussion will inevitably shift from past, to present, to future. Try to stay firmly in future mode, encouraging the employer to see you in the job. If it's possible, brainstorm ideas and possibilities for the company – it weaves you into the fabric of the company's future.

INTERVIEW PREPARATION

Avoiding interview stress

You can't. Stress is a necessary part of the process. The important thing is to use the energy that comes out of a stressful situation to your advantage, allowing it to make you more responsive, more creative. Make sure that panic doesn't lead you into a little safety corner called 'I can't do any more', which is another way of failing to anticipate and plan.

The word anxiety, I'm told, has its roots in 'narrowness'. When you're anxious, you put yourself in a narrow, confined space. You refuse to see openings and ways out. Narrowness is for bigots, people who want to withdraw from the bright light of creation into their shells. Stress is often the mind finding it hard to cope with possible outcomes. Look at your anxiety sideways, upside-down, whatever it takes to find something in it, paradoxically, that you enjoy (it may be excitement or uncertainty). That way you become far more open to possibilities, and to letting the process look after itself. In hindsight, most of the stuff you worry about in relation to jobs matters very little in the long run.

Use the interview itself as part of your learning process. Think about what you are learning from the process, about yourself and the company.

The solo interview

You've heard of the Zen idea of one hand clapping? Let me introduce to you the concept of interviewer-free interviewing.

Find time, on your own, to reflect on the interview. Think of it as a time-management exercise: a short window of opportunity for you to impress. Look at the requirements of the job, known or guessed. Now have a conversation with the best part of yourself, not the negative voice that's whispering 'You can't *do* this!', but your best half, the one that's prepared to have a go. The solo interview both anticipates questions and places the job within a much larger pattern. You'll know what the big questions are, but here are some prompts:

- What in my past makes me a good choice?
- How would this job be a great opportunity to use my skills/experience/gifts?
- How would this job be a good stepping stone?

- How does it fit into my life plan?
- Who will I help if I do this job?
- How does this job/company fit my personal and work values?
- Who will I help if I do this job?
- Since employers buy experience, which parts of my past are going to be in the window display?
- Which of my past achievements are most relevant here?
- Why do I want this job?
- What problems will I solve in the job?
- There is only one of me. I am a one-off. Which special combination of gifts am I going to bring to bear here that no one else can offer?
- What will it *feel* like to do this job? In the first week? The first month? After a year?
- How will I know if I am successful?
- Which parts of the job will be really me?
- Will this job make me happier than I am now? How would others tell?
- What will I learn about myself in this coming interview?
- What will I learn about this job?

What if . . .

'What if . . .' questions are helpful if they assist you in visualizing yourself in the driving seat, actually doing the job. They trip you up when they begin to suggest negatives: 'What if I get the job and I can't handle it . . .' Things can and will go wrong, but for all kinds of reasons, so you don't need to take responsibility for every aspect of the future. A little trust helps – in our own potential, in what life has to offer.

In the last few minutes before an interview, breathe deeply and just be. Too late to think up any more smart answers. Go back to the solo interview, and think about the questions and the answers that really mattered. Picture a fully-grown tree, a whole person, or a business plan – whatever image of direction and completeness works for you.

The prospect of hanging, said the writer Samuel Johnson, concentrates the mind wonderfully. Interviews can do the same. You can easily generate a particular mindset that shapes the whole experience, as Figure 12.1.

Who makes the picture light or dark? Well, aggressive interviewers don't help, but think again. If you watch a recruitment interview and then ask participants to say how it went, you'll find that you, the interviewee, are usually a poor judge of how you performed. In an interview you suffer from information overload – there's just too much going on.

In fact the person who makes the picture dark or light is almost entirely *you*. You can look at the same questions, the same reactions, in terms of light or shadow. Is the bottle half full or half empty?

How do you make the picture light? By remembering that there is no such thing as a bad interview. You can respond to everything that happens to you by thinking 'what have I learned?' or 'that was interesting . . .' or, if all else fails 'It's all experimental'. Try thinking of yourself as someone else – maybe

LIGHT PICTURE				
WARM WELCOME	FRIENDLY DISCUSSION	AGREEMENT	POSITIVE FEEDBACK	JOB OFFER OR AFFIRMATION AND STRONG LEADS
↕	↕	↕	↕	↕
COLD RECEPTION	HOSTILE QUESTIONS	CONFLICT AND MISUNDERSTANDING	PERSONAL CRITICISM	REJECTION
DARK PICTURE				

FIGURE 12.1 Alternative ways of seeing the interview process.

someone you admire or a film character. Remember all the good things people have said about you. Do whatever it takes to ensure that you bring the *best part of you* into the interview room.

What on earth are they going to ask?

If you are preparing for a TV quiz programme, you learn the answers to thousands of questions. The winner is not the one who knows the most, but the one with the most efficient memory. It's a capacity that most of us don't have, so there's little virtue in trying to memorize hundreds of brilliant answers to questions that might come up in interview.

TRICKY INTERVIEW QUESTIONS

There are books around listing answers to killer questions. Some of them are pretty good, but none of them tell you *What questions really matter for you, today, getting this job.*

The answer is around you, in the materials available to you: What is the job all about, and what is there about you that will make a difference?

Questions that might throw you can come from a number of areas (see the *Checklists* in Chapter 15 for more details).

History

The interviewer wants to know how your past, present and future fit together. This results in questions like 'Why do you want this job' and 'Where do you see yourself in 5 years' time.' This is a question that you should ask yourself until you get an answer; if the answer doesn't ring true for you, it won't for anyone else. Talk about career plans, and what you want to learn and achieve in the future.

Personality

It's often a bad experience in the past that prompts an interviewer to ask about personality, or sometimes a genuine concern about team fit. Avoid using technical terms that may not be shared by the interviewer, such as your Myers-Briggs type. It's useful to describe the way you interact with others and bring out the best in them, in other words describing yourself as others will see you, rather than making claims about your nature that always sound overblown. Rather than say 'I'm an ideas person', run a Mini-Screenplay recounting a time when you changed things by running with a good idea.

Stability

How will you cope in a crisis or under pressure? It's difficult for an interviewer to gauge this at interview. Some will try to put you under stress during the interview. Better interviewers will ask you about times in the past when you overcame challenges while working to strict deadlines, or times when everything went wrong and you found some way of coping.

Motivation

In this respect, you're a puzzle. Why do you want this job at all? Why did you leave your last job, and the one before that? What makes you want to get out of bed in the morning? Think *detective* again: the interviewer is trying to translate your CV into a living, breathing person with reasons for doing things. Draw a map of your career, past and future, and be willing to communicate that to an employer. Don't be ashamed of sideways moves or strange career hops – they demonstrate flexible thinking and a proactive approach to life.

'What would you do if ...'

Look back again at interview anxieties, and think of ways of calming them. But 'what would you do if ···' questions are also about creating a joint picture of the future – so welcome them. Describe what you would do within the organization as if you are there already. Create the right picture, and the employer won't be able to imagine a future without you ...

Why did you leave... ?

The well-prepared interviewee has thought about these difficult questions.

TABLE 12.4 The six-point structure at the heart of all interview questions.

1 *What brought you to us?* Why did you apply? What do you hope to get out of this interview?

2 *What do you have to offer?* What do you bring to the party? What solutions do you have to offer which match our problems?

3 *How well do you understand us?* Have you worked out how we tick as an organization? Have you worked out our need, our big problem, or the key result areas of the job?

4 *Who are you?* What kind of person are you? Are you like us? Will you fit in? What will you add to a team?

5 *Why you?* – rather than someone else with the same general profile? What puts you ahead of the pack? What's your unique selling point?

6 *What will it take to bring you on board?* What will you cost us? How do we have to motivate and develop you to get you to stay with us after we have trained you?

Employers will probe for reasons for job change. If you are currently out of work, they will probe this, too. Rehearse short, simple, positive 'stories' to cover these points. This is not the same as a glib or untrue response, just a simple summary that leaves the interviewer no negative rough edges to rub against. Interviewers are like you and me – they are very good at latching on to negative information and ignoring the positive stuff.

Question patterns

The above list of difficult-question areas attempts to cover the 'hot buttons' of most interview situations. The best strategy is not to predict individual questions, but patterns. Recruiters are likely to ask questions which fall into a general structure (see Table 12.4).

SPOTTING BUYING SIGNALS

We all demonstrate buying signals, and some people are trained to spot them. If a market trader is trying to sell you something, he watches your buying signals carefully: you might try something on, explain its virtues to a friend or maybe even check how much cash is in your wallet. A less obvious buying signal is that you ask questions about the product: Is there a guarantee? How long will the battery last? Interest is a powerful buying signal.

The first, but perhaps least obvious, buying signal in an interview is when the interviewer starts to talk about the present, and then the future. Stay with that, encourage it. The stronger the image in the interviewer's mind of you sitting in a real office at a real desk, the greater the chance it will become reality.

Other buying signals? An obvious one is when the interview turns to point 6 in Table 12.4 – how much will you cost? No one discusses terms unless they are interested. This is *not* the time to say how little you would settle for. Bring the

discussion back to key result areas, to the value you can add to the organization. Ask the employer what he had in mind when he decided to advertise the vacancy or start seeing people. Only as a last resort should you mention what you are actually looking for, because you're in danger of setting far too low a limit. If you absolutely have to mention a figure, base it on hard knowledge of what others in similar positions are earning, or aspire to, and then add a bit. Remember that employers are buyers, and buyers always feel happier if they can knock you down from your initial figure.

Never, ever, fall into the trap of answering the question 'How much do you need?' Few people outside religious communities are paid a salary based on need. You should aim to be paid what you are worth to an employing organization, in relation to the value you add, the professionalism you deliver and the size of the problems you can solve. The final factor is what the market will bear, but at this stage of the process – at this stage only – you have the upper hand. They want you. They are falling in love with you. And just for a fleeting moment you have some leverage. (For more strategies look no further than the excellent *Great Answers to Tough Interview Questions* by Martin John Yate.)

Why will they decide to appoint me?

Look at the job, and ask yourself 'who decides, and why?' Remember what psychologists tell us about buying decisions: there are five critical factors which affect the way people buy. Here they are planted in the mind of the recruiter:

- LOOKING GOOD *Will this person be an asset? Will she make our clients love us more?*
- FEELING GOOD *Will this person's work remind me every day that I made the right decision?*
- BEING RIGHT *If I appoint this person, will my colleagues respect my judgement even more than they do now?*
- FEELING SAFE *Uh-oh. Is this going to go wrong? What qualities do I know I MUST have in order to make this appointment successful?*
- AVOIDING PAIN *What will my boss/colleagues say if I appoint and it's a disaster? What if I choose the wrong person? What if I miss the right person and we have to spend a fortune re-advertising?*

It's also important to remember that most recruiters take a 'good enough' approach to recruitment. They know they won't get the ideal candidate. A good definition of recruitment is *the right person at the right time at the right price*. It's a bit like parenthood – you don't have to be perfect, and trying to be so puts a strain on everyone; being a 'good enough' parent will get you very reasonable results.

QUESTIONS YOU SHOULD ASK

Questions will arise from the interview, but prepare three or four good ones in advance. Good ones come in two types: questions that show that you have thought carefully about the key result areas of the job; questions that help the

interviewer picture you in the post. Avoid asking questions about selection criteria – they so often sound as if you are asking for special treatment or believe that the interviewer doesn't know what he's doing.

Remember this: *there's no such thing as a bad interview*. You can learn from any interview. Even if it's clearly not going to lead to a job offer, you can learn a huge amount about yourself, about human behaviour in general, and it provides a tremendous opportunity to gain information about your perceived market value, and also a huge amount of data about potential fields of work.

Ask, and you might just receive

Interviewers are trained to keep control throughout an interview. That's fine. Let them – it keeps them happy. However, you have just a little leeway at the end of the interview in terms of what happens next. Always agree some positive action, and take the initiative if the recruiter doesn't by suggesting a follow-up call or appointment.

Most importantly of all: ask. If you feel you have a chance, ask for the job. It's staggering how many people fail to do so, and how successful the question is when it is put. You'll have to find your own language, but try something like 'I enjoyed our conversation and I feel I have a lot to offer. I'd like to work here. Is there anything else I need to do to persuade you to offer me the job?'

Sometimes it's enough to say that you are strongly interested and would appreciate a quick decision. If they like you, they'll jump. Remember the list of recruiter anxieties? A new one enters the list at this stage: *What if I have found the right person and then I lose him/her?*

INTERVIEWS WITH RECRUITMENT CONSULTANTS

Recruitment consultants are, of course, professional selectors who make a living finding workers to fill particular vacancies for client employers. Remember that the recruitment consultant will not make the final selection decision, but is a gatekeeper: he or she can stop you getting in front of the decision maker. You are dealing with an *intermediary* (i.e. someone who is both a broker and barrier). If a recruitment consultant is talking to you, it is most likely for a particular post. Few recruiters will give you an interview otherwise – unless they are hungry for information about your market sector. Some pointers:

- The consultant acts as the employer's eyes and ears, but will see things in an even sharper perspective – if there's something unacceptable about your dress code, interview behaviour, CV or qualifications, the consultant will be highly attuned to it. The reason is simple: a recruitment consultant wants to put forward a *safe bet*.
- Therefore, you need to know what buttons you are pressing in terms of safety, reliability or energy and enthusiasm. Get the recruiter to describe to you what he or she is really looking for, and respond to that.
- Finally, it really pays to encourage your consultant to switch from gate-keeper to lifelong friend. Ask for professional advice on your interview technique or the state of the market. Be flexible and available. Don't let

your doubts about recruitment consultancies or agencies influence this one interview or decision. Agencies need a flow of enthusiastic, committed candidates. Just as you will show an employer how your presence in the workplace will solve problems, be a problem solver to any intermediaries.

ALTERNATIVE THINKING IN YOUR JOB SEARCH

1 Refuse to play by lottery rules

Negative-minded friends and fellow career changers will tell you that even getting an interview is like playing the lottery: the odds are stacked against you. In that situation, do you keep on using the same strategy in the hope that you will be lucky?

Play a game with yourself that begins: how can I avoid getting a job interview? Think about all the things you could do to *guarantee* that you wouldn't get in front of a decision maker: inappropriate CV, lack of preparation ... What would your chances of success be? Now think of fixing just one of those things. Do the odds improve?

2 Shorten the odds

Improve the odds with these strategies:

Get an interview through someone you know
Sounds obvious, but it's a key to success. Employers prefer to buy things they know, and that includes people. If you come even mildly recommended, your chances of a favourable decision are much higher.

Find out as much as you can about the job
Ideally by talking to someone who knows the organization well, but using *every* resource available to you.

Work out who makes the decision
Especially if the decision maker is also going to be your boss – the interview will give you big clues about your future working relationship. If you haven't yet met your boss, how can you decide if you want the job?

Think APPROPRIATE in terms of everything you present, including yourself
You are the message. What are you saying in terms of your dress, your behaviour, your history, your defensiveness when you answer questions?

Read the clues
There's no mystery here. The clues are there for you to read: What makes this job tick and how can you become the heart of the mechanism?

Work out the key result areas in the job
If the company doesn't say, ask. If the company doesn't know, write a draft job description and find out if it's anywhere near right.

Ask yourself the worst questions you can before someone else does
With the right preparation, there are no impossible questions. If you hear a question that floors you, it's because you've avoided asking yourself that question until today.

3 Try the politician's trick

Listen to a seasoned politician being interviewed on the radio. One thing you may notice is that, no matter what questions are asked, the minister always manages to make three or four strong points about government policy. This is deliberate – the airtime is being used as a way of getting a particular message across. The questions just provide an opportunity.

Up to a point, you can use the same technique. *Step 1*: Look at the *key result areas* in a job, and ask yourself 'What *three points* is it vital that I make during this interview?' *Step 2*: Write them down, and rehearse a clear, concise way of talking about them. Given a reasonable opportunity in the interview, make sure you get those three points across.

Why three points? Politicians know that their listeners can only hold a few ideas in mind at one time. Interviewers are much the same. It's also far easier for you to remember a small number of key items.

EXERCISE 12.1 TEMPORARY TERRORISM

Just for a few moments, imagine the worst. You face an interviewer with a huge overdraft and an even bigger headache. She's having a bad day, and will look at everything you have put forward in a bad light. Be that person just for a few moments. What's the worst question you could ask yourself, knowing your own weaknesses? What's the second worst question? What areas of preparation are you weakest on? Where do you think your skills are inadequate? Where do you lack evidence of achievement?

Prepare for that interview, and the real one will be a dream.

But now it's vital to remember how easy it was to see the whole thing negatively. Why is it that you are happier seeing the interview as a nightmare? Why are you more prepared to believe a poor self-image than a positive one? If it's all about the colour you paint the scene in advance, what happens if you tell yourself how brilliant you will be? Sounds corny, but try it. Self-confidence is just as powerful a career-change tool as skills, experience or knowledge.

EXERCISE 12.2 SHOPPING LIST

Find a vacancy that interests you, perhaps through a published advertisement. Ring or write for a job description.

Take an A4 piece of paper and divide it into two vertical columns. Interrogating the job description, write out in the left-hand column the employer's *shopping list* – everything the recruiter is looking for, using the following checklist:

- List all the 'wanted' elements – qualifications, experience, know-how . . .
- Work out what's essential and what's desirable.
- Now use your own industry knowledge to work out *all the stuff between the lines* – the unstated assumptions.
- Finally, try to think yourself in the interviewer's shoes. If I were interviewing, what would I really be looking for? What achievements would I recognize most?

Now, in the right-hand column, write in your matching claims *and* evidence. Think in both terms – you should be able to say what you can do, and give an example of an achievement which substantiates your claim. Go back to Skill Clips (see *Chapter 7*) to work on your mini-narratives.

"MUST DO" LIST:

☞ Practise being a detective, picking up vital clues about the employer's needs.

☞ Don't go to any interview without exploring the purpose of the job, and key result areas.

☞ Think of yourself as a product which solves the employer's problems.

☞ Observe buying behaviour, and apply it to interviewing.

☞ Try anticipating an employer's risk aversion in your interview preparation.

☞ What strategies are you going to use to ensure that at interview you are *the best you there is*?

☞ Use the interview checklists in *Chapter 15*.

WHAT THE FUTURE'S LOOKING FOR

☞ This chapter offers you a chance to get up to speed with the latest thinking on the way employment itself is changing, and the skill set that will help you to cope with an ever-changing world of work.

☞ The fluctuating idea of a 'career'.

☞ Changes in the nature of work.

☞ Future skills, and how to communicate, demonstrate and acquire them.

> ☞ To our counterparts at the end of the twenty-first century today's struggle over jobs will seem like a fight over deckchairs on the *Titanic*.
>
> WILLIAM BRIDGES, *Jobshift*

WHAT IS A CAREER?

The idea that you have any choice in our careers at all is a fairly new one. Our great-grandparents' generation believed strongly in the value of hard work, in working your way up to the top, and in the idea of increasing your chances by getting a good education. It's only really since the 1950s that the Western world has got used to the idea that we make career choices relating to our interests, personality types and backgrounds.

In the 1970s it was felt that people would work fewer hours in the future and have more study and leisure time. In the UK and USA, these predictions proved almost completely wrong.

26,000 days

In the last decade the idea of career choice has become closely tied to the idea of *life choices*. In an average lifetime, a man will live for 26,000 days (it's 28,000 days for women). That's 26,000–28,000 days to learn, work, play, raise a family, leave your mark on life and acquire wisdom. How you spend those days matters – no matter what your spiritual or ethical perspective.

What is a career? A career is largely an idea of the twentieth century. Before that, a 'job' was what we would now call an 'assignment' or 'project'; a short-term engagement. People had trades, and were 'jobbing' carpenters, masons, journalists

or sailors. A permanent job was one that was attached to an income source arising from an endowment (e.g. a 'living' in a parish church, or a royal appointment).

A career now is something that we often put at the centre of our lives. It's where we put a great deal of our energy, and we look to our careers to provide happiness, motivation and reward. Yet to 'career' is also to run away in an uncontrolled direction, as in 'the steering failed and my car careered across the motorway'. Rapid movement in an uncontrolled direction. Does that sound familiar?

In recent years we've become far more attuned to the idea of *life balance*. The answer to the question *Do we work to live, or live to work?* for almost everyone is a compromise. Yet as in any deal, it's easy to let things slip out of balance. Richard Bolles wrote a book many years ago called *The Three Boxes of Life* which is now not widely known, but it's interesting how this concept of striking a balance between life and work keeps coming around as we continue to question our values, and continue to ask the question: 'What did God/life/the universe *mean* by *me*?' Try it. Once that question bites you it'll never let you go.

NEW WORLD OF WORK

It's a risky business predicting the future job market. One guru who seems to have got it more or less right is Charles Handy. He predicted in 1989 that we face a world of 'discontinuous change', suggesting that *'less than half of the workforce in the industrial world will be in "proper" full-time jobs in organizations by the beginning of the 21st century'*. In other words: *more than 50 per cent of jobs* will be something other than 'proper' full-time jobs – part-time, flexi-hours, fixed-term contract, temporary, self-employed or some other variation which controls the risk to an employer of taking on a worker on a permanent, full-time contract.

Charles Handy's predictions were based on the fact that working patterns have changed enormously as old industries decline rapidly and new industries quickly fill their place. The workforce in many industrialized countries, including Britain, is getting older, and people (particularly men) are retiring younger.

Handy also predicted that work would change dramatically. In his book *The Age of Unreason* he suggested that the organization of the future would be shamrock-shaped, with the three leaves composed of different categories of workers:

1 Core professional and management staff;
2 External contractors brought in to undertake specific short-term or long-term tasks;
3 Temporary, part-time and occasional staff.

If anything, Handy failed to guess how far most companies would replace their core staff with contractors, consultants and external supply networks. The middle manager is a fast disappearing species in the US and UK workforce.

Work is changing beyond recognition, and is being performed in increasingly flexible working arrangements.

All we can say about the future with any certainty is that it will be very different from the present, and different in ways which we are *almost* unable to predict. The writer Eddie Obeng has become famous for his belief that this is the first time in the history of humankind that the pace of change is faster than our ability to adapt to it. He believes this happened some time in the 1990s.

☞ Learn to love change. Master today's changes and tomorrow's uncertainty because things are going to keep changing, with you or without you.

BRUCE TULGAN, *Work This Way*

Companies rise and fall nearly overnight. One Internet company in Silicon Valley went from a raw idea to a $25 million sale in just 6 months. At the same time the way companies are measured has been turned on its head. Until the brakes were put on in 2000, an Internet company might easily have sales of $1 billion yet a market valuation of more than $500 billion.

Of one thing there is no doubt: our lives will be ruled by e-business. There are currently six billion microchips in the world – one chip for every human being on the planet. In 1950 a transistor cost $5. By 2003 you will be able to buy a thousand chips for a penny. What's more, these chips either double their power or halve their price *every 6 months*. Chips, little slivers of silicon, will be cheap enough to be embedded in every object that is made or sold, from T-shirts to tins of beans.

In 1998 Ericsson launched a revolutionary new concept: *Bluetooth*; technology that will allow all kinds of electronic devices to communicate with each other without wires. Bluetooth technology will very quickly become a standard package in your phone, PC, whatever ... Among the first products are a headset which will act as mobile phone, but will also give you access to your PC or laptop, and of course to the Internet. At present the system is designed to operate only within 100 metres of the source, but recent growth in cellphone technology suggests that within 5 years or so we will all have mobile, wireless access to all the information we can now access at our desk.

It is sometimes hard to get a perspective on the *rate* of change affecting the world of work. Received wisdom in IBM back in the 1960s was that few people would want computers in their homes. After 2020 you will probably only ever see a desktop computer in a museum; our computers will be in our wallets, our phones, our spectacles. You may even have microchips implanted in your skull. What might *your* job be like when you can access 250 million web pages – all the knowledge in the world – just by blinking? Not science fiction, but the technology perhaps of the next decade. Time to imagine now: how could I survive in such a workplace? How could I not only survive, but also *shine*?

In the 1920s Mercedes predicted that there would be only 1 million cars sold in the world. They reasoned that sales could be no higher because of the lack of chauffeurs! Today, General Motors has a vision of the car of the future as a 'node on a network': global positioning systems and on-board computers mean that the cars of 2005 will be pieces of data, possibly driver free, moving around complex systems controlled by satellites. However, the rate of change is dangerous. Twenty years ago most people thought of a company like GM as a model, solid, mega-corporation. Now it's in difficulty, along with most car manufacturers, and constantly having to rethink both what it provides and the way it works.

Telecommunications have been with us for over a century and it took about 50 years to develop 18 million residential connections in the UK. In 1999 there were 13 million mobile phones in the UK. In 2000 there were 25 million. Markets appear and explode virtually overnight.

The Internet revolution is clearly the dominant piece in the jigsaw. Some 17 million jobs were created in the USA in the last decade; Europe aims to

TABLE 13.1 Predicted trends in flexible working.

- Companies will further expand the idea of the virtual organization through homeworking, teleworking, 'hot desking', and almost every imaginable variation on not being in a 'proper' nine-to-five job.

- Conventional jobs will be replaced by virtual jobs. Many companies have moved over to flexible working arrangements, letting employees choose their hours, location and choose from a range of benefits.

- Many traditional resources providing in-company information (e.g. pension or holiday details) are being provided online, along with a huge range of training and learning materials. Tomorrow's employee will be able to check her salary each month, network with international colleagues, undertake several hours' study and attend a sales conference, all without leaving her living room.

- A combination of high housing costs and travel problems will mean that employers will eventually be forced to locate staff away from the UK's south-east.

- Nevertheless there will still be a number of highly structured jobs with a traditional feel. The challenge to people who feel comfortable in those environments is that an increasingly large gulf will be created between 'new' and 'old' feel organizations – rather like those organizations that have insisted on keeping manual records throughout the last decade of IT revolution.

create 20 million *new jobs* by 2010, and it seems virtually certain that the vast majority of these will be in e-commerce of one kind or another.

☞ **Built to last now means built to change.**
STAN DAVIS AND CHRISTOPHER MEYER, *Blur*

The UK labour market is changing rapidly. Market watchers such as Cranfield School of Management tell us that the fastest growing job categories are in sales, customer services, and computing/IT. These are non-core functions which will often be outsourced or undertaken by temporary staff. The work will often be done by teleworkers, some in dedicated call centres, some working at home.

Commentators have long predicted the decline of the 'good job' – the solid nine-to-five lifelong career – and predicted the growth of portfolio careers. Whilst there has not yet been an enormous increase in temporary and contract working, there is certainly a change in thinking. Workers are looking for a psychological contract, offering their skills in return for experience, learning, *involvement*. It's an interesting fact that 40 per cent of the Dome hosts hired by Manpower for an 18-month contract left permanent jobs in order to do so. Many employees expect to be mobile, to acquire experience from a variety of sources, and to move across both occupations and job fields. Others will increasingly feel alienated by rapidly changing cultures, and will have to seek new niches or seek employment where their solid, reliable, no-nonsense approach is valued. Alternatively, they will need to look for structure and stability outside their work.

Most of the jobs our children will undertake have not yet been created. Many of them have not yet been invented. Traditional careers advice asked school leavers

to focus on skill-shortage areas. Such advice is now dangerous, since the market changes so quickly. Workers who have just got used to the idea of Handy's 'portfolio' existence will have to move on to learn adaptability as their primary skill.

☞ Progress might have been all right once, but it has gone on too long.

OGDEN NASH

Coping with change

Ask most people what they most enjoy about work, and the answer often revolves around growth or variety. In other words, change. Ask the same people what they hate about work, and it's usually uncertainty, downsizing, restructuring. Change again.

This kind of atmosphere is fine for those go-getters who love a fast-changing, dynamic environment. Those who need more stability, who seek strong maintained patterns in work, are going to be placed under even more stress. Their creative job search may be to look for organizations where a more caring, 'family' culture is consciously maintained.

The future will be as difficult as it is unpredictable. Politically correct managers say they 'relish' change, but for most people change is a huge stress inducer. Nevertheless, workers will have to change, change and change again. If e-commerce can explode over just 2 years or so, what will a 40-year working lifetime hold?

Those of us planning career paths into the twenty-first century need to ask ourselves:

- Where will the jobs be, and what will they be like?
- What will employers be looking for?
- What will employers be prepared to pay good money for?

In *Jobshift*, William Bridges refers to the idea of 'You & Co' replacing traditional jobs:

☞ The job-based career was like a chain, with each successive job serving as a link, where there was a single focus of activity. The demise of jobs is going to remove that point of focus for you. As you become a business, you will find that you now have a composite career, which is more like a woven cable, made up of multiple twisted strands of wire. The strands are assignments and projects, often for different organizations and sometimes involving wholly different personal products.

WILLIAM BRIDGES, *Jobshift*

Bridges goes on to argue that the key to career development and growth is to envision yourself as a business – a centre for profit making, ideas, adding value. Bridges' thinking leads to a powerful self-review:

THE 'ME PLC' SELF-REVIEW
. .

- What product or service are you offering to your organization (including ideas, coaching, managing relationships or generally adding value)?
- What organizational needs does that activity fulfil?
- How will you create and deliver what you have to offer?
- Why do you think that what you have to offer is a better match to your organization's needs than similar products or services from other suppliers, internal or external?

Adapted from *Jobshift* by William Bridges

Business analysts looking at the company of the future predict that companies will have to get rid of the cynics, the 'can't do' element holding up progress and cultivate the top 10–15 per cent of individuals who actively manage their own careers, who are developing themselves as 'Me plc'.

What companies need in the twenty-first century, in terms of staff, managers and suppliers, is futurists: individuals who can jump ship quickly, can accept not just change but a quantum leap in the way we do business and who can ultimately embrace not just change but an almost weekly revolution in the workplace.

Profile of the millennium job holder

The US Army has just changed its officer profile. At one time the ideal was an individual whose personality could be controlled and shaped to obey orders without question. Officers are now being recruited for their ability to cope with problems where the data is contradictory or ambiguous, situations where the rule book doesn't help. Most prized is the ability to think laterally – 'outside the box' or 'outside the envelope' – to see possibilities where others see fixed barriers. This is the profile of tomorrow's leaders.

As the market tightens and skill shortages become ever more evident, recruiters in 2001 face their biggest problem: how to predict the future workforce at a time when the only certainty is rapid and unpredictable change. Who would have predicted 25 years ago that supermarkets would offer banking, insurance and Internet shopping? Who could have guessed that retailers would target customers by messages sent to their mobile phones? Graduates hired by the retail giants in the 1980s discovered that the jobs they were trained to fill altered almost out of recognition. As companies struggle to keep up with a market that changes every 24 hours, job descriptions alter at breakneck speed.

The people who do well in this climate, according to a huge range of data, are those who can readily adapt to unpredicted situations. They will need to learn fast and then have the skills to persuade others to follow. A 'throw anything at me' approach to life will be rewarded. Tomorrow's workers will need to be good at tolerating ambiguity.

A trawl through the views of blue-chip companies and research organizations suggests that the profile of the future worker would look something like this:

- Employees will have to be 'changemasters' – not just prepared to accept change, but willing to control and initiate it.
- Workers will have to reinvent themselves constantly in terms of career routes. Many will survive by thinking of themselves as one-person profit centres, as being self-employed with an employing organization.
- Individuals will have to take far more control over their career *progression* – how many people who have worked with one firm for ten years have actually only really delivered the same 12 months' work ten times over?
- Successful workers will have a mix of 'female' and 'male' traits (e.g. strong interpersonal skills *and* a strict focus on objectives).
- Employers will have to instil a vision, a strong sense of common purpose. Some workers will be set aims that cannot be achieved in a single lifetime.
- Workers will be encouraged to grow by identifying top performers and learning from them directly.

Floating workforce

There are now strong signs that the impact of technology will dramatically change working life. This will have huge economic implications. BT, for example, had no less than seventy buildings within half a mile of St Paul's cathedral in 2000. However, it planned within a year to allow over 8,000 people to work flexibly for BT, some of them at home, some of them calling in at convenient 'hot desking' locations at various points around the UK.

It's predicted that homeworking will develop. Even now you can find interesting companies offering consultancy and information based in the most remote locations, but linked to the world by electronic channels that buzz with ideas and information every day. Britain is slowly catching up with third-world countries such as India by providing Internet centres where people can drop in and buy time online by the hour. Your town may soon have drop-in teleworking centres where individuals from different firms can share IT and office resources.

The e-revolution is not only about whizz-kid Internet companies in California; it's about the way we undertake every kind of human transaction. This also applies to education, health care and family life. The service sector, already vast, will be bigger still, with new services provided for those who do not have the time to do their own dog walking, gift shopping or holiday planning. The irony is that when the twentieth century opened the two biggest sources of employment were domestic and agricultural labour. Some trends repeat themselves in odd ways.

Finders keepers

While the 1980s and 1990s were about downsizing and restructuring – essentially about *control* – the company of the future will need to learn to trust its workforce, to build relationships which generate loyalty and ideas in equal proportions. One of the greatest assets of the future will be the knowledge contained in people's minds, and companies will make enormous efforts to ensure that this knowledge

remains within the organization. *Knowledge* management – the retention of ideas as well as personnel is a key issue in the information age.

The employees who will assist companies in the future are those who have the willingness to learn. To learn *anything*. The employees who will take you to your future will think the unthinkable. And then rethink it.

As US careers specialist Helen Harkness suggests, many will go into 'career shock'. In the 1960s Spain was transformed from a traditional rural economy into a tourist destination. Many hotel employees had been brought up in a rural environment which had not changed substantially since the eighteenth century. The incidence of stress, even mental illness, was high. The message for employers and employees alike is that the future is an exciting but also a dangerous place.

☞ Coping with career shock ... is no longer about simple stress management: It is about survival. We have been told repeatedly in recent years that rapid change is inevitable in our world, and many have found the idea of change exciting. But we have not been prepared for the chaos that has preceded or accompanied these changes.

HELEN HARKNESS, *The Career Chase*

'FUTURESKILLS'

The Association of Graduate Recruiters, a UK body, produced a report in 1995 which suggested a number of new, key skills for graduates, including self-reliance skills. Within self-reliance were a number of key career management and learning skills, including self-awareness, self-promotion, networking and negotiation.

A number of other organizations have their own models, including the Industrial Society, which believes that the Action Centred Leadership model of the 1970s (in the view of some, rather male and 'macho'), was supplanted in the 1990s by a 'softer' model requiring managers to be more intuitive and better communicators. The anticipated model for the early twenty-first century is an interesting mix of 'hard' characteristics (focus on targets, decision making, action planning) and 'soft' (self-awareness, responsiveness to the needs of others, coaching/persuading/teaching). However, there is an extra ingredient: the ability to cope with the unexpected – see Table 13.2.

As an employee in the twenty-first century, you will be invited to step way outside your comfort zone, to develop flexi-skills and complex competencies that will allow you to second-guess the future. For those who operate best in a predictable environment, the change is going to be widespread and uncomfortable. For many it already is.

Those of us assessing 'futureskills' will need to develop new instruments which look much more closely at 'what if?' and press even the most creative answers by asking 'what next? ... what else? ... *what else*?' We have to learn to cope with whatever the future throws at us, no matter how unrecognizable. The philosophy of the e-worker will need to be: 'If life sends you lemons ... make lemonade'.

TABLE 13.2 Futureskills.

The key qualities of the future, for success as well as survival:

- 'Bounce back'
- Adaptability
- Imagination
- Goal-setting
- Vision
- Self-reliance
- Improvisation
- Anticipation
- Coaching
- Multi-tasking
- Risk taking
- Flexibility
- Inventiveness

Acquiring 'futureskills'

Actually, in most cases you will not be acquiring new skills, but sharpening and repackaging skills you have. Many businesses are currently concerned that key staff possess well-developed emotional intelligence. However, for many of us born before 1960 these characteristics sound uncannily like some rather old-fashioned ideas, such as *character* and *honesty*. Much in life is recycled under new labels.

There will, almost certainly, be skills that you don't have evidence for. How are you going to acquire them, and demonstrate them? In terms of skill development, it's healthy to take a regular audit: What do I know? What am I good at? What assertions can I make? Where's the evidence? This model works whatever age you are, whether a school leaver or planning your retirement.

EXERCISE 13.1 'Futureskills' audit

Present job

Look at the opportunities for growth, learning and change in your present job. Forget the job title – look at your job as a series of projects.

Present employer

Dissatisfied workers often blame everything on their present job, and think that the only way to fix their work problems is to change employers. Is it? Look around you at the way your company is changing. Think about the 'Me plc' self-review earlier in this chapter. What new job opportunities can you see where you are? What opportunities are there to create a new job for yourself which adds value? The 'pull' of any new opportunity should be greater than the 'push' of wanting to be out of your present job. In fact, the process of career exploration can often be about redefining your

present role so that it draws more on the skills you love to exercise. If you don't try this out, the risk is that you merely transpose your problems to a new location.

Deep mining

Look back at who you are and what you know. How can you repackage past achievements, life experiences, your unique background, in the language of 'futureskills'?

Endless opportunity

How many entirely new jobs have been created since you started reading this book? Every year the list of job categories expands. These new jobs begin in someone's imagination. Why not yours? Failing that, become a trend watcher. See where the new jobs are and find out the skill sets required.

Think e-working

If you're not online, wait no longer. Email is not just quicker, but changes communication. The Internet gives you access to the world's intellectual resources.

'Me plc' as a learning organization

Your PC gives you access to, literally, thousands of online training courses. You no longer have to attend formal courses or go back to college. Similarly, the explosion of publishing in business books gives you access to concise summaries of information and ideas (look for books claiming to give quick bursts of data to busy business people – many of them are better than 12-week courses).

EXERCISE 13.2 PREPARING YOURSELF FOR THE MAD JOURNEY AHEAD

Wander into your nearest electrical or computer superstore. Look at the latest gadgets and equipment. Thinking about each one in detail, ask yourself:

1 How could I use this to change my working life?
2 What impact will this equipment have on the work I do?
3 How could I do my job better if I use this?
4 What job could I create around it?

EXERCISE 13.3 DISCOVER YOUR 'FUTURESKILLS'

How well do you match up to the futureskill set in Table 13.2? Look at each one. Seek out something in your past that demonstrates achievement or comfort exercising your skills, as in Table 13.3.

TABLE 13.3 Matching your achievements to 'futureskills'.

Adaptability *New Training Concept*
In my last job every change in the computer system meant that I had to devise a different way of training staff in my office. It wasn't just the details that changed, but the whole concept.

'Bounce Back' *The day the system failed*
The biggest problem I had was the day after we sent out 10,000 fliers and had to deal with hundreds of bookings, and our computer system crashed! We had to invent a manual record-keeping system on the spot, *and* a follow-up scheme to get back to people, *and* a plan to enter all the data over the next weekend. It was a nightmare, but I came up with a solution every time.

You'll see each mini-narrative provides both a claim ('I can do this') and evidence of how and when. That's the way your CV should be composed, and the way you should present yourself at interview. Remembering that employers are likely to be looking for skills and attributes from this list, ask yourself, 'What can I remember that I can use as evidence?' Write a mini-narrative for each of the *futureskills* printed in Table 13.2. Each needs to be specific and focused like the *skill clips* you wrote in Chapter 7: 'The time when ... ' or 'The day I ... '

Form a 'futureskills' team

Actively develop a small network of people who will actively share information about changes in work, technological developments, better and faster ways of doing things ...

MUST DO LIST:

☞ Plan now what you're going to do with what's left of your 26,000 days.

☞ Identify, develop and broadcast your futureskills.

☞ Cross the threshold and get connected. Use email and exploit the potential of the Internet.

☞ You may be perplexed or intimidated by the new economy. How can you learn from it?

BEGINNING IT HERE

YOUR FIVE-POINT ACTION PLAN FOR GETTING A JOB YOU'LL LOVE

☞ If you can fall in love with what you are going to do for a living, you've got it made.

GEORGE BURNS

While working in South Africa my colleague Lorraine Silverman and I developed a five-point job planning scheme called WorkSharp. The term 'Sharp!' is a common township term to indicate strong approval, often with a 'thumbs up' signal.

Here, adapted for this book, is the five-point plan to help you get a job you'll love:

KNOW	*What do you know?*
	What have you discovered locked away in your House of Knowledge?
	What have you chosen to learn about?
	What kind of learning is vital to your next career step?
DO	*What can you do?*
	Skills, hidden skills, talents. Seeking and recording evidence, from any part of life. Identifying your motivated skills, putting together both claims and evidence of achievements.
	What are your red-hot skills – things you're good at that you really enjoy doing?
YOU	*Who are you?*
	What stimulates, motivates, enriches your life?
	Do you prefer to work mainly with people, things, information or ideas?
	What kind of people do you like to work with?
	What are your career hot buttons?
	What are your strongest intelligences?
	What kind of creativity works best for you?
WHO	*Who do you know?*
	Helping others to help you – renegotiating your job, communicating your ambitions to others.

Developing a support network.

Building your personal web.

WHERE *Where are you going?*

Setting real goals.

Seeking the right tools and support groups to help.

Taking the first step.

Overcoming barriers to personal change.

Dealing with your *YES, BUT*s.

RECRUIT A SUPPORT TEAM

Few things are achievable without the right tools and the right people, yet all too many people try to break out of their career box alone. Get support. First of all, have experimental 'What if?' conversations with as many people you can who can give you a different perspective (but make sure the feedback is at least objective, and preferably upbeat).

Second – and do this before you finish this book – build a support team. You need to find two other people who will help. They don't need to be in the same situation as you, but they do need to be curious about people, jobs and the world of work. One other person will be a help, but a coach/pupil relationship often happens when there are only two people. With three you get two perspectives on everything that's said.

Tomorrow's work is going to be about networks of people, and the relationships that exist between them.

- How can you begin a network? What information can you share and pool?
- How can you tap into other networks that already exist?

Actively develop a small network of people who will:

1 Support you in your job search or career development;
2 Give you honest, objective advice about your claims, and the evidence you use to back them up;
3 Help you as career coaches, interview coaches or in opening doors.

Warning: if you hear a friend say 'Yes, but, in the real world ...' or 'It's not that simple ...' or even 'That won't work', don't invite them to be part of this process. Career success is as much about motivation as it is about strategy. Choose people who will give you positive, encouraging messages.

PASS IT ON

Once you've found what you're looking for, give it away.

Once you have learned some of the solutions to your own career problems, what will you do with that information? With luck and a little application you'll move towards a job you love doing. When we discover anything, there's a natural human impulse to pass it on.

The only true reason for career breakthrough is that we become equipped to improve the working lives of those around us. That may sound madly altruistic, but skills discovery is hollow if it's only about *me*. First of all we discover our talents – the solo instrument we play. The exploring continues until we hear the other instruments as well and understand our role in the orchestra. The final step is to help others to begin to hear the music.

KEY CHECKLISTS

Exploration is rather hollow if it doesn't take you anywhere. This final chapter provides six activity tools for getting the job you'll love.

I am grateful for permission to reproduce the following checklists. An earlier version was originally commissioned by www.lifebyte.com and published in its careers pages.

A WHAT TO PUT IN YOUR CV

1 Remember: a CV only has one function: to get you an interview.
2 Your CV will be read in about 20 seconds. Make it immediately interesting.
3 Make your CV detailed, but keep it *concise*. It isn't your life story. More than three pages is probably too long.
4 Sell yourself on the first sheet, which should stand alone. Start with a profile of who you are, plus your key achievements, followed by a career history in brief. List specific jobs and achievements on page two.
5 Your CV should make *claims* about who you are and what you can do, and then provide *evidence* to back up those claims.
6 *Translate* what you know and can do into terms that will appeal to a recruiter – talk about solving problems, making a difference ...
7 Try to say something interesting about your *academic history* – relate it to an employer's needs rather than regurgitating the syllabus (e.g. if you led a seminar or gave a talk, write about your facilitation or presentation skills).
8 It's all very well being the best thing since sliced bread. *Be measurable*: try to express *achievements* in terms of awards, money, time or percentages.
9 Remember your CV will be screened into a 'YES' or 'NO' pile. Do everything you can to end up in the 'YES' pile.
10 Use good quality white paper. Avoid colour, graphics, special effects.

B WHAT NOT TO DO WITH YOUR CV

1 *Don't* put 'Curriculum Vitae' at the top – put your name and contact details, including email address.
2 *Don't* include referees or rates of pay, either received or expected!
3 *Don't* include *empty adjectives*. Almost everyone is creative, dynamic, enthusiastic. Focus on what you can do well.
4 *Don't* send out poor photocopies. Print your CV on good quality paper.
5 *Don't* go into endless detail about every job you've ever held.
6 *Don't* provide huge amounts of detail about jobs you did more than 10 years ago.

7 *Don't* put anything down under 'interests' unless (a) it has some relevance to the job or (b) you can talk inspiringly for hours on the subject.

8 *Don't* put yourself down, try irony or humour. It rarely reads the way you want it to.

9 *Don't* put anything on the front page that strikes a negative note.

10 *Don't* include anything that looks incomplete or misleading (e.g. mentioning a degree without mentioning the subject or result).

C PREPARING FOR AN INTERVIEW

1 *Plan* carefully. Do you know where you are going and how to get there? Who are you seeing?

2 Make sure you know the *names* of the people who will be interviewing you. Practice saying them if they are difficult to pronounce.

3 There's no such thing as enough *preparation* for an interview. Find out everything you can about the company and what it makes or does. Look for current news – show you are up to date.

4 Why does this job exist? What problems will it solve? What are the *Key Result Areas*?

5 Remember: *employers buy experience*. Think about what *evidence of achievement* you can talk about in the interview; rehearse your success stories.

6 Work out what is *appropriate* in terms of everything you present, including yourself. Look the part, and you will feel it. Dress as if you are already doing the job.

7 Second guess the *employer's 'shopping list'* from the job details – what skills/ qualities/experience do you have to match?

8 Be your own worst interview nightmare. What is the most *difficult question* you might have to face? Practise the answer. Practise again.

9 Be upbeat. Employers latch on to negative messages, so don't give them any.

10 Prepare for rejection. On balance you will be rejected more times than accepted. Even if you don't get the job, you can learn a huge amount about your perceived market value. Remember – there's a job out there for you somewhere – more people are working in the UK than ever before.

D TOUGH INTERVIEW QUESTIONS TO PREPARE FOR (AND WHAT TO SAY)

1 *'Tell us about yourself'*. Prepare for the worst – a classic opener that can really throw you. Say something brief about your career aims.

2 *'Where do you see yourself in 5 years' time?'* – If your answer doesn't ring true for you, it won't for anyone else. Talk about career plans, and what you want to learn and achieve in the future.

3 *'Why do you want this job?'* Have a clear answer to this (even if, privately,

you're not sure – you only have to decide when the job offer is in your hand).

4 *'What kind of person are you?'* Handle questions about personality carefully. Rather than say 'I'm an ideas person', talk about a time when you changed things with a good idea.

5 *'Why did you leave ...?'* Employers will probe for reasons for job change. If you are currently out of work, they will probe this, too. Rehearse short, simple, positive 'stories' to cover these points. This is *not* telling lies, just a simple, positive summary.

6 *'How will you cope in a crisis?'* Have a couple of good examples of past triumphs up your sleeve.

7 *'How will you ...'* questions are beginning to create a *future* which includes *you* – so welcome them. Describe what you would do within the organization as if you are there already. Create the right picture, and the employer won't be able to imagine a future without you ...

8 *'What would you do if a bomb went off in this room?'* – There really is no excuse for fantasy questions like this, since all they test is acting ability. If you're applying for the Royal Shakespeare Company, fine; otherwise, ask the recruiter to relate it to the job. If you have to undertake a flexible sales job, you might be asked to 'sell me this pencil sharpener/paper clip/biro'.

9 *'What do you need to earn?'*. Wrong question. Focus on the value you can add to the employer, not your basic needs. Find out what the company is willing to pay, or work out what similar employers pay for good people.

10 *'What are your weaknesses?'* Remember that the recruiter gives far more weight to negative information. Switch the subject to your strengths as soon as possible.

E WHAT KIND OF CAREER IS RIGHT FOR YOU?

1 Do I want to work *mainly* with *things, people, information, or ideas*?

2 Think about your *career hot buttons* – do you want to catalogue the world, change the world, help the world, sell the world ...?

3 How much *independence* do you want to have about the way you work and make decisions? If you find it difficult to take instructions or you want to go your own way, maybe self-employment beckons ...

4 Look for organizations that reflect your feelings about *rules*. Are you happier working within a clear set of guidelines, or in a completely open-ended way?

5 What activities, products or ideas seem *meaningful* to you? You don't need to be inspired by biscuit technology or soap powder, but if you find any serious discussion about them just absurd, keep looking ...

6 What kind of work have you *chosen* to do, either in your leisure time or as a volunteer? Often the work we *choose* to do without financial constraint is a great clue to our best choice of work.

7 What kind of companies or products reflect your *personal beliefs* about life, spirituality, the planet?

8 Look at the *skills* you *really* enjoy using, when you are impossible to distract and rarely bored. Where could you use them?

9 What subjects *really interest* you? How can you translate your interests into fields of work?

10 Ask. *Find out.* Don't use your career as a lab experiment. Talk to people about the jobs they do. Learn from the mistakes others have made. Get careers advice.

F QUESTIONS TO ASK PROSPECTIVE EMPLOYERS

1 *Read between the lines* – what does the job description fail to tell you?

2 Make sure you communicate real *interest* (e.g. 'What are the company's biggest problems/headaches/opportunities?')

3 'Where is the company going?' (Try to work out what 3–5 years with the company would do for your CV.)

4 Try to find out how you will be *measured* once you begin the job. Are there any set targets? Is there a formal appraisal system?

5 What *learning opportunities* (courses, qualifications, training) does the job offer?

6 What *variety* is there in the job?

7 What kind of *support* will you get? Is there a formal mentoring or coaching programme?

8 Find out what you can about *standards* and *expectations*. How will you know if you have been successful?

9 Watch out for *buying signals* – usually when the conversation switches from past to future. Wait until they want you – that's a good time to negotiate your salary.

10 If you feel you have a chance, *ask for the job*. It might just work.

G ADVICE FOR OLDER JOBSEEKERS

1 Don't miss out your date of birth on your CV (put it on the back page). If you miss it out, the employer's attention is immediately drawn to your age.

2 For the same reason, it's generally not a good idea to refer to the ages of your adult children (they may be older than the person interviewing you!).

3 Finally, it may not be useful to indicate the year you obtained your degree. It may seem like ancient history to the recruiter.

4 Make your CV focus on what you have achieved, and what you have to offer, not on your age.

5 Include an e-mail address. Employers assume that older workers are not IT literate.

6 Remember that employers buy experience. Demonstrate how your know-how and maturity will be a benefit.

7 Don't focus on the bad news stories. Look at the high proportion of men and women in your age group who do actually find work, and build on their success strategies.

8 Focus on your *futureskills* by learning lessons from the new economy.

9 Try not to reminisce: 'in my day ...' Talk about the future. Show flexibility and a willingness to learn.

10 Do not apologize for your age or lack of recent relevant experience, and do not convey desperation.

H WHAT TO DO ON THE FIRST DAY IN A NEW JOB

1 Make sure you know *where and when* to report on day one. Be early: first impressions count.

2 Try not to ask too many questions about *pay day*. Plenty of time for that.

3 Listen, learn and ask intelligent *questions*.

4 Identify the major *problems* and headaches.

5 Keep a *notebook*. Write down names, procedures, contact numbers. Learn the names of key people. Be nice to the people who can make your job easier, or can make it hell.

6 Try to spot your *homework* – company information you can take home and absorb, so you can learn about products, initiatives, supply chain, customer contacts ...

7 Discover the cycle of *routine* activities: there's nothing worse than being totally unprepared for an end-of-month report.

8 Learn as much as you can about *policies, procedures, standards* – the rules. Conformity may be boring, but it keeps you out of trouble.

9 Work out the *key tasks* of your job – how you do things. Pay particular attention to the amount of authority you need to obtain to do or buy anything.

10 Familiarize yourself with *where things are* and *who does what*. Make friends with somebody who knows everybody (e.g. the office messenger).

USEFUL WEBSITES

Unless stated otherwise, these websites provide information about UK jobs and job search methods in Britain.

John Lees maintains a website at www.johnleescareers.com

SEARCH ENGINES

www.unige.ch	WWW search engine – lists other search engines.
www.wonderport.com	Gives access to other search engines.

BRITISH SEARCH ENGINES

www.ask.co.uk
www.bluebirds.co.uk
www.excite.co.uk
www.findarticles.com
www.go.com
www.godado.co.uk
www.inforocket.com
www.journalismnet.com
www.lifestyle.co.uk
www.mirago.co.uk

INTERNATIONAL SEARCH ENGINES

Here are some of the less well-known US engines. All are powerful tools and can produce some very useful information quickly. The important thing is to be precise when constructing your search terms.

www.dejanews.com
www.google.com
www.mckinley.com

COMPANY RESEARCH

www.bloomberg.com	International site, includes an 'Enterpreneur Network'
www.carol.co.uk	Company reports and investor information
www.companieshouse.gov.uk	Lists of all public companies in the UK.
www.grapevine-int.co.uk	Executive and international recruitment company which publishes a list of executive search consultants.

www.hemscott.net	A source of company information.
www.incomesdata.co.uk	Conducts salary surveys for particular occupations and industries.
www.infocheck.co.uk	
www.refdesk.com	Information about employment, but is American; however, still contains useful information about practices and techniques used by employers.
www.reuters.com	The site of the Reuters news agency.
www.reward-group.co.uk	Conducts salary surveys for particular occupations and industries.
www.thebiz.co.uk	Information about companies.
www.vault.com	Website that tells the truth about what it's like to work for various companies.
www.wallstreet.com	The US Stock Exchange site.

SITES LISTING OTHER CAREER-RELATED WEBSITES

www.career-index.com/ job-search-sites.htm	A list of interesting job sites.
www.thejobsearcherssuperstore.com	Claims to provide an updated and comprehensive list of careers websites

JOB HUNTING

www.appointments-plus.co.uk	A good general job site.
www.career-index.com	Lists interesting job sites.
www.employdirect.co.uk	A recruitment site with advertisements which also allows you to post your CV.
www.eteach.com	Jobs in teaching.
www.gisajob.com	Claims to be the UK's largest free jobs website.
www.goldjobs.com	Lists jobs paying over £100,000 p.a.
www.jobhunter.co.uk	Fish4jobs – access to job adverts that have appeared in local newspapers.
www.jobpilot.co.uk	Jobs in Europe.
www.jobs.ac.uk	Academic jobs.
www.jobs4publicsector.com	Public-sector jobs.
www.jobsearch.co.uk	A search engine which gives access to advertisements and allows your CV to be posted for employers to review.
www.jobshark.co.uk	A search engine which gives access to advertisements and allows your CV to be posted for employers to review.
www.jobsineducation.co.uk	A commercial site advertising jobs in the education sector.
www.jobsite.co.uk	Gives access to advertisements and allows your CV to be posted for employers to review. Covers UK and Europe.

www.monster.co.uk	Thousands of jobs in the UK and abroad. Includes career advice.
www.newmonday.com	A European site containing advertisements and CV services. Also contains information about employers and employment.
www.onvocation.com	An employment site for the banking and financial industry.
www.overseasjobs.com	Online newspaper with adverts and some useful guidance.
www.planetrecruit.com	Access to job advertisements in a wide range of countries.
www.senate.uk.com	For older people and senior managers looking for work or career change.
www.stepstone.co.uk/sok	Job adverts in a number of UK and European jobs and enables you to post your CV.
www.tempz.com	An on-line temp agency.
http://there.is/directions/index.html	Provides access to a wide range of resources for career changers.
www.topgrads.co.uk	Lists UK jobs for graduates and includes CV distribution.
www.totaljobs.com	UK jobs in a wide range of occupations.

CAREER DEVELOPMENT AND EXPLORATION

www.givemeajob.co.uk	A site for you to post your CV and gives advice on job search and employers.
www.gradunet.co.uk	Jobs and advice for graduates, with detailed information about employers, and online chat rooms with employer representatives.
www.hobsons.com	Jobs and careers guidance for school leavers and graduates.
www.insidecareers.co.uk	Careers advice and graduate vacancies. The site is constructed in association with a number of professional bodies.
www.i-resign.com/uk/home	Advice on how to leave your job and help with getting another including useful links to other sites.
www.JobHuntersBible.com	The website supporting *What Color Is Your Parachute* – contains a wealth of useful information.
www.manpoweronline.net	The site of the major employment agency – contains a lot of useful market information for jobseekers.
www.sky.com/rfts	Careers advice for teenagers.
http://www.unn.ac.uk/academic/hswe/careers/altlinks.html	University page with links to a vast range of career-related websites and a tailor-made database of careers resources.

PROFESSIONAL ASSOCIATIONS AND OTHERS INVOLVED IN CAREERS AND EMPLOYMENT

www.agcas.csu.man.ac.uk	Association of Graduate Careers and Advice Services.
www.agr.org.uk	Association of Graduate Recruiters (i.e. employers) who regularly recruit from universities.
www.careerzone-uk.com	Careers advice from a consultancy company.
www.cipd.co.uk	Chartered Institute of Personnel and Development.
www.cre.gov.uk	Commission for Race Equality.
www.cmplaw.co.uk	Provides information about employment law and gives access to law reports, etc.
www.employmentservice.gov.uk	UK employment Service.
www.employment-studies.co.uk/pubs	Institute of Employment Studies – conducts research into employment and related issues.
www.open.gov.uk	The main site giving access to all government departments including the Department for Education and Employment.
www.peoplemanagement.co.uk	Journal of CIPD also contains adverts for jobs in personnel.
www.prospects.csu.man.ac.uk	Comprehensive facilities for graduates, but also contains online self-assessment facilities and details of hundreds of occupations.
www.rec.uk	The Recruitment and Employment Confederation's website with listings of employment agencies by region and specialism.

HELP FOR DISABLED JOBSEEKERS

http://www.disability.gov.uk	The Government's site on disability issues.
www.ability.org/emp.html	The site of the Ability charity, includes advice on employment issues.
www.skill.org.uk	The group for disabled students.

NEWSPAPERS

http://ukplus.co.uk/ukplus/ SilverStream/Pages/ pgMSNCategories.html?id=746	Lists all UK main local newspapers.
www.fish4jobs.co.uk	Covers a range of regional newspapers.
www.revolver.com	*The Times*.
www.workthing.com	*The Guardian*'s recruitment services.

www.ft.com	*Financial Times.*
www.appointments-plus.com	*Daily Telegraph.*
www.bigbluedog.com/	*London Evening Standard.*
dynamic/home.html	

TRAINING AND COURSES

www.blueu.com	A new site containing access to training and e-learning opportunities.
www.crac.org.uk	Lifelong career development.
www.dfee.gov.uk/skillsforce	The Government's Skills task force. Contains information about training initiatives and skills needs.
www.learndirect.co.uk	The University for Industry's site.
www.newdeal.gov.uk	Information about the various New Deal schemes.
www.scitsc.wlv.ac.uk/ukinfo/ uk.map.html	A map of the UK showing universities and colleges.
www.ucas.ac.uk	University courses.

CREATIVITY WEBSITES

www.bemorecreative.com	Tips for creativity.
www.brain.com	Tapping your brain power.
www.hbdi-uk.com	Details of the Herrmann Brain Dominance Instrument.

BOOKS AND OTHER RESOURCES

Ask yourself one question first. Are you reading more books in order to put off taking the next step?

GETTING IDEAS ABOUT POSSIBLE FIELDS OF WORK

Careers Encyclopaedia, Ed. Katharine Lea, Continuum Publishing Group, 1997.
Available in most larger reference libraries.

Corporate Research Foundation UK, *Britain's Top Employers: A Guide To The Best Companies To Work For,* HarperCollins Business, 1999.
Learn the best and the worst about major employers.

Occupations 2000, COIC, 2000. A highly valuable directory of the major occupations and professions in the UK, indicating entry routes, necessary qualifications, job and pay prospects.
Available in reference libraries and in some job centres.

Vivien Donald, *Offbeat Careers*, Kogan Page, 1995.
Superb way of looking at off-the-wall ideas: chicken sexer, tripe dresser, stunt performer.

JOB HUNTING

John Courtis, *Getting a Better Job*, CIPD, 1999. No-nonsense advice.

Irene Krechowiecka, *Net That Job, The Times*/Kogan Page, 2000.
Full of references to useful UK websites, and tips on how to use the Internet to find a job.

Graham Perkins, *Killer CVs & Hidden Approaches*, Financial Times/Pitman Publishing, 2000.
An excellent, all-round guide to winning in the job hunt and interview game.

Daniel Porot, *The 101 Toughest Interview Questions*, Ten Speed Press, 1999.
Can be used either as a book or as a series of cards. Great interview preparation material.

Martin John Yate, *Great Answers to Tough Interview Questions*, Kogan Page, 1998.
US author so needs some translating, but some good strategies.

CAREER EXPLORATION AND DEVELOPMENT

Richard N. Bolles, *What Color Is Your Parachute?*, Ten Speed Press, 2000; *Job Hunting On The Internet*, Ten Speed Press 1999.
The classic guide, plus a useful spin-off which contains useful European as well as US websites.

Max Eggert, *The Best Job Hunt Book In the World,* Random House Business Books, 2000.
Includes *The Perfect CV* and *The Perfect Interview*, and tailored to the UK job market.

Godfrey Golzen, *The 'Daily Telegraph' Guide to Working For Yourself,* Kogan Page, 2000.
An excellent, frequently updated guide to self-employment.

Helen Harkness, *The Career Chase: Taking Creative Control in a Chaotic Age*, Davies-Black Publishing, 1997.
An insight into the psychological aspects of career crisis.

Peter Hawkins, *The Art of Building Windmills*, The Graduate Into Employment Unit, University of Liverpool, 1999.
A superb tool for graduates.

Nicholas Lore, *The Pathfinder: How to Choose or Change Your Career For a Lifetime of Satisfaction and Success*, Simon & Schuster, 1998.
An alternative approach with many rich insights into the power of goal setting and motivation.

Carole Pemberton, *Strike a New Career Deal,* Financial Times/Prentice Hall, 1998.
An excellent overview of the process of managing your career.

Daniel Porot, *The PIE Method for Career Success*, JIST Works, 1996.
An excellent workbook covering the whole career change and job search process.

Roy Sheppard, *Your Personal Survival Guide to the 21st Century*, Centre Publishing, 1999.

Sue Ward, *Changing Direction*, Age Concern Books, 1996.
A practical guide for those aged 40–55 facing career change.

Nick Williams, *The Work We Were Born To Do*, Element, 1999.
A British author presenting an exploration of the spiritual aspects of work. Has a strong 'new age' feel.

Bridget Wright, *Careershift*, Piatkus, 1999.
A useful general guide to career change, with a chapter on creative thinking in career exploration.

THE FUTURE OF WORK AND BUSINESS

William Bridges, *Jobshift: How to Prosper in a Workplace Without Jobs*, Addison Wesley, 1995; *Creating You & Co,* Nicholas Brealey, 1997, *The Way of Transition*, Nicholas Brealey 2001.
Ground-breaking books on the future of work.

Stan Davis & Christopher Meyer, *Blur – The Speed of Change in the Connected Economy*, Capstone, 1998.
Hailed by many as the greatest book on the new network economy.

Charles Handy, *The Age Of Unreason,* Arrow Business Books, 1991.
The Empty Raincoat: Making Sense of the Future, Arrow Business Books, 1994.

Kevin Kelly, *New Rules for the New Economy*, Fourth Estate, 1998.
A similar approach to *Blur*, but more of a UK perspective.

Charles Leadbeater, *Living On Thin Air: The New Economy*, Penguin Books, 2000.
A powerful and well-argued vision of the new economy.

Alan Weiss, *Million Dollar Consulting*, McGraw-Hill, 1992.
Still the best book I have come across on self-employed consulting, in any field.

PERSONALITY

Mihaly Csikszentmihalyi, *Creativity – Flow and the Psychology of Discovery and Invention*, Harper Collins, 1996; *Flow – the Psychology of Happiness*, Rider Books, 1992.
Csikszentmihalyi is the originator of the concept of 'flow'. Heavyweight, but the more recent book contains a huge range of examples of creativity.

Steven Covey, *The Seven Habits of Highly Effective People*, Simon & Schuster, 1989.
Another classic, but hard to beat as a method of recharging personal motivation. Covey has produced a number of interesting spin-offs.

Goleman, Daniel, *Emotional Intelligence*, Bloomsbury, 1996; *Working With Emotional Intelligence*, Bloomsbury, 1999.
Accessible guides to EQ.

Howard Gardner, *Intelligence Reframed: Multiple Intelligences for the 21st Century*, Basic Books, 2000.
The latest of Gardner's many books on multiple intelligence.

David Keirsey, Marilyn Bates, *Please Understand Me: Character and Temperament Types*, Prometheus Nemesis Book Co, 1984.
A useful introduction to the MBTI.

Allan Pease and Barbara Pease, *Why Men Don't Listen and Women Can't Read Maps*, Pease International, 1999.
Humorous introduction to the differences between men and women.

Paul D. Tieger, Barbara Barron-Tieger, *Do What You Are : Discover the Perfect Career for You Through the Secrets of Personality Type*, Little Brown, 1995.
US book which explores the impact of personality type on career.

CREATIVE THINKING

Dave Alan, Matt Kingdon, Kris Murrin, Daz Rudkin, *What If! How to Start a Creative Revolution at Work*, Capstone, 1999.
Some great practical business applications.

Tony Buzan, *The Mind Map Book*, BBC Consumer Publishing, 2000.
An essential introduction to mindmapping.

Brian Clegg, *Instant Brainpower*, Kogan Paige, 1999.
Brian Clegg and Paul Birch, *Instant Creativity*, Kogan Page, 1999.
Paul Birch & Brian Clegg, *Imagination Engineering: Your Toolkit for Business Creativity*, Financial Times Management, 2000.
Clegg and Birch, both British authors, provide a valuable range of tools and insights.

Edward De Bono, *Serious Creativity*, Harper Collins, 1996.

Edward De Bono, *De Bono's Thinking Course*, BBC Books, 1998.
De Bono's books have no special effects, minimal illustrations, yet remain the best books on thinking published anywhere.

Jack Foster, *How to Get Ideas*, Berrett-Koehler Publishers, 1996.
Lively, fun, inspiring guide from the perspective of an advertising executive.

H. James Harrington, Glen D. Hoffherr, Robert P. Reid, *The Creativity Toolkit: Provoking Creativity in Individuals and Organizations*, McGraw-Hill 1998.
Thought-provoking and practical. Comes with a CD-rom.

Ned Herrmann, *The Creative Brain*, The Ned Herrmann Group, 1994.
Not widely known in the UK, but Herrmann's 4-quadrant brain model can provide great insights into personality and career drivers.

Ros Jay, *The Ultimate Book of Business Creativity*, Capstone, 2000.
Highly useful digest of great techniques.

Roger Van Oech, *A Whack on the Side of the Head*, Warner Books, 1998.
Irritating, brilliant, great fun. A real eye-opener when it comes to creative thinking. Nothing else is quite like it.

CAREER TESTS

Adult Directions is available free of charge in many university careers services and adult careers centres. It is available commercially from Cascaid Ltd – *see* www.cascaid.co.uk

CareerBuilder is available from Stuart Mitchell Associates, Tel. 01483 423943 www.stuartmitchellassociates.co.uk

INDEX